Paint Watercolor Flowers

Birgit O'Connor

NORTH LIGHT BOOKS

CINCINNATI, OHIO

artistsnetwork.com

Watercolor Materials You Will Need

These are the materials needed to complete the exercises and demonstrations in this book. I noted the brand I used in parentheses, but use any brand you prefer. For advice on choosing materials, see Chapter 1.

Paper

Cold press (Arches), 140-lb. (300gsm) for practice and 300-lb. (640gsm) for finished paintings

Brushes

No. 30 natural round

Nos. 8, 14 and 20 sable/synthetic blend round

No. 3 synthetic round

2" (5cm) bamboo hake

Mop or other wash brush (such as Mottler no. 60 synthetic wash brush)

Transparent Watercolors

(all by Winsor & Newton except where noted)

Burnt Sienna • Cerulean Blue • Cobalt Blue • French Ultramarine Blue • Green Gold • Hansa Yellow Medium* • Indanthrene Blue • Indian Yellow • Indigo • Permanent Alizarin Crimson • Permanent Rose • Permanent Sap Green • Quinacridone Gold • Quinacridone Magenta • Quinacridone Pink* • Quinacridone Purple* • Transparent Yellow • Winsor Blue (Green Shade) • Winsor Blue (Red Shade) • Winsor Violet (Dioxazine) or Carbazole Violet*

* = Daniel Smith watercolors

Other

Large plastic paint palette (shallow wells, large mixing areas, covered)

Large wash bucket, 1–2 gallons (4–8 liters)

Small spray bottle

Terry cloth towels or paper towels

Pencil (2B)

Kneaded eraser

Masking fluid or drawing gum (Pebeo)

Masking tool of choice (old brushes, Uggly Brush, Incredible Nib, etc.)

Rubber cement pickup

Original Mr. Clean Magic Eraser (generic name: melamine foam sponge)

Sketchpad/drawing paper

Graphite or transfer paper

Artist's tape

Hair dryer (optional)

Finding the Painting Zone

With our everyday lives being so busy, the time and mindset for painting is sometimes hard to find. Here are some ways to help you get there:

- **Schedule a painting time and stick to it.** Sometimes to start we simply need to slow down, and planning a regular time for painting can help.

- **Create a routine.** This can be as simple as getting yourself a cup of tea and arranging your paints.

- **Turn on some music.** Tune in to something that moves you. This distraction can help quiet all the external sounds and internal thoughts that can inhibit painting.

- **Close your eyes.** Take a moment to look inward to reset your thoughts. Try to have an awareness of allowing creative energy to move through your body. Treat your paint brushes as an extension of that energy.

- **Breathe.** Are you holding your breath as you paint? This could mean you're trying too hard or struggling with your painting. Inhale deeply through your nose and exhale slowly through your mouth about ten times to help calm your mind and refocus. This works well for any situation.

- **Relax.** Painting doesn't have to be so serious. If it helps, do something silly or turn up the music and dance—anything to let go, change your mood, reduce stress, and set your mind and paintbrush in motion.

- **Be kind to yourself.** Your time spent painting will not always result in a masterpiece, so when this happens, remember that you're actually expanding, growing and learning.

Contents

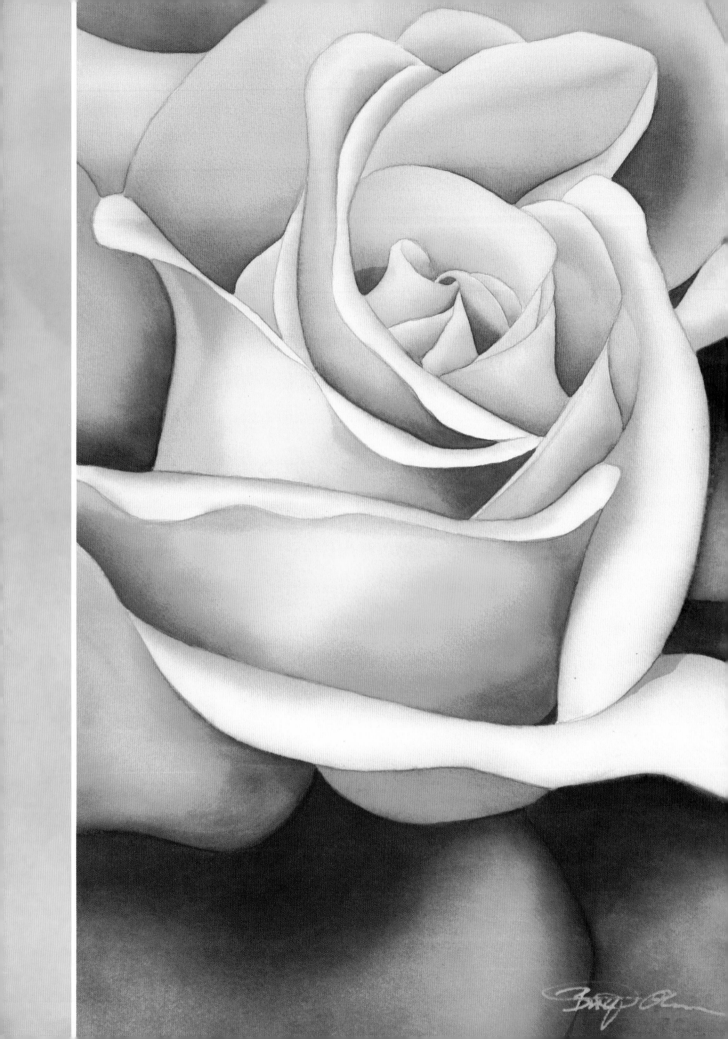

Introduction

As you look through these pages, you might, at first glance, think this book is only about painting flowers, but it's actually much more than that. The floral compositions presented are just a vehicle for freedom of expression to play with water, color, movement and design.

For some, flowers as a subject matter can seem a little limiting, but your perception is really all in your approach. Exploring exciting compositions and experimenting with the amount of water you use with your paints can dramatically change your perspective.

In general, watercolor is the most fluid and expressive medium. The variety of effects that can be created offer you many ways to express yourself. It can even become an emotional experience. Watercolor moves with or without our help and has the ability to reflect light off the surface of the paper, through transparent layers of paint. The luminous color that results is well suited for the beautiful blooms we will paint.

All the techniques used throughout this book are universal and can be applied to other subjects, such as landscapes and still lifes. Lots of people think they can't use watercolor or that it's too hard, but it really is all in how you approach it. Nothing compares to this medium, and once you learn the techniques, you can allow yourself the freedom to explore, have fun and find your creative artist within.

Golden Rose
Watercolor on 300-lb. (640gsm)
cold-pressed paper
22" × 15" (56cm × 38cm)

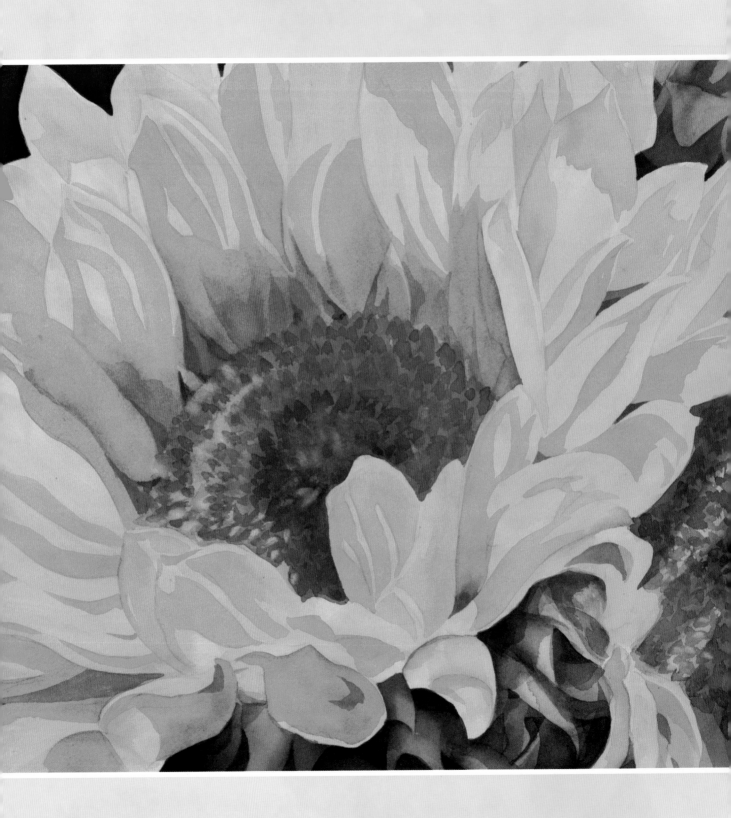

Chapter 1
Getting Ready to Paint

When I first started painting, I began with a colorful sixteen-pan watercolor set by Prang along with a pad of student-grade watercolor paper. At that time, I really didn't think there would be that much of a difference in the quality of the materials, only in price. The color set looked bright enough and came with what seemed to be a suitable brush, and the paper I bought said it was for watercolor, so that must be all I needed and I was on my way.

Then, when painting, I just couldn't understand why my colors did not look clean—in fact, they always appeared muddy. When I struggled to keep them light and transparent, they turned out weak and wimpy, and any that I tried to darken ended up thick and pasty.

I didn't realize that many of the problems I was having were actually in the materials I was using. As with anything, the tools you use contribute to the outcome of your success.

When starting out, if possible, begin with the best artist-grade materials you can afford. This doesn't mean you have to use the most expensive brand of brush, the highest quality of pigment, or the heaviest weight paper, but use materials that fall somewhere in between beginner and professional quality. Student-grade supplies can be cheaper to purchase, but they can also make it challenging to get the results you want. They just don't react the same way artist-grade materials do.

If you're thinking that you'd like to try the medium before making a large investment and you need to work within a budget, start with a good student-grade brand of paint (tubes, not pans), at least one good sable/synthetic blend brush (a no. 12 or no. 14 round), and artist-grade paper in a lighter weight or even a block. One reason to buy better paper is because the student-grade often contains mostly wood pulp and has a tendency to curl, so when layering color on it, the surface does not accept water and paint in the same way. Color can lift easily and mix with previous layers, resulting in a muddy, unattractive look.

Sunflower
Watercolor on 300-lb. (640gsm)
cold-pressed paper
15" × 22" (38cm × 56cm)

How to Set Up Your Studio

Your studio space doesn't have to be huge or cost a lot, it just needs to be some place where you are comfortable. Here are some other studio considerations.

Work Surface

Since most watercolor is done on a flat surface, all you really need is a table to work on. It doesn't have to be fancy or expensive; it can be a folding table or, if your studio space is smaller, an easel that can lay flat. Experiment and see what works for your environment.

Storage Space

Every artist needs a place to store art supplies. It doesn't have to be huge, it just depends on how much you have. For storing paint, consider using fishing tackle boxes or clear plastic containers where you can easily see inside. If your studio is in your home, you may prefer something that's more pleasing to the eye, such as baskets.

A bookshelf with clear containers works well, or perhaps a small table or cart where you can store your supplies underneath. You also don't need to store everything in the same room; for instance, you might paint in one room and hang paintings and store your supplies in another.

Lighting

Natural light is best but not always available, and you may like painting at night, so consider using lamps with daylight bulbs or color-corrected fluorescent lights. See the next page for more on lighting.

Running Water

Running water is a must, but not always available in the room where you paint. If you have a sink, kitchen or bathroom close by, that is really helpful, but if not, you can always dump your water outside and fill your water bucket using a faucet or hose.

As far as hardness or softness of the water, some artists may have a different view, but work with what you have. Don't worry about it.

Always use a large water bucket, about 1–2 gallons (4–8 liters), and make sure that you fill it up about three quarters of the way full. Change the water often, but having a large amount of water ready to go means you won't have to change it quite as often.

Ventilation

Some watercolor papers can be a little stinky when they get wet, so remember to open a few windows or have a fan to circulate the air.

Floor Covering

Watercolors are not terribly messy, so in most cases you are probably fine as is. Just to be safe, however, you might want to consider putting down a fabric dropcloth or plastic sheeting. Plastic can be slippery, so be careful.

A Place to Rest

Consider having a comfortable chair where you can sit down, rest, reflect, contemplate your composition and just take a moment for yourself.

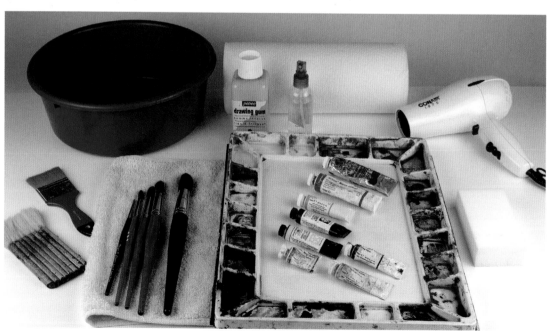

Be Prepared
Before you start painting, have your basic supplies ready: water container, palette, watercolor paints, brushes, paper towels, masking, fingertip spray bottle and hair dryer. You can always add more to your setup later.

Studio Lighting Conditions

When it comes to the kind of light to have in your studio, it's best to have full-spectrum natural light, ideally from north-facing windows. The reason for this is the light will stay fairly consistent throughout the day without direct light coming in.

For many of us, that's not always possible. The windows may be facing the wrong direction, your studio space may have no windows at all or perhaps you like to paint either at night or early in the morning. Sometimes you may even start a painting in the day then continue to paint at night, which can greatly affect your color choices. Other people find the only time they can paint is with a group, and with that, lighting can be questionable. In any case, you don't need to wait for the conditions to be perfect or for the sun to be facing the right direction in order to paint.

We all want the lighting where we paint to show the colors as accurately as possible. If your painting style is more realistic, then full-spectrum light is very important to you, and if you're a little more free-flowing, you may have a little more flexibility.

All of our situations can be corrected with lighting fixtures, lamps and bulbs. If you paint in a group or travel from room to room, workshop to workshop, consider a portable full-spectrum tabletop, craft, hobby, desk or clamp-on lamp. You can even find full-spectrum collapsible lamps. One brand popular with artists and hobbyists is OttLite, found at hobby, craft and big-box stores or online. Some are wireless and battery-operated. You just want to make sure you have enough light when painting.

Let's talk a little about studio (light) temperature created by the light bulbs you buy and how to create the environment you want. Studio temp is measured in degrees of Kelvin (K) on a scale of 1,000 to 10,000.

- **Warm white light (2000K–3000K):** Produces a warm white that ranges from orange to yellow-white in appearance and creates a cozy, calm, intimate environment and is best for living rooms, kitchens and bathrooms (not a painting light).
- **Cool white light (3100K–4500K):** A cool or bright white that will emit a more neutral white light and can have a slightly blue tint. It's good for work environments like basements and garages, and it makes an okay painting light.
- **Daylight (4600K–6500K):** The closest to daylight, this appears crisp and clean and is the best painting light. 5000K is better for artists because it is less blue and cool and is closer to what most galleries use.

Don't worry if you feel overwhelmed by too much technical information on lighting—you don't need to change all your fixtures, you just need to learn a bit about bulbs.

- **Incandescent bulbs** use too much energy and give off a yellow light that can distort colors.
- **Halogen bulbs** are acceptable but produce too much heat and are expensive.
- **Compact fluorescent bulbs** use less energy, are brighter, last longer and come in a larger range of color temperatures. Just understand that they brighten up a little more slowly.
- **LED bulbs** are usually more expensive but use the least amount of energy and are said to have the longest lifespan. A 60-watt bulb uses 10 watts of electricity and is equivalent to 5000K.

Basically, all you need is a clean white light that is closest to daylight without being too blue—5000K should do fine. Many artists prefer compact fluorescent or LED bulbs because you can simply replace the bulbs in your lighting fixtures to get the proper studio lighting.

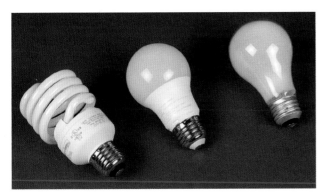

What Light Is Right for You
To get the right studio lighting, it's an easy fix: replace bulbs with full-spectrum compact fluorescent or LED bulbs, or choose a full-spectrum lamp.

Paints

In order to have the best results, it's always good to start with the best materials possible, because they will help you have a better understanding of how the watercolor medium works, and you are less likely to create muddy color. But if you are just starting out or need to be more economical, student-grade paints are a good place to start. They are less expensive but not as many colors are available.

Student-Grade Watercolors

Student-grade paint is not as finely ground and is made with cheaper materials, so you can't expect the same results you might get with artist-grade paint, and you may find some noticeable differences with student-grade color. Depending on the brand, some may not be as rich and others may even be chalky. They can have more filler (that clear, gooey substance you see when squeezing a tube of color onto your palette) and less pigment load, meaning you may have less coverage and a weaker tinting strength, and color will not be as lightfast, meaning less likely to fade.

Student-grade paints may have the same color name as some of the artist-grade paints, but the color will not be the same, and color choices are limited. You may notice that the word "hue" appears in the name of many student-grade paints; all it means is that alternatives have been added to replace some of the more expensive pigments or those that are toxic, and their tinting strength may not be as strong or may be less predictable. (With today's concerns over toxicity, even some artist-grade paints are now starting to include more alternatives, so you can see the word "hue" there, too.)

If using student sets, I suggest tubes over pans, but if you plan to do more outside painting, pan sets will be fine. Some good beginner student sets to try are Sakura Koi, Van Gogh, Grumbacher Academy or Winsor & Newton Cotman.

Artist-Grade Watercolors

When painting, the best choice to use is artist-grade or professional watercolors. They can cost about twice as much as student-grade but are well worth the investment. Artist-grade paint is heavily pigmented and more finely ground, which means it has the richest color. It will flow the best when applied to water and is more lightfast.

Many brands of artist-grade paint are available. Prices will vary, and the pigment load and extender or filler may vary slightly, but the biggest difference is the range of hues each brand offers.

Student Grade vs. Artist Grade
Student-grade paint is inexpensive but has more filler and less pigment, weaker tinting strength, and its color will not be as lightfast. Artist-grade (or professional) paint is ground finer, has less filler and a heavier pigment load and is more lightfast. In most cases, to tell the difference between the two grades of paint, look for the words "Student" or "Academy" (compared to "Artist Watercolor") on the label of the tube.

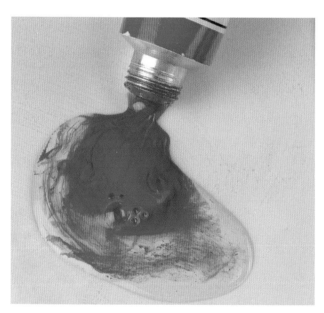

Clear Gooey Stuff
Also known as the binder or extender/filler, this is what holds the watercolor pigment in a creamy liquid state. Student-grade colors tend to contain more filler than the artist-grade colors. When squeezing a tube color onto your palette, if you see more filler than color coming out, insert a toothpick into the tube and stir.

Picking Brands

With so many brands of paint available, the variety can sometimes be overwhelming. The place where you are purchasing your supplies can determine what's available to you. Art stores will carry the most popular and best-selling brands. Online art supply companies will have a wider variety. In reality, you don't need to worry about all the different brands that are out there; just start with what is readily available.

To get advice on which brand to choose, consult art instruction books or videos, or ask your retailer for options. Talk to other artists or join art groups or social media groups to find what colors and brands they like to use.

Mixing Brands

You can mix different brands together, but some artists believe you should stick with only one brand for the best results. When mixed, different brands may give you unexpected results and appear dull or muddy. They may also move or interact differently than when mixing paints of the same brand. This is why having a scrap piece of paper handy to test a color or blend is very important, and making color charts is even better. When mixing, consider labeling your mixtures so you can return at a later time and use what you like.

Colors With the Same Name Are Not the Same

No matter what brand you buy, not all pigments are created equal, even the ones bearing the exact same name. Each manufacturer's interpretation of the pigment color can differ, and there are many other variables, such as shade and lightfastness, which can vary from brand to brand. So don't expect all brands with the same color name to be the same.

Student Paint Sets
You can buy student-quality paints individually or in a set. Some student sets include a small palette and brush. If purchasing a set, consider buying a good large brush for more flexibility.

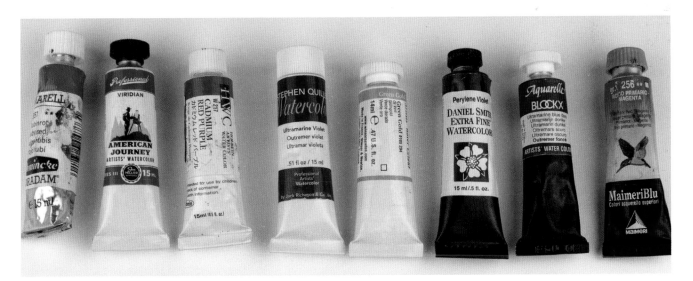

Making the Grade
Artist-grade paints are made with higher-quality pigments, making them a bit more expensive than student-grade. Every artist will have their personal preference colors and brands they like to use. On the tube you will see the words "Artist Quality" or "Professional" paint. Just a few of the brands available include Winsor & Newton, Daniel Smith, Schmincke, Maimeri Blu, M. Graham, Sennelier and Daler-Rowney.

Tube Size Matters

The most common tube sizes are 5ml and 14ml, and now some of the more popular colors are available in the 37ml size, but for general purposes I suggest buying 14ml.

You might think that getting the smaller tubes of paint will save you money, but that's not true. With smaller tubes, you will find yourself being stingy with the amount of color you put on your palette or worried that you will run out. Plus, using less can leave you with a painting that is weak in color. Buying larger tubes of the artist-grade paint not only gives you better-quality paint and color, but you will have more freedom when painting to explore without being inhibited. So, in the long run, the larger tubes will save you money.

Organizing Your Tubes

If you're like many artists, over time we start to accumulate different colors or more and more tubes of the same ones we like. With so many tubes, how can you organize them so you can easily access the colors you want when you need them?

If you have just a few colors, they can fit nicely in a box, but if you have lots of tubes, you will need some kind of inventory system. They can be sorted into color families or into primary and secondary colors or even by brand or type (transparent vs. opaque, granular vs. non-granular, etc.).

Tool or tackle boxes can store tubes nicely, but if you have a lot of colors, you might try using a clear-pocket shoe organizer that can hang on a door (where you can easily see the tubes of color), clear plastic boxes or bags or rolling bin organizers (label the outside with swatches of the colors or families of colors inside) or attaching tubes to a board using binder clips.

Storing Extra Tubes

Sometimes colors get discontinued, and you may find yourself purchasing more color than you need for fear of running out. For some artists, one way to keep a lot of paint at its peak is to vacuum seal the color into bags and freeze it.

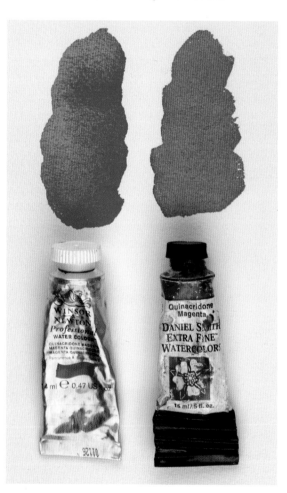

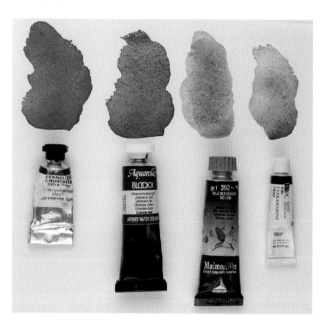

Differences Between Brands
Shown are different brands of Ultramarine Blue—some are more intense, others are lighter in hue.

Watch When Mixing
These are both wonderful colors, but you can see one is brighter than the other. This can be important when mixing pigments together, because depending on what you're mixing, one blend or brand can be vibrant and the other dull or even muddy. For example, one brand of Quinacridone Gold may appear as a light gold, while another brand may appear slightly brownish or even more greenish. Indigo can appear as a deep blue in one brand, but purplish or black in another brand. These differences can be critical to your paintings and change their tone.

Make Your Own Pan Sets Using Tube Colors
You can make your own portable painting sets by filling empty pans with tube colors and gluing them into a small tin. If you want the pans to be removable, hold them in place with modeling clay or Velcro. Pair your set with a collapsible traveling brush or even cut an "inexpensive" brush in half and your travel painting set is ready to go.

Tube or Pan Colors?
Color in tubes is moist and color in pans is dry, but both can deliver color at full strength. The only determining factor of the value will be the amount of water used. Tube colors are great for studio painting or mixing large batches of paint. Pan colors work well when you're on the go. Give both a try to see what you like best.

Tubes vs. Pans

Artist-grade tube colors are rich and vibrant. They're ready for mixing and dissolve easily in water, blending and flowing effortlessly. Some artists like to use the color right out of the tube without diluting it. Tube colors are great for mixing large batches of color or when working on large-scale paintings, because you have control over how much color you squeeze onto your palette. You can fill your wells with as much color as you like and even refill pan colors or make your own sets.

Tubes can take up a lot of space, so some artists prefer to fill all their palette wells with entire tubes of paint. This can make it more convenient to transport and easier to travel with. Like other artists, I prefer to squeeze out fresh color when starting a new painting and take advantage of that smooth, creamy consistency.

Pan colors are dry pigments that come in a set or individual pans, which you activate by re-wetting them before painting. Color choices can be more limited though, as most manufacturers do not have all colors available in pans. You can make your own pan sets by purchasing empty pans and filling them with tube colors of your choice; these work well for collapsible palettes or travel sets.

To re-wet, simply spray dried pigment with clean water. Be aware that some colors may appear light and washed out if you're using larger brushes and more water.

Pan colors do present some challenges. Depending on the brand, their tinting strength may not be as strong. Depending on the brush size you want to use, you may be a little limited with smaller pans. There can be a tendency to want to dig into the paint with your brush to pick up more color, which can damage your brush and also jam pigment into the ferrule, carrying the potential to contaminate other colors. Pan colors can also become crumbly and bits of pigment can hide in your brush, only to be found again when working on a large wash.

Smooth and Creamy
Artist-grade tube colors have a creamy consistency compared to pan colors, which are dry pigments that must be activated with water.

Using Transparent Colors

Make sure you are using transparent watercolors rather than opaque. Transparent colors are best for glazing and tinting and make for some of the cleanest color blends without turning muddy.

The transparency of a color is determined by how much light can pass through it. When transparent color is applied in thin layers, you can see through it to the reflective paper surface underneath, where the light is able to bounce off of the white paper, creating jewel-like effects similar to stacking one layer of colored glass on top of another. Not only is this a wonderful effect, but the technique can alter the hue.

A color's transparency is stated on the side of the tube. Even when a color is labeled as transparent, its transparency will vary depending on how finely ground it is and the heaviness of the pigment load.

Choosing Paint Colors

Earlier in this book you were provided a list of the watercolors I use, which you will see later in the demonstrations.

If you started with student sets and are now ready to make that leap into artist-grade paint, but still want to keep your investment as low as possible, you can start out by purchasing only a few colors—particularly red, blue and yellow, because you can mix these three colors to create all others.

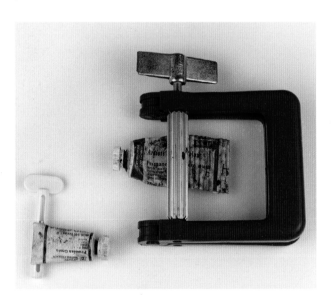

Squeezing Out the Last Bit of Color
Looking to get the last bit of color out of a tube? You can use toothpaste or paint keys or a paint tube squeezer (insert the end and roll). You could also cut the tube in half and use it as a pan. This can work well for color that has become thick and does not flow freely.

In traditional watercolor, black and white are eliminated from the palette. Any white you see is created from the light reflecting off of the paper surface. White pigment has a chalky appearance and can distract from the transparency of the painting or, when mixed, can become muddy.

When black is added, it can change the tone of the painting but also has the ability to kill it. Consider mixing your darker colors by using complements (opposites on the color wheel) or by adding darker pigments such as Indigo, Indanthrene Blue, Winsor Violet (Dioxazine) or Daniel Smith Carbazole Violet.

Setting Up Your Palette

When working in the studio, a large palette with a big area for mixing is best. Make sure that it has a lid or cover to help keep the colors moist and protect them from external debris, such as dust or animal hair.

The wells should be located along the sides. I prefer shallow wells, as deeper wells have a tendency to accumulate water in the bottom, which can dilute and weaken the colors. The shallow wells don't seem to have that problem—the color stays nice and creamy.

Before adding any paint into the wells, to prevent color from beading up in the mixing area, rough up the shiny slick surface in the center with a mild abrasive such as Soft Scrub or even an original Mr. Clean Magic Eraser, then rinse thoroughly.

Arranging Your Colors When first starting out, I had no sense of how to organize my colors, so I separated them into families of color—yellows, reds, greens, browns, blues—and always kept my Indigo in the lower left-hand corner closest to me (just a quirk). I left occasional empty wells in between for any new colors or blends I decided to add.

Every artist has their own individual way of placing color on their palette. Some organize them from light to dark or from warm to cool, or arrange their colors like a color wheel, with complementary colors on opposite sides. (Mixing two complementary colors together will give you neutral grays.)

Label the Colors or Make a Map Using a permanent marker, write the names of your colors on the rim or side of your palette or even on pieces of artist's tape so they're removable. Another way to keep track of the colors you use is to make a map of your palette on a separate sheet of paper, with the color names and a stroke of each, to remind you of what you have.

Filling the Wells Some artists like to fill each well with an entire tube of paint. Others squeeze out fresh paint every time they work.

If you fill your well with the entire tube, the color can dry out, but depending on the brand, some colors can stay moist longer. The logic is if the entire tube of paint is in the well, there is less surface area to dry out and it's much easier for traveling.

Filling wells can make it easier for traveling, but depending on how often you paint and environmental conditions, the tinting strength may not be as strong or the color flow as good.

Sometimes with filled wells or pan colors, even after re-wetting, you might find yourself digging your brush into the color. Then little chunks of color mysteriously can find their way into the ferrule or accumulate into the hair of the brush, showing up as horrifying streaks across your beautiful wash.

If you only put a little color in the well, you might not have enough color to complete an area, or you might get skimpy with your paints, which can leave you with weak color. Personally, I like the creamy consistency of tube colors and like to add some new fresh color (about the size of a lima bean) into the existing color that I already have on my palette, because it mixes well and flows nicely.

To reconstitute dried paint or to soften any color on your palette, just spritz it with a little clean water.

Once you have your colors in place on your palette, you don't need to remove them or clean your palette between paintings, but it may need some tidying up now and then to keep the colors clean. If covered, some colors can get moldy. If left uncovered, debris or hair may fall into them, or over time, tube colors can dry out and crumble. This can also happen with pan colors.

Right- or Left-Handed? Depending on whether you're right- or left-handed, keep your palette, brushes and color on your dominant side. This way you're less likely to cause any accidental drips across the painting.

Common Paint Palette Problems and How to Solve Them

- **Little bits of color.** To avoid little bits of color showing up in your washes after you've re-wet your color, mix it well.

- **Contaminated color.** If the colors in your wells get contaminated with other colors, you don't need to scrub out all the color. Just take a brush and try to wipe the contaminated color out or simply run a little clean water over it to help loosen it. If you're using pan colors and one color becomes a little contaminated with another, simply wipe over the area with a cloth or a brush to remove the unwanted color.

- **Cracking or crumbling paint.** Depending on the brand, your environment and how long the paint has been in the wells between paintings, some colors may crack or even crumble over time. If the color is cracked, simply re-wet it or add a little gum arabic or glycerin. Be aware that the gum arabic slows the drying process, has a slight shine and can even intensify color.

- **Moldy paint.** Mold needs the right conditions to grow, which are easy to find in a closed, damp palette. (This is one reason why I prefer to only squeeze out a generous amount of what I plan to use at a time, instead of filling my wells.) A good way to prevent paint from molding is to let the surface layer dry a little before covering your palette. Then re-wet by lightly spraying with water when you're ready to use it again.

Little bits of color can ruin washes.

Dried paint can crack or crumble over time.

Brushes

Watercolor brushes can be expensive but are well worth the investment. A few good brushes can last a lifetime (or close to it) if you take care of them. Many beginning artists try to get by with inexpensive brushes from sets or use the ones they already have on hand from experimenting with other mediums. These can be too hard or too soft and often too small and usually do not hold enough water.

This doesn't mean that if you buy the most expensive watercolor brush you're guaranteed a masterpiece; the dollar amount won't determine the right brush for what you need. It's more important to know about the hair or synthetic fiber used to make it—whether it is natural hair, synthetic or a sable/synthetic blend, as that will affect its performance and what tasks are best suited for it.

Think of this like you would any other craft, sport or hobby, or even if you were building a house—in order to get the results you want, you need the best tools that you can afford.

Parts of the Brush

Brushes are made of three basic parts:
- **The tuft:** The tip of the brush made out of natural or synthetic hair, tightly tied together at the base. Traditionally the hair and fibers have been carefully chosen and shaped by master brush makers. To keep the cost down and more affordable for artists, many manufacturers today allow brushes to be machine made and cut into shape, instead of hand shaping.
- **The ferrule:** The metal sleeve that protects the hair or fiber and adds the support needed for handling.
- **The handle:** Made of lacquered wood. Compared to acrylic or oil painting brushes, watercolor brushes usually have a shorter handle length.

Brush Fiber

When painting, you may wonder why you can't get the results you want. The answer often involves the brushes you're using. For instance, your painting may look dry if your brush is stiff and doesn't carry the amount of water you want. Working with a brush that is too soft and floppy or adds too much water can also give you poor results.

The fiber or hair a brush is made with affects how it works and what it can do.

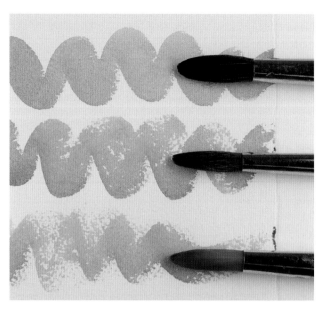

Not All Brushes Are the Same
Synthetic brushes (bottom) are stiff and give you a lot of control but hold the least amount of water. A natural brush (top) holds the most water but that may be too much. A synthetic/sable blend (middle) is a good all-around brush and in general holds the right amount of water and color for most painting.

Synthetics Today there is such a wide variety of high-quality synthetic fibers available that many synthetic brushes can be good alternatives for some of the more expensive brushes.

Depending on the quality of the fiber, some lesser ones can be too stiff and easily lift the previous layer of color when layering. Higher quality synthetics are softer and compare to some sable/synthetic blends.

Synthetic brushes spring back to form quickly and hold much less water than blended or natural-hair brushes. That they hold less water can be useful for the right task. For instance, when applying paint to a damp surface, the stroke has the ability to hold together without dissipating as much, making it ideal for some techniques, such as applying a fold or bend to a petal.

Synthetic/Sable Blend The most versatile brushes for most techniques are the sable/synthetic blends. These have a good balance between both synthetic fibers and natural hair. They hold a nice amount of water similar to some of the natural brushes, while being soft enough for layering without lifting, along with having the spring and control of a synthetic.

Natural Hair Natural-hair brushes are softer and hold the most water compared to blends or synthetics and are easier to use for layering color upon color without lifting the previous layer. When wet, these brushes can easily be flicked back into shape without splaying or splitting. When painting they hold a consistent bead of color.

Many natural brushes are made of not only kolinsky but also a blend of other natural hair. Pricing depends on the type of hair used.

Many of us feel that we have finally arrived as an artist after we purchase our first pure kolinsky brush, but it can be a little disappointing if you don't know how to use it, because it's soft and floppy and doesn't spring back to form like some other brushes. To some artists, the challenge of a pure kolinsky is that it is so soft it can have a tendency to skip over the surface, catching the tooth of the paper and leaving white spaces of the paper showing though. It all depends on the technique you're trying to achieve. These are best used on lighter weight papers such as 140-lb. (300gsm) or papers with a smoother surface.

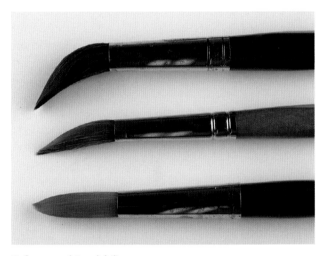

Softness and Bendability
When damp, a brush made of natural hair (top) is softer and will stay bent longer. A sable/synthetic blend (middle) is somewhat soft and will have a slight bend. A synthetic brush (bottom) is stiffer and will spring back to form the fastest.

Shopping for Brushes

In the art store you will find brushes in different groupings of brands, types and mediums, such as watercolor, oil or acrylic. Within the watercolor section you will find brushes sorted by size, brand and type (synthetic, sable/synthetic blend or natural hair), but once you leave the store it may not always be so clear as to what kind of brush it is, because most often you will find that the handles are not labeled with the brush type.

In the store you can ask a salesperson, but if it's not their medium of choice, they may have limited information. So, it's good for you to have a better idea of what to look for when purchasing a brush.

While at the art store, ask if you can get the brush wet and test it on a piece of Magic Water painting paper or a Buddha board or Art Advantage brushstroke paper (most art stores will have one of these). All three brands are basically the same, and with only water you can test the brush, feel the spring of the tip, see the type of stroke and water release. Then within minutes the paper dries, leaving no visible mark or residue. If these papers are not available, see if you can test on a piece of plain paper, watercolor or note paper. You just want to get a feel for the brush. Try to notice if it's stiff, soft or somewhere in between. Does it spring to form or stay floppy? Does it hold a good amount of water or not much?

Spring and Bend If you're able to get the brush you're testing wet, that's great; if not, that's okay too. Try to get a feel for the brush and how the tip feels when pressing it onto a surface.

Synthetic brushes feel stiffer and harder on the surface, and their fibers stay tighter together. They don't hold as much water, and they spring back to form quickly. Sable/synthetic blends have more bounce and go from wide strokes to thin strokes easily. They hold more water than a synthetic, with a smoother stroke and can stay slightly bent when wet. Natural brushes are the softest when pressed onto a surface and hold the most water, with the tip staying bent longer.

The Shine Before testing, look at the hair and fiber in the tip. If the sizing is removed and the tip is pliable, bend the hair to the side. If the fibers all look the same and there's a consistent shine, most likely it's a synthetic. If you see shine with some duller ones mixed in or an uneven sheen, this would be a blend of sable/synthetic. If you don't see any shine, then it's a natural brush.

Round Brushes

Many watercolorists have a tendency to work with smaller round brushes such as nos. 6, 8 and 10, with no. 10 being the largest. Depending on the technique and size of your painting, however, these sizes may be a little limiting, because with a smaller brush it takes many more brushstrokes to cover a large area than it does with a larger brush. For wider brushstrokes and fewer limitations, consider increasing the size of your brushes to nos. 14, 20 and 30.

To find the brush size, look for the number on the side of the handle. While painting, you are going to be using multiple brush sizes. If it's difficult for you to remember the sizes, write the numbers out larger on pieces of artist's tape and place on the handles until you are familiar with the sizes that you're using.

The larger brushes can still be used for smaller paintings. Some larger brush sizes can be harder to find, because many art and hobby supply stores make a large investment in inventory and the smaller sizes sell much faster. If your local art store doesn't carry the brush size you're looking for, go online and look for art supply mail-order companies that have a larger inventory.

Wash Brushes

Wash brushes hold lots of water and cover large areas quickly. They're usually about 2"–3" (5cm–8cm) wide and are either synthetic, natural or a blend. Depending on the pressure applied to the brush, wash brushes can easily release larger amounts of water.

If using a flat synthetic or blend wash brush, try not to slice across your wash on an angle, otherwise, you risk lifting some of the previous color. By using a very soft or natural wash brush, this is less likely to happen. For smaller areas where more water is needed, consider other brush types to apply water, such as cat's tongue, round, sable, mop or oval.

For the type of painting that we're going to do, we will be using the wash brush more to apply water rather than color. The bamboo hake brush is an inexpensive natural brush that has the ability to hold lots of water, but it can lose hair easily. A synthetic wash brush won't lose any fiber and applies an even layer of water, but, depending on the angle, can cut into previously applied color. Natural wash brushes are softer and less likely to slice into the previous layer, and they have the ability to apply more of a puddle to the paper.

When to Replace the Brush

This is really going to depend on the type of painting you do. Some artists feel that as soon as the tip has rounded off, it's time to replace it. Others like myself don't mind, and in some cases actually prefer it—it just shows the love of your tools. Depending on how you paint and hold the brush, a fine point can flick the color around your painting, tossing little spots everywhere, but a point also has the ability to give you finer detail.

If you have old brushes, there is no need to throw them away, because at some time in the future you might use them for something else or another technique, such as scrubbing, creating surface texture or masking, and who knows—it might be just the right brush at another time to give you a particular stroke that you need.

Cleaning Brushes

There is no real reason to wash your brushes with soap; I only rinse mine in clean water. But if you feel you need to wash them, use a mild dish soap such as Ivory or brush soap. Place soap and water in your hand, then gently swirl your brush in it and rinse with cold water. Repeat until the water runs clear. Some colors may stain brush hairs or fibers, but this will not affect the brush and its performance. Once dry, place it tip up in a container.

Brush Tips

Brushes can last a lifetime if you take care of them.

- Use watercolor brushes only for watercolor.
- Do not store in direct sunlight.
- Dip your brush in water to prepare the tip before painting.
- Do not submerge the ferrule; it will weaken the glue and loosen the tip.
- Never leave your brushes tip-down in water; it will ruin the point.
- Between paintings, store brushes tip-up in a heavy jar.
- Lay brushes flat to dry.
- Do not dig or gouge the brush into pan colors or dried palette colors; the excess paint builds up around the ferrule and can easily migrate into other colors.
- Inexpensive brushes will need the same kind of care as the more expensive ones.
- Use only old, inexpensive brushes to apply masking fluid.

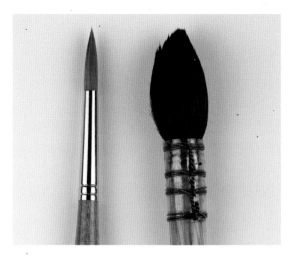

Same Number, Different Size

When looking for a brush, realize that not all brushes with the same number are the same size. For example, a no. 8 in one brand can be very different than a no. 8 in another.

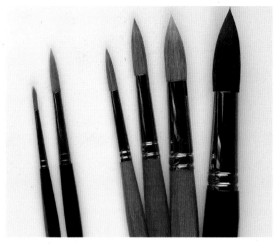

Round Brush Sizes Compared

Smaller brushes can offer a little more control, but their size makes looser, more expressive brushwork more difficult. On the left are a few commonly used sizes (nos. 3 and 8) compared to the grouping I use, on the right (nos. 8, 14, 20 and 30).

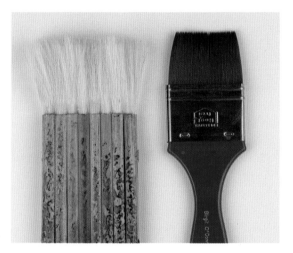

Hake and Flat Wash Brushes

Both of these brushes hold lots of water, but the bamboo hake brush (left) has longer natural hairs that deliver more of a puddle to the paper surface rather than an even layer of water, and it's soft enough not to lift the previous layers of color or leave angular lines when glazing color.

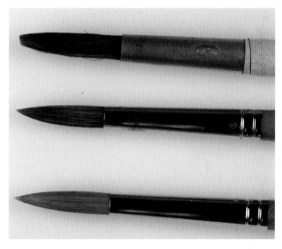

When Is a Brush Too Old?

Not all painting requires a fine point. Brush tips may wear and round off, but you may find a new use for them. Shown are a twenty-year-old brush (with the roundest tip), a well-used brush (still pointed but darkened with use) and a new brush (finest point, lightest hair color).

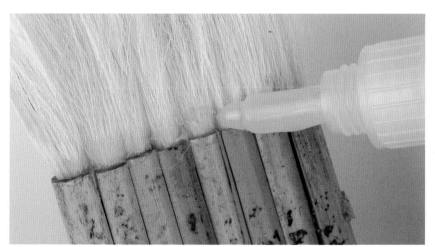

The Brush Fix

The bamboo hake brush loses hair easily. For a good fix, use a little liquid superglue. Holding the brush vertically, apply the glue along the bottom of the hair just above the bamboo handle, then, using a toothpick or needle, work the glue deeper into the center. The glue should only travel about ¼" (6mm) up the tip of the brush hair, just so the glue can penetrate into the center of the brush. Let dry thoroughly.

This also works well if the ferrule has loosened or separated from any other brush—just glue it back on.

Paper

Today, there is such a wide variety of fine art paper to choose from that deciding which one to use can be a little confusing, because each one will react slightly differently. The fiber, sizing, weight and format all affect the consistency of how the paper accepts water and color, as well as the durability of the surface and how it handles lifting and reworking.

Most papers are made by beating cotton or wood down to a pulp, thereby separating the fibers. Once it's in a liquid state, it is poured into a mould with a textured screen on the bottom, which allows the excess water to run out. It is then left to dry. The screens, usually ribbed or woven, give the paper its texture. Woven screens create a pebblier appearance.

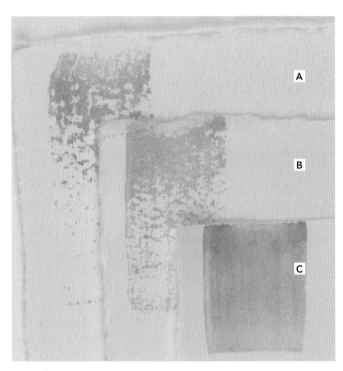

A 300-lb. (640gsm) cold press—heavier and stiffer, more absorbent surface

B 140-lb. (300gsm) cold press—semi-smooth, more absorbent surface

C 140-lb. (300gsm) hot press—smooth, less absorbent

 300-lb. (640gsm) rough—the most texture (not shown)

How Paper Finish Affects Applied Paint

The smoothness of hot-pressed paper is best for either detailed botanical paintings or a very loose style where you want to encourage paint to move. Rough paper has a heavily textured surface where color tends to settle into the deep crevasses. Cold press, particularly 140-lb. (300gsm), has a fairly even texture that is between smooth and rough and is universally used by most artists.

As the paper settles, the side facing the screen develops more texture than the smoother top (or "felt") side. Once dry, you can paint on either side, the smooth felt side or the textured side—this is a personal choice. The wonderful thing about two good painting surfaces is that, if you make a mistake, you can simply turn the paper over and start again.

Before you buy any paper, here is some other important information to help you choose wisely.

Fiber Makeup

The most common fibers used for making paper are cotton, cellulose or a combination of both. Many of the fibers come from cotton or plant cellulose such as wood, flax, hemp, bamboo or rice straw. All of these have varying degrees of length.

Cotton is considered the highest and most archival grade available. It is naturally acid-free and most often called 100 percent rag paper. Cotton has the longest and strongest fibers, making it the most durable for reworking and lifting without showing much wear and tear on the surface. Unfortunately, not all rag papers are the same. A lesser-quality version is also available, made from the leftover shorter fibers from the grinding process, called linters. These papers can get very fuzzy when reworking the surface.

Cellulose paper is considered to be a low- to mid-quality student grade paper and will have the shortest fibers. It's usually made from plant pulp such as wood, making it less durable. Cellulose papers are more acidic and are not archival, which means that, over time, they can break down. Sometimes these papers may be buffered with a neutral pH to extend the life, but they should still be considered mostly for craft or student projects.

Combination paper, a mixture of both wood and cotton, is generally considered a multipurpose paper. Some examples are Bristol board, pastel, charcoal and watercolor papers, depending on the percentage of cotton used.

Finish

There are three basic types of watercolor paper finishes available. Each one has a different surface texture (or tooth) that is created by the mould frame used to make it; this can be a metal screen (like a window screen) or evenly spaced horizontal and vertical wires.

Cold-pressed paper is the most commonly used. While the paper is still wet, it is re-pressed to a semismooth surface, leaving a slight texture. It absorbs water and color and is easily workable. This is a good choice as a standard painting surface for most watercolor artists, good for both texture and detailed paintings. Controlled washes and clean lines are easily achieved.

Rough paper has a distinct surface texture as a result of it being allowed to air-dry without any smoothing or re-pressing. Color likes to settle in the hollows of the surface, which can create some very interesting effects. This paper is wonderful for bold work or paintings where you can use the texture to your advantage, such as fences, wood, barns or rocks, but it's not recommended for detailed paintings. The surface is absorbent and toothy, which can leave white spots if not enough water and color is used.

Hot-pressed paper is a smooth, flat, hard surface that is created by running a fresh sheet through heated rollers to iron out the texture. Since the surface is so hard, it does not absorb water and color well, making it difficult to achieve controlled washes. Hot-pressed paper is ideal for detailed work where you use less water; on the other hand, if you want very loose paintings, use lots of water and take advantage of backwashes and blossoming effects.

Types of Paper

Papers will react differently, even when using the same techniques.

Handmade paper is usually made with 100 percent natural fibers such as silk, linen, flax or cotton, and individually formed by skilled craftsmen. It is generally more expensive, with many irregularities in the surface texture, making it very interesting to work with.

Mouldmade paper is a close imitation of handmade paper because of the random arrangement of the fibers and the look of the surface. This paper is actually made by a high-speed machine called a cylinder mould using 100 percent cotton fiber. It is considered very durable under intense use and is the most archival.

Machine-made paper is created by a rapidly moving machine that forms, dries, sizes and presses the sheet. This process produces an extremely uniform, smooth sheet without deckle edges. Made from cellulose or a combination of fibers, it is considered less durable, without the feel or look of the mouldmade papers. Do not expect the same results as the 100 percent cotton rag paper.

Yupo is 100 percent polypropylene, a machine-made product with a smooth, slick surface. It has no deckle edges. It is waterproof, stain-resistant and incredibly strong, with a neutral pH. This paper does not react like others. Since it does not have an absorbent surface, the color can completely lift off, making it very difficult, if not impossible, to layer color in the traditional sense. One advantage to this surface is that, if you make a mistake, you can completely restore the surface back to white. You really don't have much control over this paper. One way to handle it is to add your color and allow the paper to lead. It is possible to get some interesting effects by laying the color on and placing it facedown on top of a flat surface such as Plexiglas, turning it back over and letting it dry, then working the patterns.

Bristol board was originally created in Bristol, England, hence the name. It has two workable surfaces with a bright white background, making it ideal for reproduction purposes but not as desirable for gallery viewing. The board consists of a combination of two or more sheets of paper pasted together, forming a thick two- or five-ply board, which makes it resistant to warping. It is acid-free and archival. Since it has a smoother surface, it is ideal for detailed paintings or illustrations.

Illustration board is similar to Bristol board in that both are rated by the number of layers or "ply" of the board. However, there is a difference: Illustration board has only one workable surface, and it is thicker and heavier. For example, a 5-ply Bristol board is roughly equivalent to 14-ply illustration board.

Quantities and Sizes

Fine art papers are most often sold as single sheets, with the most common size being a full sheet (22" × 30" [56cm × 76cm]). Full sheets can then be torn down into half sheets (15" × 22" [38cm × 56cm]) or quarter sheets (15" × 11" [38cm × 28cm]). Larger paper sizes are also available, such as single elephant (25¾" × 40" [65cm × 102cm]), double elephant (29½" × 41" [75cm × 104cm]) and triple elephant (40" × 60" [102cm × 152cm]). Larger sizes can be difficult to find; you can ask your local art store to special-order it or try mail-order companies. For the lowest price, buying in bulk is best. You can place a large order by yourself or go in with some friends.

Which Is the Right Side of the Paper to Use?

You can use either side of your watercolor paper, but the true right side is determined by the watermark. The watermark is the brand name and identifying symbol of the paper manufacturer. It is most noticeable when using sheets. If you hold a sheet of watercolor paper at an angle, you will see it. The side where the name is most legible is considered the right side of the paper. It is the smoother felt side and is considered to be the most consistent. The placement of the watermark can change depending on the size of the paper.

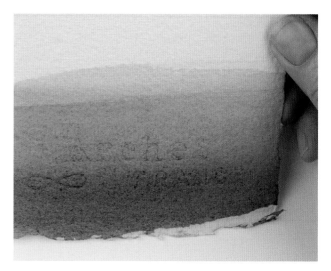

Watermark
The watermark is the symbol or brand name of the manufacturer and can be found in the corner of a sheet of artist-grade paper.

Blocks are portable pads of mouldmade 100 percent cotton paper glued together on all four sides. They come in a variety of sizes and are convenient for traveling or working in the field. They don't require stretching to prevent the paper from buckling when paint and water are applied, but react slightly differently than larger single sheets due to the sizing.

To separate individual sheets from the block, insert a dull knife or blade into the small entry point along the side and follow the seam along the edge. Small palette knives work best because they don't tend to cut the paper.

Rolls are an economical way to purchase paper, especially when you want to paint larger, but they can be difficult to use and store. They measure 44½" × 10 yards (113cm × 9m), and you can cut them to the desired length. To remove the memory of the curl, cut your paper to size, soak it in a water-filled tub, then hang it on a line using clothespins, pin it to a wall or mount it to a board with staples, tape or bulldog clips and let it dry. You could also ask your framer to dry mount a sheet to acid-free foamcore board to give you a flat surface to work with.

Paper Weight

Paper weight is determined by ream, which is 500 sheets of paper. The higher the number, the thicker and stiffer the paper. For instance, 500 sheets of 22" × 30" (56cm × 76cm) can weigh 300-lb. (640gsm).

Standard watercolor paper weights are 90-lb. (190gsm), 140-lb. (300gsm) and 300-lb. (640gsm). Heavier weight papers can be more expensive but require less preparation time, lay mostly flat and are much more durable than lighter weight papers, which have a tendency to buckle. Lighter weight papers are less expensive but, depending on the amount of water used in your painting, they can easily buckle and cause paint to pool, creating unwanted effects.

I prefer to use 90-lb. (190gsm) or 140-lb. (300gsm) for painting practice, quick renderings or any painting that requires less water and 300-lb. (640gsm) for paintings requiring more water, lifting and reworking. When using the heavier weight papers, if they do curl a bit, lightly spray the back with clean water, then bend back into shape.

For the painting demonstrations in this book, I use 300-lb. (640gsm) cold-pressed Arches paper, but if lighter weight papers fit more easily into your budget, or if the surface is what you prefer, you may want to consider stretching it first. The only problem with stretching paper is it breaks down and removes the sizing, which is something we want for creating smooth washes. (Stay tuned for more on sizing and stretching.)

Deckle Edges

During the paper-making process, once the pulp is poured into the mould, the wooden frame that rests on top that defines the edges compresses the pulp as it moves toward the outside, giving the sheet's edges a feathered appearance, called the deckle edge. This type of edge is desired by many painters, especially if you paint out to the edges of the paper and prefer to float your paintings in a frame rather than using a mat.

If you prefer to work on smaller paintings, try not to cut your paper down to size; tear it down instead to help give you the illusion of deckle edges.

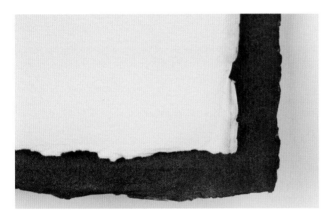

Deckle Edges
Mouldmade paper has a deckle edge that results from the papermaking process. Consider painting to these edges, then instead of covering them with a mat during framing, float the painting in the frame to reveal more of the authenticity of the art.

Artist Grade vs. Student Grade

Not all paper is created equal, and you will not be able to get the same results with student-grade paper as you will with the more expensive artist-grade paper. Even when using artist grade, each brand can vary so much that techniques that work well on one paper will react differently on another. For instance, some papers are softer and more absorbent, meaning you may have to work faster to get the effect you want. Others stay wet longer, giving you more time to work with the paint as it's applied to the paper.

Student-grade papers are usually made out of cheaper materials and most often entirely out of wood pulp, meaning the surface will not accept color in the same way as the artist-grade. What happens is that water and color sit more on the surface; even when dry, the color is not able to penetrate the surface, making it difficult to layer and glaze. Because of its slicker surface, color has a tendency to lift and mix with the previous layer, creating muddy colors. And, since it's primarily made of wood pulp, it has a tendency to yellow over time.

Student-grade papers may say cold press, but since the surface is harder and slicker, it can react more like hot-pressed paper, meaning the color and water can sit on the surface, resulting in more uneven color, and it can also have a tendency to curl. It will be just about impossible to get the same results with student-grade paper as with artist grade.

Artist-grade paper is made out of 100 percent rag, internally and most often externally sized with a gelatin-like substance. It handles and absorbs paint differently and more evenly, is archival and is less likely to yellow over time.

Tearing Watercolor Paper to Size

It's always better to tear watercolor paper rather than to cut it. Cut paper has a harsh appearance and limits your framing options, because often the edges will need to be hidden with a mat. Tearing, if done correctly, will give you an attractive edge similar to a deckle edge.

The easiest way to tear it is to fold the paper in half, work the seam back and forth to weaken it, then make a small tear at one end. Place that end on the edge of a table, pinch the other end closest to you and apply pressure evenly while pulling up one side as you tear your way along the rest of the seam.

Different brands of paper can be more difficult to tear due to how the fibers lay. In this case, dampen along the seam and apply pressure with a straightedge before tearing.

Tearing watercolor paper is easy and looks better than a cut edge.

What Is Sizing?

Every brand of watercolor paper has a coating on the surface called sizing. Sizing affects the performance of the paper, such as how well it takes paint and the flow of color on the surface. It helps to protect the surface to resist scratching and determines the artist's ability to make necessary changes and corrections, such as lifting and removing color and how much the artist can rework the surface. Too much sizing can repel water and color, and too little sizing can make the paper much too absorbent. The type of sizing determines how hard the surface will be.

Gelatin sizing, made from animal bones and hides, creates a harder, more durable surface. The color sits on the surface longer instead of soaking into the paper fibers, which can make applied colors appear brighter and more intense, and allows for color lifting and reworking without damaging the paper itself. Hard-sized papers can be a little smelly, like dirty socks.

Vegetable sizing, made of natural starches like potato, rice or wheat, creates a surface that is less smelly but softer, more absorbent and more susceptible to damage (for instance, the paper may tear more easily if tape or masking is used). Colors applied to it may not be as intense and, depending on the amount of water absorption on the surface, some colors can appear a bit flat.

When considering which sizing to choose, it's not always about the price because each paper type will create slightly different results. My preference would be a hard-sized paper for more dramatic paintings, and for looser and more delicate paintings, I would reach for a soft-sized paper.

Papers are usually both internally and externally sized.

Internal sizing is used during the papermaking process before pulp is placed in the mould to help bind the fibers together to make the sheet of paper stronger. Its purpose is to resist any liquid such as ink or watercolor. Papers with only internal sizing tend to be softer, making it difficult to build color due to the fact that the color continues to wick into the paper.

External sizing is applied after the papermaking process to dry paper for a less absorbent, harder surface, making it more durable for reworking, lifting and scrubbing and consistent for color—it acts as a protective coating to inhibit absorption. External sizing allows color to be held more on the surface, which can make it easier to get richer color.

Little or No Sizing
Paper with little to no sizing can be very soft and absorbent, making it difficult for color and water to flow freely. This can be fun for wet-into-wet effects but does not work well to get smooth, blended washes of color, because the color does not have time to move before soaking in. If you look closely, you can see how the color is captured by the texture of the paper.

Hard Sizing
Hard sizing makes paper more durable and not as delicate. It gives you time to work the surface and be able to lift color and scrub if needed. The hard sizing acts like a protective shell and allows the water and color to stay on the surface longer, so if you bend and tilt the paper, color is able to move to create soft blended colors.

Soaking and Stretching Paper

Before painting, depending on the weight of the paper used, some watercolorists soak their paper in a tub of water to remove the sizing, then stretch the paper by taping or stapling it to a board support. Soaking and stretching is a bit time-consuming and frustrating, especially if you want to start painting right away, but it will give you a flatter, more consistent surface so paint puddling is less likely.

Soaking is not always necessary, however; it really depends on the style of painting you want to do and the amount of water you're using, along with factoring in the weight. Lighter weight paper such as 140-lb. (300gsm) is likely to buckle as it dries if you don't soak and stretch it first. If you are using heavier paper, soaking isn't necessary to prevent buckling, but it makes the paper more pliable.

Removing the sizing allows pigment to soak into the paper fibers more easily. Depending on the painting technique used, removing the sizing can create smooth washes without puddling. Not removing the sizing will keep the water and color more on the surface, and it can puddle more—but, when used correctly, the bead of water can be used to your advantage to even out washes, prevent blossoms and create luminous transitions of color.

Some artists, like myself, prefer not to tape the paper down or remove the sizing, and instead use the external surface sizing to carry the water and color in a seamless wash. When working with surface sizing, one of the most important things to remember is to watch how the surface is drying. To prevent unwanted blooms—the spots created when wet paint spreads on a surface that's not quite dry—the paper must dry evenly; but again, this all depends on the effect that you want to create.

Two Ways to Stretch Paper

To use lighter weight paper for your paintings and prevent it from buckling when you paint, follow these steps to soak, stretch and attach it to a board. You will need gummed brown tape or ⅜" (1cm) staples, a drawing board or Gator board and a sponge.

1. Cut gummed brown tape approximately 6" (15cm) longer than each side of the paper.

2. Soak the watercolor paper for a couple of minutes in a tub of water or spray it with a generous amount of clean water so the paper fibers can expand, and allow the excess to run off.

3. Place the wet paper on a drawing board or Gator board so it lays flat.

4. With a soft, clean, damp sponge, smooth out any bumps.

5. Moisten the tape and apply firmly to one edge, then repeat for the other sides (if you don't have gummed tape, you can also use a stapler).

6. Leave flat and let dry.

7. Once dry, paint as desired.

8. After your painting is done, remove the tape, being careful not to tear the paper. You may also want to consider trimming the edges.

Another option is to use canvas stretcher bars. Soak and stretch as you normally would, allow the paper to overlap, fold in the corners so they appear clean, staple the paper on the back, and let dry. After the painting is done, remove and frame as usual, or leave it on the stretcher bars and treat with a UV polymer varnish to protect it. No frame is necessary.

1. Choose your desired size using a standard canvas stretcher. Brace if necessary.

2. Soak the paper and allow the excess to run off.

3. Place your paper on a clean working surface. Allow the paper to overlap 2"–3" (5cm–8cm) on all sides.

4. Fold one edge over and on the back staple every 1"–1½" (3cm–4cm).

5. Leave 2" (5cm) on the corners to fold later.

6. Rotate to the opposite side and repeat.

7. Then rotate the sides toward you one at a time and repeat.

8. If you plan to leave the painting on the stretcher bars and protect it with varnish, fold in the corners.

Storing Paper and Finished Paintings

Watercolor paper is an organic product, so special care should be taken when handling it. You will want to try to control the environment it's in as much as possible against light, moisture and air. Stack sheets of watercolor paper (and finished paintings) flat and in a cool, dry place, out of direct sunlight (see sidebar for tips).

Store your paper and any unframed artwork in flat files. Portfolios are another way to prevent paintings from moving around. Watercolor blocks can be stored on a shelf just like any other book.

If you have the room, flat files are best for storage, either wood or painted metal (bare metal can sweat and rust). I prefer wood; I have one that was custom-made to accommodate my large 40" × 60" (102cm × 152cm) paintings. If you don't have the space, you can store them in the original packaging under a bed (bedrooms usually have a fairly consistent temperature).

I like to store my finished paintings in flat files with a sheet of glassine (a thin, glossy paper resistant to oils and water) in between, so they are less likely to get damaged.

With framed artwork, most times the back is sealed, protecting the paintings against bugs and the environment. If you want to really protect it, keep it out of direct sunlight or make sure it's framed using glass or Plexiglas with UV protection (but this can be expensive).

Shopping for Paper

When going into an art store, keep in mind that products get moved. For instance, you may ask a salesperson for a certain type of paper, and they lead you over to the flat file where it's stored, hand you the sheet, you purchase it, take it home or to a workshop and start painting, only to find they gave you the wrong paper. So, before purchasing and leaving the store, check for the watermark and feel the surface. Check if it's soft or hard, slick or rough; if there is a label on the back, does it say "hot or cold press" and the paper weight? If possible, look at the original package it came in, just to make sure you're getting what you asked for, because a change in paper can really affect the results of your painting. You are less likely to get the wrong paper if ordering online.

Intimidated by Paper?

Many people get paralyzed by the cost of heavier weight papers and are afraid of making a mistake on them when painting. But you can't grow as an artist or get better with technique if you don't take that next step and give them a try.

To help you get over the fear of a blank sheet of 300-lb. (640gsm) paper, first practice on a lighter weight paper to get the feel of applying large amounts of water and color without feeling intimidated. You'll find that it will buckle more, and the surface will dry more quickly.

If the paper does buckle, let it dry, then place it facedown on a clean towel and iron the back using low heat. Keep this practice sheet—it will be helpful later to test colors and practice glazing and layering. I advise against using student pads or spiral-bound paper, because these papers are more acidic, they do not react the same and the surfaces will not dry evenly.

If you decide you'd rather work with less water, that's fine too, but you may not get the transitional colors and the luminous glow that you want.

When you're ready and you do try heavier weight paper for your finished paintings, you will be surprised how workable the surface is in comparison.

Other Supplies

Pencils

When transferring an image onto watercolor paper, I use a regular, everyday 2B pencil. Some other artists like to use watercolor pencils. Before painting, consider rolling an art gum eraser over your drawing first to remove any excess graphite.

Erasers

When it comes to doing line drawings on watercolor paper, ideally we want to have minimal lines, but sometimes lines need to be erased while, hopefully, not damaging the paper surface. Some erasers will work better than others.

- **Art gum eraser:** This type of eraser won't ruin your watercolor paper, but it tends to crumble.
- **Kneaded eraser:** Soft, pliable and flexible enough to be formed into shapes, this eraser will not damage the surface. Simply roll or smudge over the sketch to lighten or remove pencil lines. I prefer this type of eraser because you are less likely to overrub areas.
- **Moo eraser:** Used on dry paper to remove pencil lines, this amazing eraser is soft yet dense and will not damage the paper, even with excessive rubbing. It won't smear or streak graphite like some other erasers. It works similar to a kneaded eraser; the residue clumps together to make strands for easy cleanup instead of crumbles.
- **Vinyl eraser:** This is one of the toughest erasers and can even remove ink, but it can also damage watercolor paper.
- **Pencil eraser:** Do not use this eraser to remove any pencil lines from watercolor paper. You can easily press too hard, gouge the paper and damage the surface.
- **Melamine foam (Mr. Clean Magic Eraser):** Use the original Magic Eraser (without detergent), or purchase it under the generic name *melamine foam* (in the original form, it is nontoxic). It is a light, flexible, open-cell foam product made from melamine resin. When dipped in water, it breaks the sponge down into a microscopic polymer abrasive that can grab the pigment particles in the tiny spaces in the paper that a sponge or brush can't reach, which makes it perfect for lifting when needed in watercolor painting. It is available where cleaning supplies are sold or online.

Paper Towels

Make sure you have paper towels handy. They are good for cleaning up any messes, lifting color and making wonderful texture, such as clouds, in landscape paintings.

Many artists prefer to use Viva towels—these will give you softer edges—but for my painting style it doesn't make much difference. I primarily use them for wiping up my work surface or removing excess water out of puddles in the painting and, if needed, from my brushes.

Terry Cloth Towels

Terry cloth towels are great for eliminating excess water from brushes and for laying your brushes on to prevent them from rolling around on your work surface. At the end of the day just hang them to dry and reuse later. They can be washed and used again and again. Just make sure you're using old towels—this way the excess lint has already been removed.

Disposal Tips

- **Disposing of dirty water:** Watercolor is generally considered nontoxic and is known to be the safest medium to use, especially if you stay away from cobalt and cadmium colors. But if you are trying to be ecofriendly and are concerned about the footprint that watercolor has in the world, consider dumping your dirty water outside on your plants instead of the drain.
- **Disposing of dirty paper towels:** These work well for wiping color out of the palette, cleaning up a work surface, removing excess water from a brush or lifting a puddle off a corner in the painting. They can get soaked quickly, but you can dry and reuse them a few times. Then, when they are absolutely saturated with color, dry them again and use them for other art projects, such as collage or crafts for children.

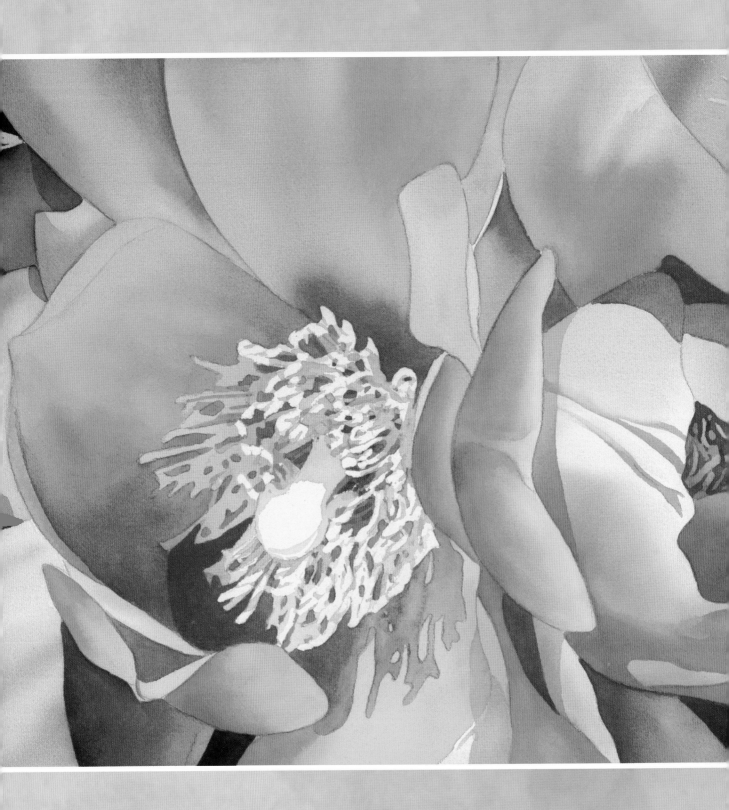

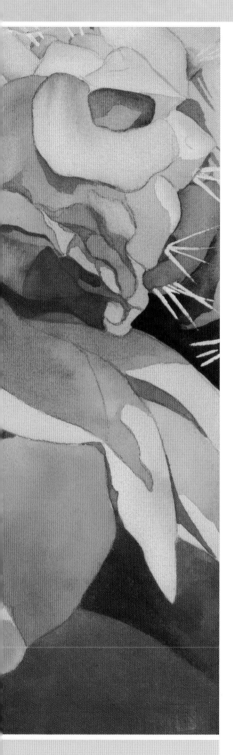

Chapter 2
Basic Watercolor Techniques

Some watercolor newcomers have a tendency to paint with too much color and not enough water, resulting in paintings that are thick, pasty and heavy-handed. In contrast, some beginners can be afraid to use enough color and water resulting in weak, pale and anemic paintings. It's important to strike a balance by understanding your materials, learning what they do and why they matter.

It's also crucial to understanding the proper amount of water and pigment to use. Remember, this is watercolor after all, and water is our friend. It makes the pigments more transparent, allows seamless transitions between washes and evokes emotion through movement. Don't be afraid to push yourself as you go. Watercolor is a learning process, and pushing yourself will help you grow as an artist.

Orange Cactus Flowers
Watercolor on 300-lb. (640gsm)
cold-pressed paper
15" × 22" (38cm × 56cm)

Brushwork Basics

Have you ever looked at a painting and wondered how the artist got that one magical brushstroke that set the tone for the entire piece?

Brushwork is the foundation of the artist's ability to execute what they are trying to convey, because a brush is an extension of the artist's vision and creativity.

Different Brushes, Different Strokes

Most paintings are done with round or flat brushes or a combination of the two. Flat brushes are more angular and the stroke straighter; a round brush comes to a fine point and the stroke is more organic. A flat brush creates very straight lines, great for architecture and more angular-looking paintings. Both brush types can be used for landscapes, flowers, still life and other subjects—it's just a different outcome, and the preference will be up to the individual artist. There are also other kinds of brushes with unusual shapes, which can give you entirely different results.

Aside from shape considerations, the type of hair or synthetic fiber used in a brush will affect the stroke it makes due to the amount of water it holds and releases onto the paper.

When painting, some artists will choose to use one brush type in a single size or a range of different sizes, or some will use a combination of different sizes and brush types. It really depends on the look and feel you're trying to create. If you have large areas to paint, using bigger brushes can help cover them with only a few strokes and give the appearance of effortlessness; in contrast, using smaller brushes for the same areas would require lots of strokes, which could make it look as if you were struggling.

Holding the Brush

Try not to hold your brush like a pencil. Hold it a little higher up the handle so it's looser in your hand. Find a nice balancing point where it feels comfortable but you still have some control. Holding it this way will give your stroke a natural appearance.

The only time you need to hold it closer to the tip is when you are working on tighter details and need more control. You will most likely also switch to a smaller brush.

How Your Body Affects the Stroke

A brushstroke is nothing without the artist who is making it. Have you ever thought of where the brushstroke originates? Does it come from your fingers, wrist, arm, shoulder or your whole body?

For instance, if you're listening to music while painting, you might find yourself moving to the beat and dancing around your studio, and that freedom can easily be carried through your stroke and into your painting.

If you paint standing up, your brushstrokes may tend to be bigger, and you may find yourself using more of your shoulder and arm. If you are sitting, you might still be using your shoulder but tend to make smaller strokes and work on more details using your arm, wrist and fingers. If you've watched artists paint, have you ever noticed, when they stand and begin, that one hand seems to automatically go behind their back or into a pocket and how subconsciously the focus naturally turns to the opposite arm?

Be aware of how your body and the adjustments you make affect your brushstrokes and use this to your advantage as you paint.

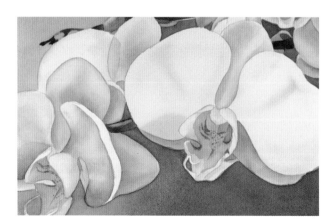

Using Round Brushes
Round brushes will give you more organic lines and a softer feel to your painting.

Using Flat Brushes
In this painting of moving water, you can see how using a flat brush creates straighter and more angular strokes.

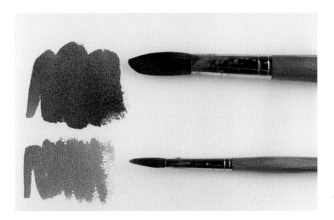

Cover More With Fewer Strokes
It takes a lot more strokes to cover an area using a smaller brush than it does a larger brush. And larger brushes are not only for large paintings—they also work well for smaller paintings to give the impression of even color.

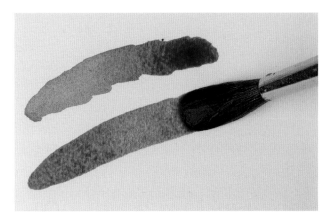

Shaky Brushstroke Solution
If you have shaky or wiggly lines in your strokes, support your elbow or the heel of your hand on your work surface or apply more pressure to get a cleaner line.

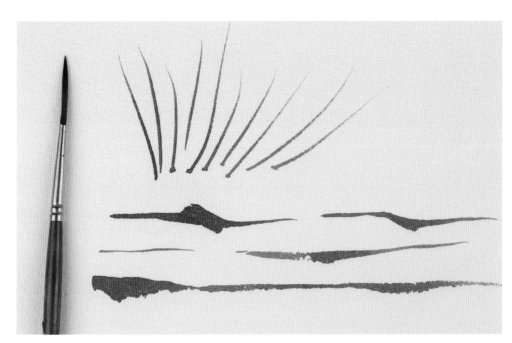

Liner Brush
Longer with fewer hairs, this brush has the ability to make very thin lines and is great for painting grasses, cracks in rocks, trees, vines, wire in a vineyard or ropes on a sailboat.

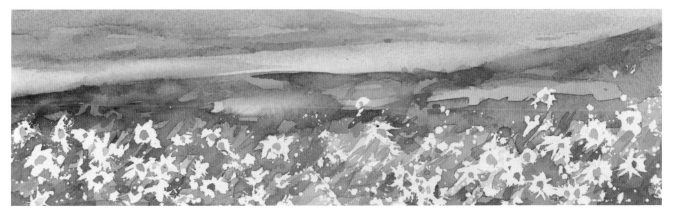

Using Flat and Round Brushes
In this painting, both brush types were used. Notice the more angular strokes in the foreground and the rounder, softer strokes in the distance.

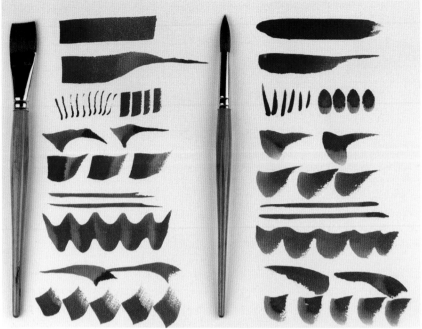

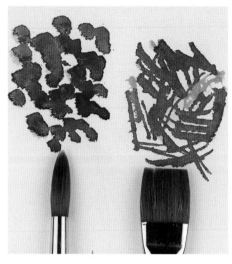

Stippling: Flat vs. Round
Using the technique of stippling (bouncing the brush in a dot-like pattern), each brush gives you a different result. A flat brush is more defined and deliberate, and the round is softer and relaxed.

General Strokes: Flat vs. Round
Brushes in general create many different kinds of strokes, from wide to thin, long to short and broken lines to wavy. They can hold lots of water and give you smooth lines or be drier to grab the texture of the paper. When applying any of these brushstrokes, the outcome really depends how you hold the brush and the amount of pressure you apply.

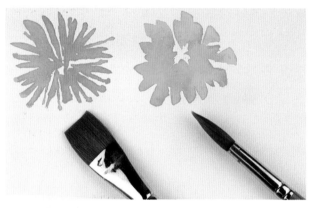

Flowers: Flat vs. Round
If you are painting flowers, the look and feel of the petals can be entirely different depending on the brush.

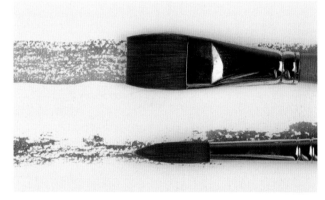

Dry Brush: Flat vs. Round
Using less water and a drier brush, you can catch the tooth of the paper, creating a textural effect.

Trees: Flat vs. Round
The flat brush (left) creates strokes that are straighter and more deliberate, while the round brush (middle) flows more with smoother lines. The example on the right is the result of stippling with the round brush.

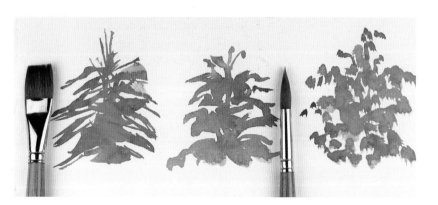

How Much Water to Use With Your Paint

Watercolor can seem difficult to control at first. Some think it is too runny or too dry or that the color can be weak or that it bleeds to areas where you don't want it. It comes down to understanding how much water to use on the palette and on the paper to get the right consistency and color for the effects that you want to create.

Water-To-Color Ratio

When mixing color on the palette, the amount of water you use depends on the value of the hue you want to create, as well as other considerations.

Do you want the color to easily spread and mingle with the water on the paper surface, or do you need a more controlled stroke of color to help shape an image? Color with a lot of water is more fluid and dries lighter; pigment with less water has stronger intensity but doesn't move much on the paper, which can make paintings look overworked.

The right amount of water in a mixture can help create a luminous wash with wonderful highlights, or less water can be used for more intense color to help add depth to a painting. Use too much water, though, and colors can appear weak and anemic. Use too little and the flow release from your brush tip can be more challenging, and color can appear dry and pasty.

So, the amount of water you use to mix your paint really all depends on what you need at the time.

Color Strength

To compare the color and consistency of watercolor, some artists describe color mixtures as weak or strong, while others use more descriptive words like "water, tea, coffee and cream" or "milk, cream, buttermilk and butter." Use whatever term helps you to visualize the consistency best. One of the easiest ways is to keep a scrap piece of paper handy and simply test the color consistency.

- **Weak or pale color** looks too light or washed out. This can happen when using old, dried watercolor on your palette. If the well color is in pieces and crusty, remove it and start over. If your well is filled with a tube of color, moisten it, or, if you have just a little color in the well and it is still decent, add new, fresh color to what is already there. Then use a larger brush, and before painting, mix a generous amount of color in the puddle on the palette and don't be stingy.
- **Medium-strength color** is ideal for general purpose painting. It is transparent, flows well when added to a damp or wet surface and is easy to apply with any size brush—in single or multiple layers—with good results.
- **Strong color** is intense, vibrant and rich. It is usually a medium to dark value and helps add depth within a painting. More heavily pigmented than medium color but not as thick or creamy as straight from the tube, it still has the ability to move when added to a wet surface, but may need encouragement to do so.
- **Color straight from the tube** is often too thick and heavily pigmented, but in some instances, when applied thoughtfully, it can command desirable attention in paintings.

Loading the Brush
For a really wet, juicy brush, dip it into clean water, drag it on the side of the rinse bucket to remove the excess, then bring it to the puddle of color on the palette. For more controlled color, lightly dab it on a terry or paper towel as well before bringing it to the palette. As you load the brush, the tip swells with water and color, which releases when applied to paper.

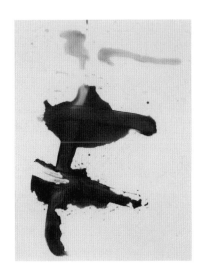

How Weak, Medium and Strong Color Looks on Your Palette
The blue mixture at the top has very little color and mostly water, which will produce paintings weak in color, without much depth or statement. Medium color (middle) is a good all-around water-to-color blend to use. Strong color (bottom) won't move much and is good for accenting areas.

Dark Pigments

Dark pigments work well to add drama to a painting, but if they are too thick when applied to the paper, the surface can easily have a shine to it even when dry that you may not want. This is what happens when you try to get a deep color too fast and your paint is too thick, without enough water.

To make successful darks, follow these tips:

- **Build darks in layers.** Don't try to get the dark you want on the first try.
- **Just add water.** Instead of applying the tube paint directly from the well, mix a dark puddle on the palette to soften the color into a darker value that can flow.
- **For the darkest darks, apply color to dry paper.** Try to tilt your paper and use the bead of water to carry the color as you move along so it evens out.
- **Try applying color with a larger natural or sable/synthetic blend.** The softer brush will be less likely to leave brush lines.

Loading Your Brush

This means bringing the brush to the palette to absorb water and color into the tip or tuft of the brush before applying it to the paper.

To load a brush for painting, mix a juicy amount of paint on the palette (containing enough water so the color can move), then bring a damp or wet brush back to the palette and pick up the color into the brush.

Sable/synthetic blend brushes are a good balanced brush for general-purpose painting; color disperses easily onto either a wet or dry surface without flooding an area or leaving brush lines.

Sometimes the brush may hold too much water, which can lead to uncontrolled brushstrokes, unwanted blooms or hard rings around the edges of a wash. This type of brush is best used for looser painting styles.

Drybrush Technique

Drybrushing means using a brush with less water to apply color to a wet or dry surface. The applied color tends not to flow or move as well. When applied to dry paper, the brush drags on the surface, leaving areas of the white paper showing through. This technique is good for creating textures including tree bark, rocks and wood.

How to Mix Color on the Palette

Expand the Brush Tip
First, dip the brush in water to expand the hair.

Add Water to the Palette
Place a puddle of water on the mixing area of your palette.

Add Paint Color From the Well
Add color to the puddle.

Blend and Test the Color
Blend together the water and color, mixing well. Then test the mixture on a scrap piece of paper, noticing how it flows and the intensity of the color.

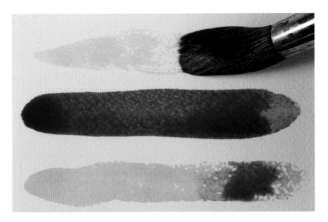

Controlling Flow and Color

The amount of water and color you mix on the palette and load into your brush affects not only the color intensity but the flow of your stroke.

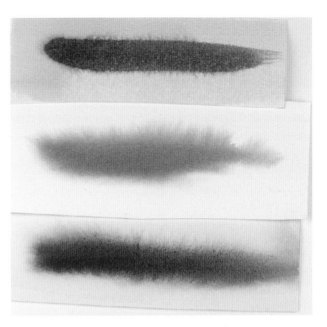

Paper Sizing Affects Stroke

Paper with little to no sizing (top) absorbs color quickly, making it difficult to work with. Softer sizing (middle) pulls the color into the paper but is still able to move when tilted, and the color appears just a little lighter. Hard sizing (bottom) keeps color more toward the surface, allowing color to move and blend, enabling you to build richer, darker color.

Drybrushing

With this technique, you load paint into a brush that contains a smaller amount of water. Less color is absorbed by the brush, revealing more of the texture of the paper as it is applied. For general painting, it's a good idea to use more water with pigment so the color can flow well.

Softening an Edge

Using a natural brush, dip it into clean water and remove the excess so it is no longer sopping wet but still damp. Glide the brush along the edge (not on top) of the damp color that you want to soften, applying even pressure. Be careful if using a brush that holds a lot of water; it can easily flush water back into the stroke, creating a blossom.

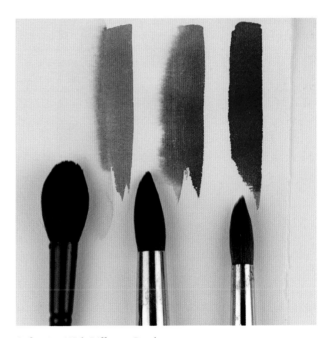

Softening With Different Brushes

The edge of the brushstroke can be softened with different brushes depending on the effect you want. Shown are a mop brush (left), a natural hair brush (middle), and a sable/synthetic blend brush (right) and their resulting softened edges.

How Much Water to Put on Your Paper

Have you ever wondered why you get blooms in your water-color washes or why your painting seems to be too dry and overworked?

How your color appears in your painting has a lot to do not only with the amount of water (and color) in your brush, but the wetness on the surface of your paper. Being able to judge how wet or dry your paper is will help you determine what you can do at different stages of a painting.

Flooded
This surface is very wet, with a high-gloss shine; water easily runs to the edges and puddles. Left alone, it can have a tendency to blossom. If this happens, before it completely dries, use the additional water to run back over problem areas to even out the surface.

Shiny Wet
The surface glistens with a reflective shine but is slightly less wet. Water and color move easily on it, making it great for transitioning color values and large washes, but bad for controlling color. To prevent blooms, remove any excess puddles by tilting and pooling the excess water in an area, then, using the tip of your brush or the edge of a paper towel, lift out the puddle so the surface can dry evenly.

Moist Paper
Still reflective, moist paper works well for wet-into-wet techniques. Strokes of color diffuse easily, but it's not great for control—if more water is added, color can lift and migrate to the outside edges, leaving a hard ring. Works well where a slight diffusion of color is needed or for soft blending where additional water is controlled.

Damp Paper
This surface is more matte (non-reflective), with a dull, satin sheen. The paper is limp, not yet dry, cool to the touch, and there is no movement of water and pigment on the surface. In general, leave damp paper alone—do not touch it or add more color or water to it, or you could easily get unwanted brush-strokes or blooms.

Dry Paper
A dry surface has no moisture, no coolness and the paper is stiff. Water from the brushstroke pools, and brush lines appear crisp and sharp. A dry surface is ready for an initial wash or the next layer of color.

Common Watercolor Problems

Blooms (Also Called Blossoms or Backruns)

Have you ever wondered why a wash may look perfect one minute, then as soon as you turn away, unwanted blooms appear? This is because parts of the painting were drying more quickly than others.

Before walking away from drying paper, make sure the surface has an even sheen and has dulled to a matte appearance, especially if you will be away for an extended period of time. If you can't babysit the painting, use a hair dryer on low heat to speed up the drying process. Don't hold it over the same spot for too long; keep it moving. Be aware that hair dryers have a tendency to flatten and homogenize the color.

Messy, Undefined Edges

A common mistake watercolorists make is painting an area too soon before an adjacent area has had time to completely dry. This is great for looser styles, but not if you aim for clearer definition in your paintings.

If a loose look is not your goal, you will need to allow areas that touch to completely dry before working on the next. If needed, walk away from the painting for a while. Often you can resolve much of this by letting the entire painting dry, then cleaning up the edges using a wet-on-dry technique.

Hard Rings of Color

We have all had those hard rings form around the edge of a shape. The reason for this is you're adding too much water to an area while the previously applied color is still damp, and the additional water is lifting the color from the surface and pushing it out to the edge. If an area needs more color, let it completely dry first, then reapply color in layers.

Avoiding Hard Rings of Color

If you notice a hard, thick ring forming around the color on your paper once it has dried, too much water has been applied and reapplied, lifting the pigment and pushing it out to the edges. To avoid this, you must let each layer of color dry completely before applying more color.

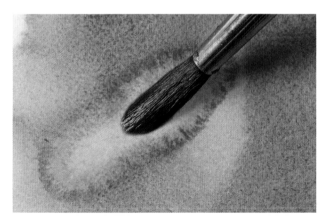

Problem: Blooms

One reason why blooms occur is that we just can't leave the painting alone. We go back in too soon and fuss with it or try to fix something, which only makes things worse. The additional water competes with the drying surface and has nowhere to go. It tries to crawl back over any damp color in order to expand. An edge that has a cauliflower appearance is also called a bloom; this happens when the water and color dry unevenly.

Solutions to Try

Any water applied or dropped onto a drying surface can easily bloom, ruining smooth washes and causing feathered and hard edges. If that happens, you can either leave it alone, wait for it to dry and try to lift or soften the edges with a melamine foam eraser or while it's still damp (and you're willing to take a chance), add more water and allow the puddle to move around the surface to spread the water out evenly.

Uneven Washes

Uneven washes also tend to have uneven color and look too dry, overworked or brushy with lots of lines. They can easily distract viewers from the rest of the painting. Here are some tips for creating more consistent washes.

- Make sure there is enough water on the paper surface and in the color mix on the palette so the color can flow easily.
- Use the appropriate type and size of brush for the area you are covering.
- Keep your brush moving in one direction, not back and forth.
- Don't try to get all the color down in one pass. Build layers of smooth, transparent washes.
- Heavily pigmented washes need more water to flow.
- Thicker color with less water will not move.
- If the color doesn't move, lightly mist it with clean water or reapply water with a brush. Each additional layer will have a tendency to flow less.
- Allow water and color to dry evenly.
- Avoid water accumulating along the edges. Remove it by lifting the excess water with the tip of your brush or the edge of a paper towel or allowing the excess to run off of the paper onto the table.
- If the paper surface is drying faster than you can work, consider picking up the pace, or work in smaller areas at a time.

Loose Hair in Wet Paint

In this situation, there is a natural tendency to pick it up with your fingernails or brush or just leave it in. Be careful; you can make the situation worse. Do not try to remove a loose hair with your fingers or you can easily damage the paper surface with your nails.

If you leave the hair in the wash while the painting dries, a couple of things can happen: the hair can act like a resist, leaving a small white line, or color can accumulate and settle along the hair, leaving a colored line. If this happens, hopefully it's not in a large, smooth wash because that can be very difficult to remove. You can try to layer color over it again or lift it out, but it's not the most desired effect.

The best thing to do is to use a small synthetic brush (such as a no. 3 round) to gently lift the hair out. Using a larger brush can remove too much color from the painting. Get the brush wet first, dry it, fan it out, and then with a flick of your wrist, lift the loose hair. Stiffer synthetic brushes work best. If you use a natural or a sable/synthetic blend, the hair can be too soft and hold too much additional water, causing unwanted blossoming.

Wet Paint Contaminated by Hairs
Sometimes you may get a loose hair or speck of dirt or color that falls onto your wet painting. Lift the loose hair using a small brush instead of using your fingers

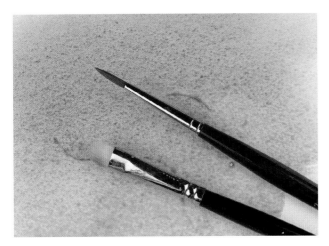

The Right Brush for Lifting Hair and Debris From Wet Paint

You can use any small synthetic brush that has a stiff tip, even a scrub brush. The idea is to allow only a few of the fibers of the tip of your brush to catch the loose debris, not to touch the paper with the entire brush tip and risk damaging it.

Don't Touch

Do not use your fingernails to lift loose hair or other debris from a painted surface, because you can easily damage the paper, leaving unintentional divots the color can settle into, which may be even worse than what you just had.

Preparing a Brush for Lifting

Wet a small synthetic brush and remove the excess water, then fan the tip.

No Soft Brushes

If you use a brush that's too soft (a natural brush or sable/synthetic blend), you can find yourself digging your way around the wash or reapplying too much water, creating unwanted blossoms.

Barely Catch the Hair or Debris to Remove It

Using the splayed tip, remove the loose hair or other debris with a gentle flick of your wrist. Repeat as needed to remove any other hairs or debris.

Lifting Color

Depending on the style you are trying to achieve in watercolor, in general, it's best to begin with the lightest values and slowly work your way toward the dark ones. When just starting out, many beginners have a tendency to be a bit heavy-handed—the paint goes on too thick or, once dry, seems a bit too intense or perhaps the color is dull and drab.

You may even change your mind and want to recover the white of the paper to fix mistakes or create highlights, or for other purposes such as making buildings, backgrounds, stones, grasses and so on. A good way to handle this is to lift color out.

In general, many paint colors can lift easily, but staining or permanent colors can be more challenging to lift because they are just that—staining and permanent. The degree of what a color will lighten to depends on if it is permanent or staining and will vary from brand to brand.

Recovering the white of the paper can damage the surface, so if reapplying color to such an area, try not to expect the same results as color applied to a new piece of clean paper.

Lifting Damp or Dry Color

Any kind of brush can be used to lift color, but when lifting color from dry areas, you may need a stiffer brush such as a synthetic or even a scrub brush. With clean water, wet the area you want to lift first, then scrub and lift out the excess color. Following are a few tips:

- **To lift color**, use the tip or edge of a flat brush and, using clear water, rub over the area you want to lift, then blot with a paper towel or tissue.
- **For small highlights**, apply a dab of water to the surface, let it sit for about three seconds, cover with a paper towel for three more seconds, then, with an art gum eraser, rub over the area to recover your highlights.
- **For larger areas**, apply clean water first and let it sit for a moment to soften the color, then very gently lift the color with a paper towel or a soft natural brush to transition the lifted area into the rest of the color.
- **To recover your whites**, you can use an original Mr. Clean Magic Eraser (or melamine foam). Wet the sponge with clean water, then wipe over the area you want to lift. It works on both damp and dry surfaces.

Lifting Color From Wet Paper
While the surface is still damp, lift color out with a clean, semi-dry brush. Wipe off the brush and repeat as needed; the amount of times will depend on the surrounding color and if it continues to bleed back into the lifted area.

Lifting Color From a Dry Surface
If the color you want to lift has already dried, use a damp brush to soften the surface and lift the color.

Lifting Paint Using a Stencil
If you need to lift very defined shapes, consider making a stencil. All you need is a scrap of 140-lb. (300gsm) watercolor paper, Yupo or any stiff, thin plastic. Cut out your design and place it on the dry color. You can even use masking tape to cut out smaller shapes. Then, with a dampened original Mr. Clean Magic Eraser (or melamine foam), wipe over the area to lift the color and reveal the shape.

This works nicely to define highlights in an area, or to create more stamens in the center of a flower. This even works well to add shapes in the background or houses in a landscape.

Erasing the Entire Painting

Let's say you have a painting that just isn't working. Consider removing all the color by placing it under running water using a faucet, hose or by submerging it in a tub.

By re-wetting it you are allowing the color to soften to be able to move and lift again. While it is wet, use either a large, soft brush or an original Mr. Clean Magic Eraser (or melamine foam) to gently wipe the surface to remove color from the painting. Just don't press too hard or you could damage the paper fibers. The amount of abuse the paper can withstand will vary by brand and by the sizing used during the papermaking process. Most often you won't be able to get back to the bright white of the original surface because some colors will be more permanent and staining than others, so you will be left with a ghost image. Be creative, and try using that ghost image as an undercoat for another painting, or rework the one that was there. You will definitely learn from the experience.

Give a Troublesome Painting a Bath
If the overall color of your painting is too strong or there are too many different colors, give the painting a bath by submerging it in water, then wipe with a towel.

Ghost Image
Continue to lighten the painting by soaking and lifting color as needed. Once dry, build upon the foundation for another painting.

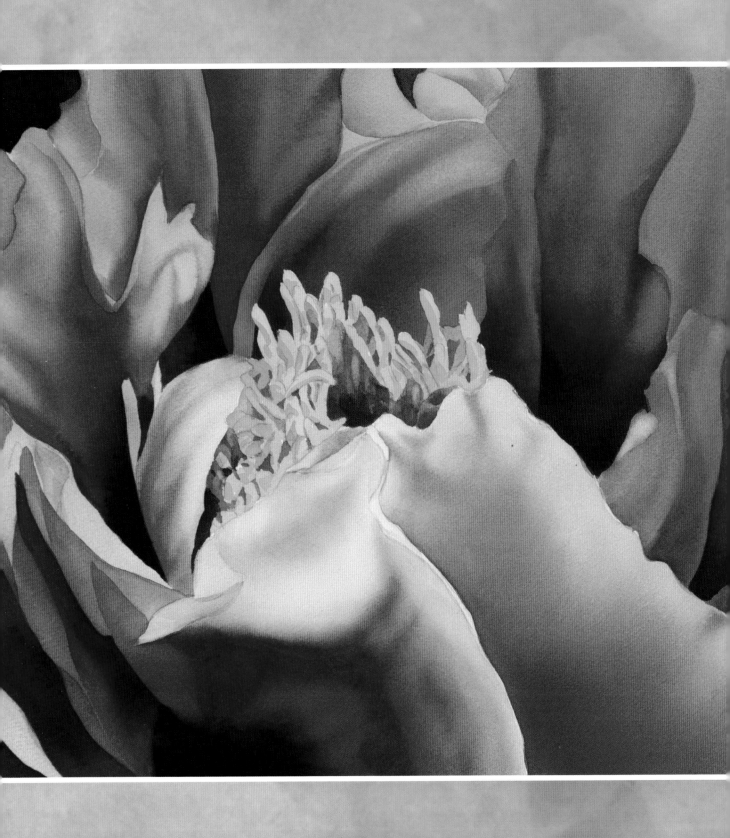

Chapter 3
Understanding Color

Color is exciting and stimulating, and it's part of how we as artists express ourselves in the world. Color can set the mood and tone for a painting—it has the ability to make a painting light, happy and fun or dark, dramatic and mysterious.

Many of us unknowingly choose colors that reflect our current feelings and emotions. For others, it's more important to match exactly what they see. Most artists fall somewhere in between—the colors we decide to use may not reflect the true color of our subject, but it's less important to be exact than it is to show what we want viewers to see.

Delving deep into color theory, though fascinating and important information, is not for everyone. Many well known artists don't really care or think about the chemistry of pigment or the technicalities of color—they merely react from an intuitive place to express themselves in their artwork.

You can read all about color theory—what the different properties of color are and how they work together—but the only real way to understand it is to practice and experiment. Even if you don't know what you are doing with color, you can have fun just moving it around and watching it interact with water or other colors.

There is no right or wrong in how you choose to go about your own painting process, but in order to get the results you want, some basic information can lead you to a better understanding of what colors work best together to create cleaner colors or how to set the tone for your painting. So, let's explore some basics that can help you create more successful paintings and give you more of what you want with color.

Gloria Shirley
Watercolor on 300-lb. (640gsm)
cold-pressed paper
15" × 22" (38cm × 56cm)

The Meanings Behind Color

Color is not only about the technical ability to recreate what you are seeing but also a reflection of how each artist sees the world and what each is trying to say.

For years color has been used for marketing purposes: to invite a person to purchase an item, to increase the appetite, to encourage sleep, to agitate, to soothe or to create excitement. Similarly, your color choices as an artist can invite, excite or provoke others. They can even affect you physically.

Reactions to Color

You may find yourself drawn to or repelled by certain colors within a subject and have no idea why. At first glance, color is what we see, but on an emotional level, the impact can be much more profound. When painting, the goal is not only to represent an object or scene but to create an impact and a reaction.

Try asking a group: What color is happy? What color is sad? What color is anger? What color is love? The responses may vary, but we do tend to share some common reactions when it comes to color.

- **Red** is the most powerful and emotionally intense color. It is associated with love, frustration, passion and anger—basically a fight or flight response. Red demands attention and is a sign of action; it can even be a sign of danger. A little red goes a long way and is most effective in smaller doses. Paintings with lots of red can be exciting or intimidating.
- **Blue** creates the opposite reaction of red. Blue can convey peace and tranquility, importance and confidence. Dark blue is associated with intelligence, stability, unity and conventionalism. Deep royal blue conveys richness and perhaps even a touch of superiority.
- **Green** is a refreshing, calming color. Dark green is masculine, conservative and implies wealth. Hospitals often use green because it relaxes patients.
- **White** signifies cleanliness, purity and softness; in Western countries, white is the color for brides. White is used to imply sterility—that is why many doctors and nurses wear it. White can make darker colors look more prominent and help reds, greens and blues look cleaner.
- **Black** can be the color of authority and has the ability to convey power or elegance. It shows sophistication with a touch of mystery.
- **Brown** is a middle-of-the-road color, not as harsh as black. It represents the earth and conveys a feeling of warmth, honesty and wholesomeness. It makes excellent backgrounds and helps accompanying colors appear richer and brighter. Brown is often considered a fall and winter color, even though it's easily found year-round in nature.
- **Yellow** is cheerful and optimistic. A sunny yellow gets attention and can create a happy environment. However, too much or the wrong yellow can be overpowering and difficult for the eye to take in and can increase arguments and temper.
- **Purple** is associated with royalty, luxury, wealth, sophistication and spirituality. In nature, true purple is rare and can appear artificial.
- **Orange** stimulates emotions and even the appetite. It is useful to get people thinking or talking.

Common Color Terms

Here are some basic terms to know as we discuss color.

- **Primary colors:** red, yellow and blue. All colors can be mixed from these three colors.
- **Secondary colors:** orange, green and violet. Produced by mixing two primary colors together.
- **Local color:** The true color of an object's surface without any influence from atmospheric conditions or shadows.
- **Color wheel:** A visual representation of colors arranged in a circle. The placement and arrangement of these chromatic hues reveals their relationships with each other.
- **Analogous colors:** A group of related colors appearing near or next to each other on the color wheel (example: red, orange and yellow). They usually coordinate well and create harmonious design. They can also appear monochromatic.
- **Complementary colors:** Colors that appear opposite each other on the color wheel. Complements placed side by side will make artwork more vibrant. Complements that are physically mixed together make good neutral grays for shadows.
- **Hue:** The basic color or category of a color (red, for example).

- **Temperature:** The warmth or coolness of a color.
- **Value:** The lightness or darkness of a color. The range of value of a single color can be determined by adding increasing amounts of water.
- **Tint:** A very light value of a color.
- **Tone:** A general term often used interchangeably with value to describe the overall mood or feeling of a painting. Basically, how light or dark a color is.
- **Shade:** The result of darkening a color with black or a color's complement.
- **Clean color:** A pure transparent hue that allows light to pass through and reflect off of the paper surface underneath, without being altered by sediment or too many mixed colors. For the cleanest color, try to use only transparent pigments and only mix two to three colors at a time.
- **Muddy color:** The unattractive result of mixing too many paint colors into one or including certain colors in a mixture, such as opaque colors. Not recommended for clean washes. If you took all the leftover color on your palette and mixed it together, this would be called palette mud, and in some instances, it may be used to tone colors down.

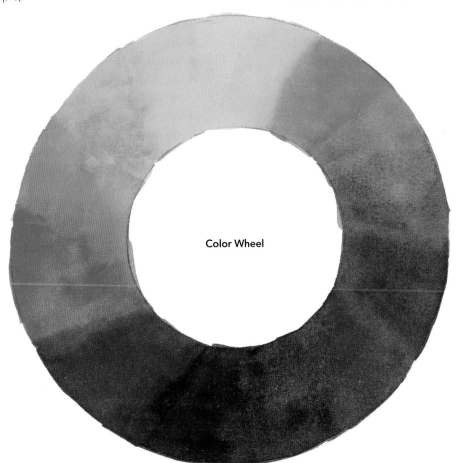

Color Wheel

Mixing Color

When watercolor painting, there are many tube colors you can choose to paint with. No matter how many you accumulate, you need to have a basic understanding of mixing color in watercolor.

Mixing From Primary Colors

In theory, the only colors you really need are red, blue and yellow—known as the primary colors. These three colors can be used to create all other colors, but depending on the feeling and effect you are trying to create and convey, some primary mixtures work better than others. For instance, for a more dramatic painting, you may want to use bolder primaries than you would for a painting that you intend to have a lighter feel.

Mixing equal amounts of two primary colors will create a third secondary color. Red mixed with yellow creates orange, red mixed with blue creates purple and blue mixed with yellow creates green.

Mixing Tints and Shades

A tint is a light value of a color. In watercolor, this can be done by simply adding more water. This can be useful as an underpainting or to simplify areas so you can focus on the main subject. Depending on how tints are used, they have the ability to change the entire tone of the painting.

A shade is a darker value of a color. In watercolor, shades are created by mixing a color with its complement. Shades can be effective in adding depth and dimension to a painting. Be careful, though, because too much shading can be overpowering.

Traditionally, watercolor artists do not use black or white paint. Black is not considered a color, since it does not reflect light—it only absorbs it. In fact, using black in watercolor can kill your painting, as it dulls down other colors. Much more colorful darks can be made by mixing complements.

White is considered a color, since it is the combination of all colors and has the ability to reflect light. White has the ability to help all other colors to look crisp and clean. When painting in watercolor, however, white paint is not required. Rather, the lighter colors are created by using more water, which allows more light to reflect off of the white of the paper beneath the paint.

Mixing Neutral Grays

When placed side by side, complementary colors enhance one another and make the opposite color appear more vibrant and intense. When a color is mixed into its complementary color, it gradually loses its vibrancy and neutralizes and dulls down into different variations of gray or muted brown.

These mixed grays or neutral blends can be used to paint shadows and to tone down areas of a painting. Be careful when working with complements, however, as you can get a dull painting if overmixed.

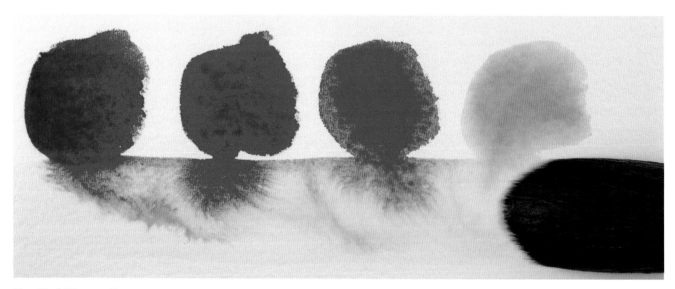

How Much Water to Use
The color on the left contains very little water and gradually increases to the right. Color with less water has a stronger tinting strength but does not move well when applied to a damp surface. To find the right amount, gradually increase the water and see how the color moves and lightens when dry.

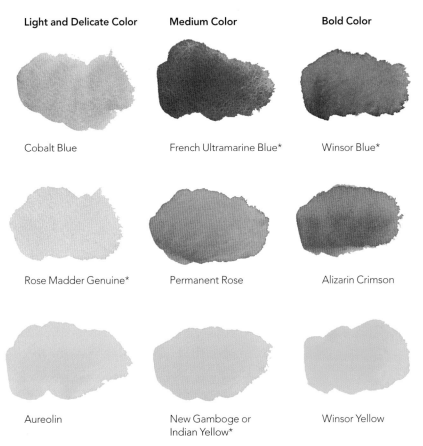

Light and Delicate Color	**Medium Color**	**Bold Color**
Cobalt Blue	French Ultramarine Blue*	Winsor Blue*
Rose Madder Genuine*	Permanent Rose	Alizarin Crimson
Aureolin	New Gamboge or Indian Yellow*	Winsor Yellow

* = see color comments below

French Ultramarine Blue varies by brand; this can affect color when mixing. My favorite brand for this color is Winsor & Newton.

When a manufacturer calls a color by their brand name such as **Winsor Blue** or Winsor Green, it means Phthalo Blue and Phthalo Green.

Rose Madder Genuine is a fugitive color, which means it can fade over time. Fugitive colors are not recommended for serious painting, only for playing.

Winsor & Newton has changed their formulation of **New Gamboge**, so I now prefer their Indian Yellow or Daniel Smith's New Gamboge.

Primary Differences

The primary colors are blue, red and yellow, but the intensity can vary depending on the specific tube colors you choose, which can affect the overall feel of a painting.

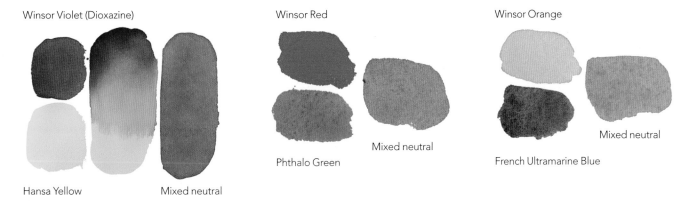

Winsor Violet (Dioxazine)

Hansa Yellow

Mixed neutral

Winsor Red

Phthalo Green

Mixed neutral

Winsor Orange

French Ultramarine Blue

Mixed neutral

Mixing Neutral Grays

If you look directly across any color on the color wheel, you will find its complement. When two complements are mixed in varying amounts, they can create neutral grays that are useful in painting. The temperatures (warm or cool) of the complements you mix together will affect the appearance of the resulting grays.

Preparing the Brush and Your Palette for Mixing Color

A good way to start is to swish your brush around in your wash bucket of clean water and get it really wet. Drag it once or twice across the rim of the bucket to eliminate any excess water, and bring the brush into the mixing area on your palette to make a clear puddle. If you find that doesn't give you enough water, then bring the brush directly from the water container to the palette.

Bring your brush to the edge of the color of your choice, then gently pick up a little color and mix it into the water. There's no need to gouge the paint or to cover the entire brush tip with pigment. Simply mix it well into the water and evaluate—you can always add more color later. The puddle should be wet, shiny and able to move. The value of the resulting color will be determined by the amount of water in the mixture (the more you add, the lighter it will be).

From here you can incorporate other colors to make more variations of different hues. Before adding any of these colors into your paintings, it's always a good idea to test your colors on a scrap piece of paper or add them to a chart, journal or notebook with the color combination written beside each one.

Consider the Color Wheel During Palette Layout
The layout of colors on my palette does not exactly match the color wheel, but it would have been helpful to do this when first starting out. If you arrange yours according to the color wheel, it will make it easier to see the complements of colors for mixing.

How to Keep Your Colors Clean and Avoid Making Mud

Clean colors are essential to creating paintings in watercolor. Overmixing or layering colors improperly can lead to muddy-looking artwork. To prevent this from happening, here are a few pointers to keep in mind:

- **Try not to mix too many colors at a time.** Stick to no more than two or three.

- **Try not to overmix colors on your palette.** Allow colors to mingle and mix on the paper—the results are much more interesting.

- **Try to work with the most transparent colors possible.** They will create some of the prettiest mixtures and also layer the best, allowing light to penetrate through applied layers and reflect the white of the paper for luminous paintings.

- **Avoid mixing cadmiums, opaque colors and earth colors together.** When colors such as siennas, umbers and ochres are blended, they can get muddy.

- **Don't overuse mixed complements.** Mixing complementary colors together creates neutral grays and browns that can be useful, but complements are much more vibrant when placed side by side.

- **Be aware that every color has a warm or cool bias that will affect the final mixture.** If you mix a warm red with a cool blue, the resulting purple can be dull or muddy.

- **Allow each layer of color to dry completely before applying the next.** Otherwise, layers may lift and mix, giving you muddy color.

The Temperature of Colors

Every color has a temperature, a bias toward warm or cool. Temperature is used to help set a mood or a feeling in a painting. It can help establish a time of day or season of the year or even the weather.

Generally, reds, oranges and yellows are warm, and greens, blues and purples are cool. Red, orange and yellow can feel like fire or a hot summer day or give the impression of warmth and coziness. Greens, blues and purples can feel icy or like a cold winter day and are often associated with the ocean.

However, temperature is relative—for instance, some reds appear cooler than other reds, and some greens look warm when compared to other greens.

Painting With Warm and Cool Colors

Understanding warm and cool colors and how they interact with each other can instantly give your paintings a sense of harmony.

Warm colors are bright, vivid and exciting—they invite you in and can be used to enhance the glow of an object, such as the center of a flower.

Cool colors are calm and soothing. These work well for shadows and to push away the background to give a painting more depth.

The warmer and more intense the color, the closer it appears, and the cooler and less intense a color appears, the further away it seems, creating a push-and-pull effect.

Using both warm and cool colors side by side in a painting will help keep the viewer's eye moving.

Temperature on the Color Wheel
If you divide the color wheel in half, one side is warm and the other side is cool, but within each range, any color can appear warm or cool, depending on where it lands on the wheel. For instance, a blue that's closer to the green on the wheel will appear warmer because it will have more yellow in it compared to the blue that's approaching the violet.

cooler

| Winsor Red | Permanent Rose | French Ultramarine Blue | Phthalo Blue |

Comparing Temperatures Within the Same Hues
Look to see where each color falls on the color wheel to help determine its temperature. Winsor Red and French Ultramarine Blue are closer to the warm side while the colors on the right, Permanent Rose and Phthalo Blue, lean more toward the cool. Notice how the cool color recedes more than the warmer color.

Warm vs. Cool Colors
Red-violet, red, red-orange, orange, yellow-orange and yellow are generally considered warm, while violet, blue-violet, blue, blue-green, green and yellow-green are cool.

Minding Temperatures When Mixing Colors

Knowing the difference between warm and cool colors is very important when mixing colors.

Mixing any two primaries, warm or cool, will give you a secondary color, but depending on the temperature bias of each, the resulting mixture might give you duller results. For the cleanest colors, mixing two warms or two cools works the best. If you mix a warm color with a cool one, you are introducing some of a third primary color, which can dull down a painting.

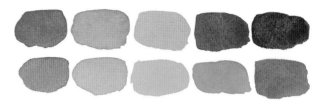

Warm vs. Cool

The vibrancy of color depends on both temperature and transparency. The colors in the top row are warmer than the bottom row. The transparency is affected by the amount of water in each color mixture; the more water that is added, the more light is able to pass through it and reflect off the surface of the paper.

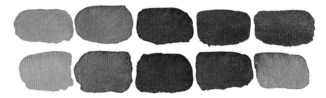

Adjusting the Temperature

Starting with the same violet color as our foundation—seen in the center of each row—if we added more orange (top row) the color variations change and become warmer. In contrast if we used a cooler blue color (bottom row) the range of violets becomes cooler.

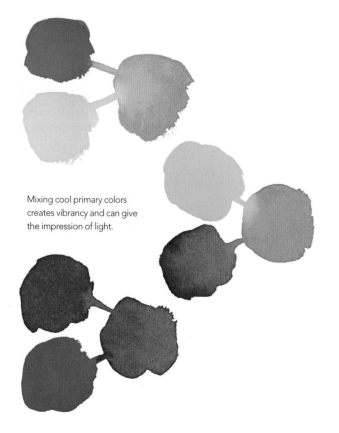

Mixing cool primary colors creates vibrancy and can give the impression of light.

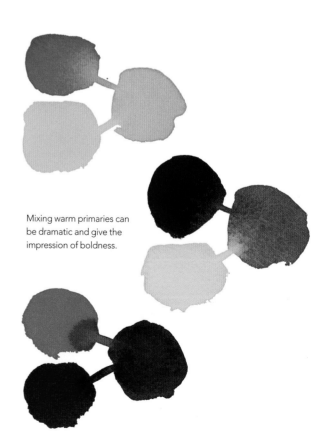

Mixing warm primaries can be dramatic and give the impression of boldness.

Tube Color Temperature Guide

Warm reds: Bright Red, Cadmium Red, Naphthol Red, Pyrrol Scarlet, Scarlet Lake, Vermilion, Winsor Red. Since these pigments have a yellowish cast, they do not mix clean violets. They are better for mixing oranges or browns.

Warm yellows: Cadmium Yellow, Hansa Yellow Deep, Indian Yellow, New Gamboge, Quinacridone Gold, Winsor Yellow Deep. These mixed with warm reds make for purer oranges.

Warm blues: Cobalt Blue, French Ultramarine Blue, Indanthrene Blue, Ultramarine Blue, Winsor Blue (Red Shade).

Cool reds: Anthraquinoid Red, Carmine Red, Magenta, Permanent Alizarin Crimson, Permanent Rose, Pyrrol Crimson, Quinacridone Magenta, Quinacridone Rose, Rose Madder. These reds have more blue, so if mixed with a warm red, the color won't be as vibrant or as clean. Try to mix with cool blues.

Cool yellows: Bismuth Yellow, Cadmium Yellow, Hansa Yellow Light, Hansa Yellow Medium, Lemon Yellow, Nickel Azo Yellow, Transparent Yellow. Since these colors lean toward the cooler side, they have more green to them, and when mixed with a cool blue, they can produce some wonderful spring greens.

Cool blues: Cerulean Blue, Manganese Blue, Phthalo Blue, Winsor Blue (Green Shade). These contain very little red and are wonderful for creating pure, clean greens.

Push and Pull

Using the same image, notice how your perception of it and reaction to it change depending on the temperature of the colors. Cool blue pushes back, warm red pulls closer and a combination of the two keeps the eye moving.

Cool yellow (Hansa Yellow) mixed with cool red (Permanent Rose) = brighter orange

Warm yellow (Indian Yellow) mixed with cool red (Permanent Rose) = duller orange

Mixing Clean Color

Mixing a warm and a cool color together will create a third color, but it may be dull and less vibrant. For the cleanest color, mix either two warms or two cools.

It is difficult to try to memorize all the colors and whether or not they're warm or cool. It's best for you to see them for yourself. Try separating your tubes into families of color (red, yellow, blue, green), then, using a reasonable amount of water, paint a swatch on a scrap piece of paper and see where each falls on the color wheel.

What It Means When the Brand Is Part of the Name

When a brand name is part of a tube color name, that is usually indicative of a Phthalo color or the hue closest to a basic primary color. When searching for a Phthalo color within a brand of paint, most often you will find it under the brand name of the manufacturer and the basic name of the color; for instance, Winsor Blue.

How Pigment Qualities Affect Results

Some artists may amaze and even baffle you with their knowledge about pigment, and when they're talking about it, you may find yourself feeling a bit overwhelmed. Pigment numbers are one way to help you find a comparable color in a different brand, but depending on the hue the manufacturer chooses, there will still be variations. When you're just starting out, there's no need to memorize pigment numbers and staining properties, but learning a bit more about the following characteristics of paint colors as you go will help you make better choices when you paint.

Synthetic vs. Sedimentary Pigments

The most transparent and cleanest watercolors are synthetic pigments—man-made colors developed by scientists. They are brighter and more permanent than natural colors and are often the most staining. Synthetic pigments allow light to easily pass through the color and reflect off of the paper's surface, which makes them best for glazing multiple layers.

Used for thousands of years, sedimentary colors include earth and mineral pigments that come straight from nature—principally iron oxides that are found in rocks and soils, with some being unique to a specific region. Often earth pigments are roasted to intensify their color.

Since these colors are heavier and denser, they have a natural tendency to gravitate and settle into the texture of the paper, which can make them more difficult to lift than some of the other colors. The amount of sediment left on the surface can also depend on how heavily textured the paper is and how deep the pockets on the surface are for the sediment to hide.

Usually a thicker pigment, sedimentary colors are in some cases considered opaque. They work well to add texture and make shadows interesting and can bring a sense of harmony to a painting.

When mixed with other colors, earth and mineral pigments can turn muddy. Imagine going outside to find a clean puddle of water, then mixing in some dirt. It can be difficult to see through, and you will notice heavier particles floating until they settle again. In watercolor, once dry, these pigments have a tendency to separate, creating some interesting textural effects.

Some of my favorite colors for mixing shadows are French Ultramarine Blue and Burnt Sienna because they tend to separate, giving the impression of two colors within one. This combination works well for shading and texture on white flowers.

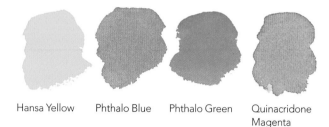

| Hansa Yellow | Phthalo Blue | Phthalo Green | Quinacridone Magenta |

Synthetic Pigments

Synthetic pigments are the cleanest, most transparent colors and work well for glazing in multiple layers. Colors include: Phthalo blues and greens, Prussian Blue, Hansa yellows and all Quinacridone colors.

Sedimentary Pigments

Sedimentary colors include earth and mineral pigments that tend to granulate and settle into the tooth or pockets of the paper's surface. These are best used sparingly in watercolor for a bit of interest or an unexpected detail. Colors include: French Ultramarine Blue, Ultramarine Blue, Sepia, Cobalt Violet, Cobalt Blue, Viridian, Manganese Blue and Sap Green.

Transparent vs. Opaque Colors

With enough water, any color can be transparent; however, some artists believe that, for a color to be truly transparent, it must meet certain criteria of light passing through the pigment particles. The more transparent a color is, the more light can pass through multiple layers (or glazes) of clean color and reflect off the paper's surface, resulting in a luminous look similar to that of stained glass.

The most transparent colors are synthetic colors. They are bright and clean and make beautiful transparent mixtures. They are ideal for making paintings with multiple glazes. However, using only transparent colors can make it difficult to achieve the deeper, darker, more dramatic results that are sometimes required.

Semitransparent, semiopaque and opaque colors can change the tone and help make a painting stronger and more interesting. They are heavier and denser, and the results can be almost unexpected. These are great to use in areas where you want a solid color or to cover any underlying mistakes, but if you mix too many of them together, the colors can get muddy easily.

How to Test Transparency

If it is not clearly indicated on the paint tube or you want to do your own test, use India ink to paint a black line on a piece of watercolor paper and let it dry. Then, using different watercolors with a reasonable amount of water, dilute the color so that it flows easily and then paint over the black strip.

Once the paint dries, if you can see the black line through it, then the color is transparent. If you see a hint of color, it is semitransparent; more pigment, semiopaque; and if you hardly see the line, opaque.

To give a wash more transparency, you can add a little gum arabic if needed.

Staining vs. Nonstaining Colors

Staining colors are man-made, dye-based pigments that, once applied, stain the surface of the paper the most, making them difficult if not almost impossible to lift and return to the white of the paper. These colors can also stain your brushes or palette. In general, they are known for greater permanence, and the hue is more intense. Depending on the manufacturer, some colors stain more than others.

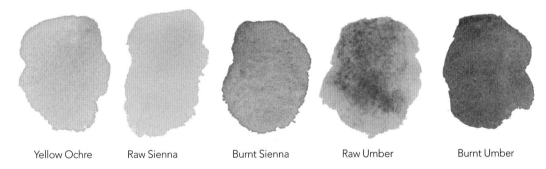

| Yellow Ochre | Raw Sienna | Burnt Sienna | Raw Umber | Burnt Umber |

Earth Pigments
These are naturally occurring pigments from nature, useful for adding shadows, texture or a little interest to an area. Colors include: ochres, siennas and umbers.

| Hematite Violet Genuine | Amethyst Genuine | Sugilite Genuine | Sleeping Beauty Turquoise Genuine | Zoisite Genuine | Sodalite Genuine |

Mineral Pigments
At this time Daniel Smith offers thirty-five different mineral pigments, possibly the widest selection available. Their unique brand of Primatek colors range from mineral pigments to semiprecious minerals. If not overworked, the effects and granulating properties can appear almost magical.

Transparent to Semitransparent Colors

Yellows: Aureolin, Indian Yellow, New Gamboge, Transparent Yellow, Winsor Lemon, Winsor Yellow, Winsor Yellow Deep

Reds: Alizarin Crimson, Opera Rose, Permanent Alizarin Crimson, Permanent Carmine, Permanent Magenta, Permanent Rose, Perylene Maroon, Quinacridone Magenta, Quinacridone Red, Rose Doré, Rose Madder Genuine, Scarlet Lake, Winsor Red

Violets: Cobalt Violet, Permanent Mauve, Perylene Violet, Ultramarine Violet, Winsor Violet (Dioxazine)

Blues: Antwerp Blue, Cobalt Blue, Cobalt Blue Deep, French Ultramarine, Indanthrene Blue, Phthalo Turquoise, Prussian Blue, Ultramarine (Green Shade), Winsor Blue (Green Shade), Winsor Blue (Red Shade)

Greens: Green Gold, Hooker's Green, Permanent Sap Green, Perylene Green, Viridian, Winsor Green (Blue Shade), Winsor Green (Yellow Shade)

Golds/Browns: Brown Madder, Burnt Sienna, Burnt Umber, Gold Ochre, Quinacridone Gold, Raw Sienna, Raw Umber

NOTE: All colors listed are by Winsor & Newton. Transparency and opacity may vary from brand to brand.

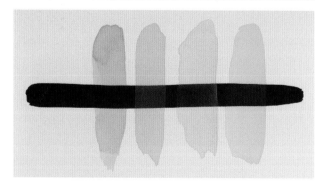

Test Transparency
Even when the paint label says a color is transparent, it's always a good idea to do your own testing. This can help you become more familiar with your pigments and keep your color mixtures clean.

Staining colors are very transparent, non-granulating pigments that work well with water to create clean colors and build multiple glazes of overlapping color.

When mixing color, a little goes a long way, and staining colors can easily dominate others in the mix. If accidentally dropped onto your painting, blot immediately and do not wipe. If needed, add a drop of water to the spot and blot more. If you catch it right away, most times you can lift the color out; if you leave it on too long, you can easily have a spot forever.

In some cases, using a staining color first then lifting can leave a light tint of color underneath that can work nicely for backgrounds of filtered light in landscapes or florals. But, in general, remember that it may be impossible to recover the white of the paper, and if you continue to scrub, you can damage the surface.

Lightfast vs. Fugitive Colors

Lightfast colors resist fading when they are exposed to certain environmental conditions, such as sunlight, humidity, temperature or pollution. A fugitive color is less permanent. Over time, fugitive colors can lighten or darken, change color or even disappear. Basically, think of them as temporary colors that should be used only for fun in temporary projects.

For instance, reds are notoriously known for being fugitive, and it can be a challenge to find a permanent red that you like. Many of us may have a fugitive color that we absolutely love, but if it's fugitive and you want any kind of permanence, you shouldn't use it, especially if you're considering selling your paintings. You really don't want a person to purchase one and come back a year or two later to tell you the color has changed or gone.

Some of the most fugitive colors are Gamboge, Opera, Alizarin Crimson, Rose Madder or any color with the word "Madder" in it. In order to use anything close to those in more reliable colors, look for the words "New" (like New Gamboge) or "Permanent" (like Permanent Alizarin Crimson). You also may want to consider more of the synthetic colors such as the Quinacridones.

How to Test Lightfastness You can find lightfastness ratings on the side of a tube of color, but you can also do your own test. Paint a strip of color on a scrap piece of watercolor paper, then, when dry, place it in a window that is exposed to sunlight, but block one side from any light. After a day, a week or even a month, take a look and see how much the exposed color has faded or changed when compared to the unexposed color.

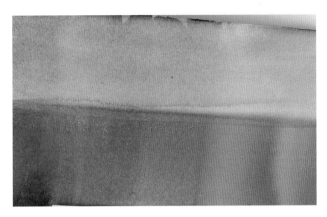

Staining Colors
These colors will immediately stain the paper and leave a residue. You will not be able to return to the white of the paper even when lifted.

Nonstaining Colors
These colors sit more on the paper's surface. They can be re-wetted, and it is much easier to return to the white of the paper.

Semiopaque to Opaque Colors

Yellows: Bismuth Yellow, Cadmium Lemon, Cadmium Yellow, Cadmium Yellow Deep, Cadmium Yellow Pale, Lemon Yellow (Nickel Titanate), Lemon Yellow Deep, Naples Yellow, Naples Yellow Deep, Turner's Yellow

Oranges: Cadmium Orange, Winsor Orange, Winsor Orange (Red Shade)

Reds: Cadmium Red, Cadmium Red Deep, Cadmium Scarlet, Indian Red, Light Red, Venetian Red, Winsor Red Deep

Blues/Greens: Cerulean Blue, Cerulean Blue (Red Shade), Cobalt Green, Cobalt Turquoise, Cobalt Turquoise Light, Indigo, Manganese Blue Hue, Oxide of Chromium

Golds/Browns: Magnesium Brown, Sepia, Yellow Ochre, Yellow Ochre Light

NOTE: All colors listed are by Winsor & Newton. Transparency and opacity may vary from brand to brand.

Staining and Nonstaining Colors

Staining: Alizarin Crimson, Bismuth Yellow, Brown Madder, any Cadmium color, Dioxazine Violet, Hansa Yellow, Indanthrene Blue, Indian Red, Lemon Yellow, Naphthol Scarlet, Permanent Carmine, Permanent Rose, Perylene Violet, Phthalo Blue, Phthalo Green, Phthalo Turquoise, Prussian Blue, Pyrrol Orange, Pyrrol Scarlet, Quinacridone Gold, Quinacridone Magenta, Quinacridone Rose, Quinacridone Violet, Thioindigo Violet, Transparent Yellow, Vandyke Brown, Venetian Red

Nonstaining: Cerulean Blue, Cobalt Violet, Manganese Violet, Naples Yellow, New Gamboge, Raw Sienna, Viridian, Yellow Ochre

NOTE: Staining information is not always easy to find, and it is most often best to test for yourself. The degree of staining can vary from brand to brand.

How to Look at a Tube of Color

If you can't find a particular color but know the pigment numbers that were used to make it, most often you can find what you are looking for in a different brand of paint. The degree of hue can vary slightly depending on the manufacturer, but it will have the same compositional makeup and is a helpful way to have some consistency.

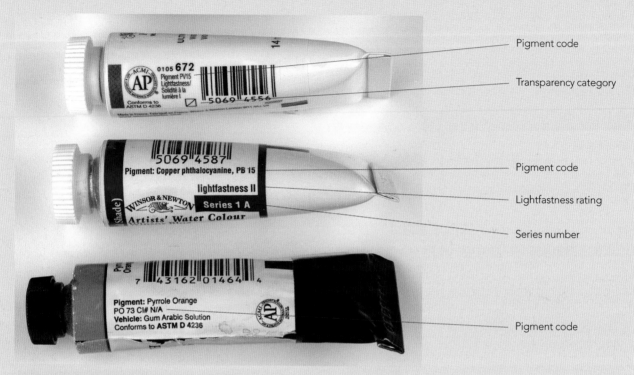

Pigment code

Transparency category

Pigment code

Lightfastness rating

Series number

Pigment code

Every paint manufacturer has their own way of labeling, but you should be able to find the same information on any paint tube label.

Series number: This number indicates price. Paint pigments can be expensive, and manufacturers group the material into the amount used and rarity of the raw product. The paint is then split into a series that reflects the price (1–5, for example, with Series 1 being the lowest price).

Lightfastness rating: This rating refers to the permanence and chemical stability of a color in relation to environmental factors, as determined by the ASTM (American Society for Testing and Materials). Some brands will use different labeling such as Roman numerals, letters or dots. I would recommend artist-grade paint with a lightfast rating of I (Excellent) or II (Good), rather than III (Poor) or IV (Fugitive). Winsor & Newton's labels are AA (extremely permanent), A (permanent), B (moderately durable) and C (fugitive). Most student-grade pigments are not as lightfast.

Pigment code: Each pigment can be universally identified by its pigment code. This is a generic international number used for pigment name and color indexing. **P** stands for pigment and **Y** for yellow, **R** for red, **O** for orange, **G** for green, **B** for blue, **V** for violet, **Br** for brown and **M** for metallic, and the number that follows is the chemical composition of the pigment. For example, Cobalt Blue is PB28 and Winsor Violet is PV23.

Transparency category: Many brands will have symbols, letters or the word on the side of the tube that will tell you if a color is transparent (T, or □), semitransparent (ST, or ▨), semiopaque (SO, or ◪) or opaque (O, or ■). Labeling will vary by brand.

Working With Value

In painting, the placement of light and dark values is critical. Values give form and depth to a subject. They also help to guide the viewer's eye through a scene and set the overall mood or tone for a painting.

Value also creates the illusion of space and distance. Value is directly related to the amount of light on an object or the atmospheric influence. For example, in a landscape the areas closer to you are more vibrant in color and darker in value; as you look into the distance, values lighten due to atmospheric conditions. With a flower, the impact of color is most noticeable and value may not be as obvious, but as you look at the shape, you will start to see the more subtle shading and values at play.

Value can be used to create a focal point. In general when looking at an object, our eyes are immediately drawn to the lightest objects next to the darker ones.

Paintings without different values can appear flat and lifeless or uninspiring. It's the range of values in a painting that invites viewers in by drawing their attention and engaging them. In general, many artists work with four or five different values of light, medium and dark, with one or two midtone values.

Discovering a Color's Value Range

In watercolor, the range of value is controlled by the amount of water used to dilute the color. To determine the range of values you can achieve with individual colors, think of a scale of 1–10 (some say 1–7)—basically, a range of light to dark or dark to light. Make a 10" (25cm) long strip of 1" (25mm) squares. Leave the first square as the white of the paper, and starting in the second square, use the lightest value of one color or a neutral gray to fill it in, then let it dry. Once dry, continue to layer color in each square, deepening the color until the darkest color is reached in square ten.

The strip-of-squares method might make it easier for you to identify individual values, but you could also simply place your color on the paper, add water and let the color flow down the strip, naturally creating a change in value by gently transitioning from dark to light.

Different colors will have different ranges of value and knowing these ranges will help you choose which colors are best for certain areas of your painting.

How to See Value

Many people have problems seeing beyond color to the values of a subject, but there are several ways to make it easier. The quickest way, if working from a photograph, is to make a black-and-white photocopy of it, or to do a quick, small thumbnail sketch in pencil or even use a single paint color such as gray, blue, indigo or sepia.

Another way to quickly see value differences is to hold a sheet of red plastic or acetate over a scene. The red color will eliminate all other color, leaving only a range of values.

These methods can help you develop a better awareness of value, which will help you create more interesting paintings.

Eliminate All Color to Evaluate Values
An easy way see value is to use red plastic or acetate. The red eliminates all other colors, revealing only light and darks. You can find sheets of red acetate in office or art supply stores.

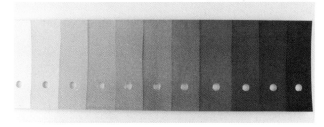

Punch a Hole in It
To help you see and evaluate the values in a painting, make a gray scale from light (white) to dark and punch a hole in each section. Hold this scale over your painting and match the areas you've painted to the value on the scale. Don't worry if you're not exact. At this moment, all you need to know is if there is a wider range of value than you first thought, and when painting, that it is more than just a single light or dark shade.

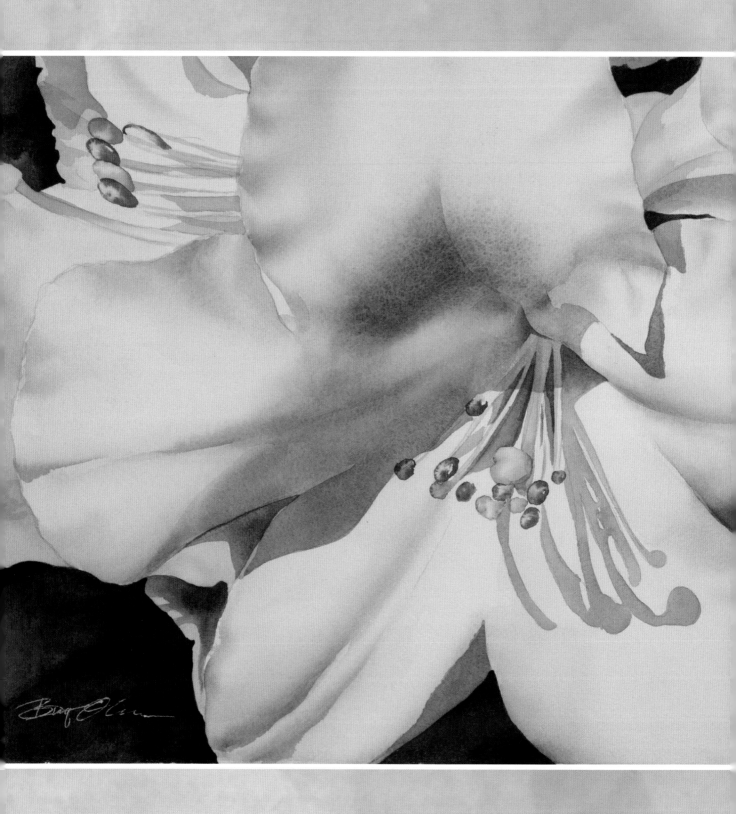

Chapter 4
Designing Strong Compositions

When choosing a composition for a painting, there are several ways you can approach it. You might focus on what you intend to convey to the viewer about your subject, or the emotional reaction you want to evoke; or, you may simply want to express how you feel about the subject at the time.

The way the story that is held within your painting unfolds has a lot to do with how much of your subject you choose to share. The general design of a painting has the ability to invite a viewer into the artist's world and give a sense of peace, harmony, mystery, movement or drama. All of this can be accomplished with shapes, color and placement of the focal point, among other things, so we have much to consider.

Simple Rhododendron Flower
Watercolor on 300-lb. (640gsm)
cold-pressed paper
15" × 22" (38cm × 56cm)

Making the Most of Reference Photographs

Sketching daily (or at least as often as you can) is a great way to improve your drawing skills for painting, but it's not always convenient to stop and sketch. So, for that unexpected moment when the light is just right and the subject is perfect, keep your camera handy to take reference photos.

Fortunately, in this day and age most of us already carry a camera with us in our smartphones. Phone cameras are excellent for capturing all the basic information and most of the detail we need to create future paintings. For those special excursions when we venture out in search of new reference material, bringing along an additional point-and-shoot or EOS camera can be helpful to give a different perspective.

The wonderful thing about using a phone for taking photos is instant accessibility—you can send pictures to your creative cloud, printer, copy shop or, if needed, email them to yourself. With so many different photo applications now available, you can also easily adjust, crop or add filters to photos and be as creative as you want. There are even applications that give you a better idea of what your photo might look like once painted and inspire how you might approach it.

Organize your photographs or digital images by subject, color, size or other categories into files, either in a box or on your computer, whatever works best for you and will make them easy to come back to later.

Taking Useful Photos

Two of the most common mistakes people make when taking reference photos is standing too far away from their subject and taking only one picture. If you take only one shot, the lighting or color may be off, a shadow may be in the wrong place, the image might be blurry or you could cut off important parts.

In general, one shot is fine for basic information, but it might not give you all the details you need, or much else. That's why it's important to take multiple pictures, more than you think you need, from close to far, up and down and side to side—you never know which one will make the best composition or contain exactly what you need.

Closer shots will capture the details, but standing further away from your subject will help you capture shapes, colors and shadows that will inspire interesting compositions and force you to simplify and not get too caught up in the details.

When taking pictures, remember that they don't have to be perfect. You're simply trying to capture that moment of inspiration, perspective, color and lighting. In fact, the imperfections of the subject are where much of the character lies. If the photo is missing some things or the balance is a little off, that's all right—you can compensate in the composition of the sketch you make before you paint, and whatever imperfections there are can add to the story of the painting.

Too Much Information
When taking photographs of flowers, especially when just starting out, it's fairly common to capture more of the field than necessary. As you can see here, there is no flow to the composition and too much information, no focal point, it's difficult to see details and there's no place for the eye to rest.

Selecting Photos to Work With

At times you may find that you don't have any idea what to paint. This is when you visit your reference library for inspiration. Simply flip or scroll through your images quickly and see what jumps out at you. Try not to overanalyze, just see what catches your attention. You may not even know exactly what it is that inspires you, but if something made you pause for a moment, then it's worth your consideration. Just set it aside to revisit later and continue looking through the other images.

When you have a stack or grouping of images that strike you, flip through them again and see what you like about them. It might be the colors, shapes, values or something else that catches your eye. By quickly going through your images, you're allowing your unconscious mind to see things from a different perspective without overanalyzing.

Some artists think that working from photos will leave you with a flat and lifeless painting, but with a better understanding of value and color, you can change that. The only downside of using photos is getting too caught up in every tiny detail you see and turning the painting into a copy of the photo instead of an artist's interpretation.

To help you see as a painter, try squinting your eyes as you look at your photos. This forces you to focus on the most obvious shapes and light and dark values that attract the eye. When determining what will make it into your painting, remember the old sayings "Less is best" and "Say more with less."

And always keep in mind that it's not important to paint exactly what you see; rather, use reference photos as tools on your artistic journey.

Make Sketches and Take Notes

When taking reference photos, you might also make some sketches on location. When doing that, be sure to take some notes of the colors you see and of your experience at the time. This is a wonderful way to connect you to the environment you're trying to capture, and your notes will help you remember later what attracted you to the subject you want to paint.

A Better Shot, but Room to Improve for a Painting
Here you can see slightly larger objects and a bit more detail, but with all the different colors and flowers of the same general size, the eye jumps around the photo, not knowing what to focus on or where to rest.

Discovering Designs With a Viewfinder

If you are overwhelmed with your subject, try using a viewfinder. A viewfinder is a tool that allows you to expand or reduce an area that you are seeing into a more manageable size for a composition. This can help you simplify your design and allows you to focus on the main areas of interest in your subject.

Commercial viewfinders are available wherever art supplies are sold, or you can make your own. For a quick way to isolate key elements when you're on location, look through your camera's viewfinder or smartphone camera setting. You can also simply punch a hole in a piece of paper or cardboard or make a circle with your hand to look through.

If working from reference photos, you can make a view finder by cutting a small mat in half at opposite corners to make two L shapes, then position the L shapes over your photo and adjust the opening to test out different compositions. This viewfinder allows you the flexibility to increase the area or reduce it and to play with different proportional sizes.

If you're using a portable viewfinder on location, push it out to arm's length or pull it in closer to show more or less of your subject. This visual cropping will help you determine the overall feel you want for your composition—a wider view that captures more of your subject or a closer, more intimate one.

Try not to overanalyze your options. Allow the elements and shapes to speak to you, and let inspiration be your guide.

Using a Viewfinder
Viewfinders allow you to reduce or enlarge an area to find the best composition for your subject. An inexpensive way to make one is to simply take a piece of paper or cardboard and punch a hole through it with a pencil, then move it forward and backward to see how much of your subject you want to paint.

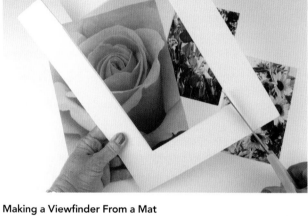

Making a Viewfinder From a Mat
An easy way to make a viewfinder is to cut two L shapes from a mat or paper and place them over your reference photos. Move and slide them into any shape you like. Also try changing the format from a vertical portrait to a horizontal landscape or even a square.

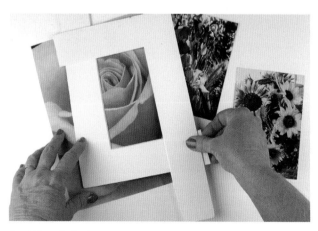

See What Grabs Your Attention
When using your reference photos, viewfinders can be helpful in isolating the more exciting parts of your image.

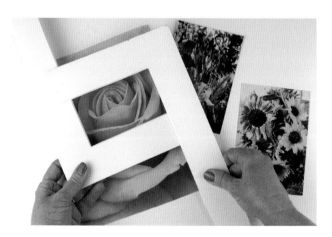

Successful Composition Strategies

Compositions should demand attention. Ask yourself, where does the viewer's eye go? Does it see the main subject first then travel through the rest of the painting, or do you notice everything all at once?

Not knowing exactly where to look can confuse the viewer. It's most important to invite the viewer in, lead them to a point of interest, then allow them to use their own imagination to wander through and around the rest of the painting. Here are some strategies to help you put together a composition that does just that.

Organize and Optimize Shapes

Shapes are a powerful way to communicate. They provide points of interest and have the ability to change how we feel about a design. Too many of the same size or color can confuse the viewer and make a painting appear more like a pattern rather than a piece of art.

These shapes can be big or small, free-form or geometric (see the sidebar for meanings they can suggest). By varying their sizes, overlapping their edges or separating them in purposeful ways, you can use shapes to organize the picture space and easily lead the eye through a painting.

Simplifying shapes helps to bring more attention to the main areas of interest in your subject. If you are having problems seeing shapes, squint your eyes or turn the image upside down—this forces you to eliminate details and focus on what's important. There is no need to replicate everything you see; eliminating the unnecessary and simplifying your subject into larger shapes allows the viewer's eye to focus on areas of interest and lets them fill in the rest with their mind. Try to build a trail so the composition flows and allows the viewer to enter into, wander through and exit out of the entire painting.

Follow the Rule of Thirds When Placing Your Focal Point

Try to avoid placing your focal point—the area you want to draw the viewer's attention to—directly in the middle of your paper. Otherwise, the viewer's eye will go directly to it and ignore the surrounding areas. Instead, divide your paper into thirds vertically and horizontally, and place your focal point at one of the intersections. This is called the rule of thirds. If you find this difficult to visualize, go to your reference photo and draw lines with a pencil or pen to help you find where the intersecting lines would be.

Keeping the placement of your main focal point off-center helps to make the painting more interesting and harmonious. Then use other elements such as petals, flowers and branches, or general design elements such as line, value and color to lead the eye toward it.

Eliminate Order and Embrace Randomness

It's rare to find anything that neat and orderly in nature. It's also rare to find two objects spaced evenly or sized the same. There is a beauty in the randomness of how things move and grow; imagine the wind blowing through a field or the blossoms on a tree branch. Elements in varying sizes and different directions inspire us to look at a subject in wonder.

When painting, it's the same idea: it's the randomness that keep the viewer's eye moving through the painting and to create a more interesting and pleasing image. This can be done with a suggested shape or a line—anything that draws the viewer's attention through the painting to another area and around. Try not to have items evenly spaced or the same size—it confuses the viewer. The subject would be obvious, but it won't be very interesting, and the viewer will likely ignore the rest of the painting.

How Shapes Are Interpreted

- **Squares and rectangles** represent order and formality, and bring a sense of security and rationality to areas. These are the most familiar shapes and are pleasing to the eye, even if they have rounded edges.

- **Circles** imply grace and flow with a sense of unity, connection, harmony and community, all of which can convey a sense of safety and protection.

- **Curves** represent happiness and movement and can suggest energy, a journey or even power, similar to a wave.

- **Triangles** when sitting upright, represent power and stability and can focus energy. A triangle on its point can convey instability.

Not Dead Center
Placing the focal point directly in the center of a composition can make it look like a bull's-eye, forcing the viewer to see only that object and avoid the rest of the painting.

Off-Center Is Better
With a little cropping and using the rule of thirds to place the focal point off-center along intersecting lines, we've created a more harmonious composition. It allows the viewer to move freely through the painting and observe more, and generally it is much more interesting.

Think in Odd Numbers

When considering a composition, think of it just like you would when planting a garden—it always looks better when you plant in odd numbers. For a painting, it's the same basic concept: elements always look better in three, five or seven rather than two, four or six. This is because the viewer identifies elements in even numbers right away and then is not very curious about anything else. Pairs bore the viewer, but odd numbers keep the eye moving throughout the painting.

No Kissing Edges

Avoid having the edges of elements barely touch in a painting. Elements connected in this way create weaker shapes and distract the viewer, making them pause for a moment while they try to figure out the problem instead of engaging them in the painting. It's better to have the edges of a subject overlap instead, or for those that will be separated, make sure it is not by equal distance.

Have Variety

Too many same-size shapes with no focal point can leave the eye with no path to follow or place to rest. It breaks the flow of the composition and is not very dynamic.

In this situation, eliminate the repetition of the size, change the color or value of the surrounding shapes, and try to isolate the most interesting objects. Make sure you apply the rule of thirds by placing the focal point on intersecting lines.

Use a Range of Values

It's not only the placement of the subject that makes an interesting composition, but the values—the lights and darks. Before painting, make either a black-and-white copy of your reference photo or do a quick value sketch with a pencil or in watercolor using only one color. Study how the light and shadows fall on the subject. Make sure your painting includes lights, darks and midtones, and that they are arranged in a way that makes sense and guides the viewer.

Unify the Parts

The elements in the painting should feel unified, as if they belong together, not like separate pieces thrown together. We want the viewer to visually move through the painting with a sense of flow, design, movement and harmony. It should have a sense of balance and proportion, along with pleasing shapes defined by lines or color, with recognizable boundaries. Do you feel invited in? If not, then your design needs to be adjusted.

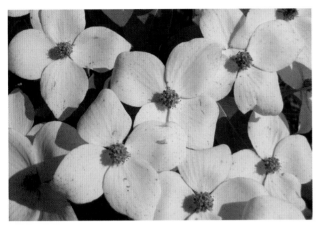

Too Much of the Same
Too many of the same size objects can be boring and makes the painting appear flat and pattern-like. Use a variety of different shapes, values and colors to direct attention to a point of interest.

Too Few of the Same, and Kissing Edges That Distract
Without a definitive focal point, it's hard to tell where you should look. The number and placement of the flowers divides the composition in half, and the touching edges of the petals eliminates any flow through the painting. Logically, we know we should be looking at a flower, but it's not clear which one, and that can be distracting.

Overlap the Edges
It's much more interesting with the overlapping edges, but using an even number of flowers doesn't lead the eye anywhere, just back and forth between the two shapes.

Make It More Interesting
Using the rule of thirds and placing the focal point at intersecting lines of the rectangle, overlapping the edges and including shapes in a variety of different sizes makes this image much more interesting.

Getting Close

To give the viewer a more intimate experience and the impression that they could curl up inside a flower, it's all in how you crop the image. If you zoom in close enough, this can look almost abstract.

You can do this with almost any photo; just decide where you want your focal point to be and then change the emotional reaction with color or design.

Original Photo: Fine but No "Wow" Factor
As is, this is a fine composition of a Matilija poppy—it has a focal point and leads the eye off into the distance. But, with only a few adjustments, this can turn into a painting with a better composition and a stronger statement.

Closer Crop: to Bee or Not to Bee?
This more dynamic view draws the eye to the center of the flower, giving you a different perspective, as if you were a bee. The white petals of the design lead the eye down and around and back into the center. One approach to this painting would be mingling the gentle values in the petals and warm yellows in the center using a negative painting technique (see Chapter 5 for more on this).

Closer Crop: Simplify the Scene
You don't need to capture all those petals to make an interesting composition. Cropping to the center of a single dahlia and using the rule of thirds to place it creates a much stronger and more intriguing design.

Original Photo: Lovely but Too Much
In this image of dahlias, it's easy to get lost in all the petals and shadows. Here we find four main elements: two flowers and two buds. They are easily identifiable as flowers, and with their placement and the surrounding space, the viewer doesn't have much to think about regarding the composition.

Original Photo: Colorful but Busy
You can always paint the entire flower, but change it up a little and focus on shapes, shadows and color.

Cropped Photo: Think Color and Shape, Not Petals
Cropping the photo into an abstracted image is more fun and inspiring to paint. This gives you an opportunity to unify and glaze color, bend and curve petals and learn about shadows as you paint them.

Building a Composition From Multiple Photos

At times, when looking for a composition, you might not be able to find everything you want in a single reference photo. For instance, you might like the background in one, the focal point in another and the colors from somewhere else.

Find the elements you like and start pulling them together. It doesn't have to be perfect to expand your ideas and explore other possibilities.

Take the parts you like and make a sketch. Or you can make photocopied enlargements of your photos, cut out the shapes and move them around (you can also do this digitally on your computer). Then, when you're happy with the design, create a final sketch.

Let's try using this to build a composition of apple blossoms, which we'll paint later on.

Original Photo: Conceptualizing
Looking at this photo, I was drawn to the top two blooms, the overlapping edges of the petals and delicate cast shadows of the stamens. However, the background is not very interesting, and its color is a bit drab. The branch is an intriguing element that draws attention to the main subject.

Cropped Composition: Isolating Key Elements
By cropping the image, unnecessary details have been eliminated, and attention is drawn to the two main flowers in the foreground.

Bud Detail: Looking for Color
To help break the even number of the two flowers into three elements for a more eye-pleasing odd number, buds from another photo would work nicely and help add a little color. Since these are facing the opposite direction, it would be a good idea to flip them so they're less distracting.

Background Ideas: Adding Interest
To change the drab green of the background (which is a little boring and lifeless) and give the painting the uplifting impression of new growth and fresh air, choose a different photo that better demonstrates filtered light.

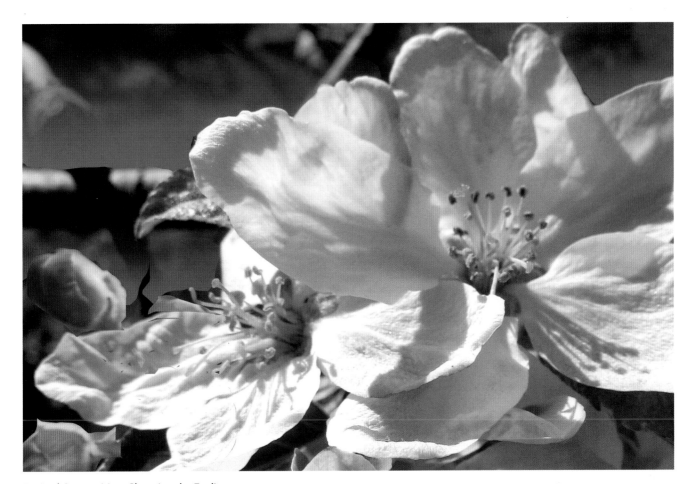

Revised Composition: Changing the Feeling
To get a better idea of how a lighter color may look in the background, add a basic blue. This can be done on a computer or by cutting shapes out of craft paper or colored watercolor paper. For the final painting inspired by this composition, see the last demonstration in the book.

Putting Your Design on Watercolor Paper

There is no doubt that the design concept for a painting reveals the individuality of the artist, and knowing how to draw is fundamentally important to your painting. But before an idea can be translated onto watercolor paper, it can go through many stages, which means lots of pencil lines and erasing.

To avoid damaging the surface of your watercolor paper, consider working and reworking your design on a sketchpad first. This allows you a little more freedom to experiment and results in a cleaner line drawing to transfer to the delicate surface of the watercolor paper.

Making Pencil Lines

When it comes to pencil lines, many artists struggle with what to do with them. Should they be seen in the final painting? Does it matter? Some artists have an aversion to them, while others feel they reveal more about the artist's painting process and intention. Pencil lines can add to the piece of art, and they have the ability to connect the viewer to the artist. Whether or not to show them in your artwork is a personal decision. Be aware, however, that if you're painting for competitions, and depending on the organization, showing pencil lines may not be acceptable.

When using a pencil on watercolor paper, don't press too hard. The resulting line can be too thick or heavy and difficult to hide, or it can imprint the paper. Use a light touch and apply just enough pressure so you can see your design. The goal is not to distract from the painting but to provide the proportions of your subject and a guide to follow.

Artists draw with different types of pencils, ranging from soft to hard. Depending on how much water they use, some prefer the kind of pencil where the line disappears when wet. However, I find that the common 2B pencil works fine for me—it's not too hard or too soft, or too dark or too light.

Before beginning to paint, try to minimize as many lines as possible, because when wet, even clean water can permanently set them in place, making them difficult to remove.

Some pencils are softer than others, and when water and color are applied, the graphite can smear or muddy the color. To lighten and remove excess graphite from your drawing before painting, roll a kneaded eraser over the surface, or dab or gently rub it. Also make sure to tap your watercolor paper on the table surface to help remove any excess.

Do not use a hard vinyl or pencil eraser; these can easily damage and scar the soft surface of the watercolor paper. You may not notice the damage at first, but once water and color are applied, it will show up as darker areas and rough patches.

Enlarging the Design

Some artists may feel that if you can't create a painting from memory or freehand a drawing, then it's cheating; however, each artist is an individual and how you choose to make your art is your personal creative process.

Knowing how to draw is very important, and once you are comfortable with your skills—or even if you are not—there are alternative methods to speed up the transfer process, allowing you more time to create new works of art. The reality is, many people just want to paint and express themselves, and drawing is not for everyone. Some artists don't want any restrictions; some want to get right to the painting. It's really up to the individual artist to find their own path and what works for them.

Traditionally, when enlarging and transferring a sketch, artists would freehand or use the grid method. While rewarding and ego-gratifying, each of these approaches can be laborious and hugely time-consuming. Let's look at several different methods that artists are using today to help you enlarge and transfer an image to your watercolor paper.

The Grid Method Used by artists for centuries, the grid method has been the most popular way to transfer an image. It is a bit time-consuming but can help you improve your drawing skills. To begin, create a grid over your sketch or reference photo—usually in 1" (25mm) squares, but if it's small, you can use ½" (13mm) squares. Then, using an equal ratio, create the same number of squares in the desired painting size. For example, 1" (25mm) sketch square = 2" (51mm) painting square or 1" (25mm) sketch square = 4" (10cm) painting square and so on. Once you have your larger grid of squares, draw the contents of each smaller square into each larger corresponding square.

Some artists like to show how much work they did in preparation for the painting by drawing the grid lines directly onto their watercolor paper, leaving a ghost image of the squares in the final painting. But if your intention is to erase all grid lines, you might want to consider creating them (and your drawing) on a separate piece of sketch or tracing paper, to avoid damaging the watercolor surface and to give you a reusable template.

Enlarging at Photocopy Shops or on Your Home Computer Today many artists don't want to take the time to use the grid method and just want to start painting right away. One option is to take your sketch to your local copy center and have them enlarge your design to the desired painting size. When enlarging at a copy center, make sure you're using your own designs, or the copy center may refuse to enlarge due to copyright laws. Once your image is enlarged, use the transfer method of your choice to transfer it to watercolor paper.

Though a bit more tedious, you can print a grid or an enlargement of your design in panels using your own home computer, scanner and printer. Afterward, transfer to your watercolor paper.

Using a Projector Using a projector is essentially the same thing as making enlargement copies, only in a different format. It allows an image to be projected to almost any size onto a surface where your paper is placed, such as a screen or wall, and then traced.

Most times when projectors are used, it is for capturing basic perspective rather than detail. In fact, many Old Masters were known to have used the camera obscura—a box with an angled mirror and a pinhole opening—to enlarge an image to get proper perspective of their sketches. We have different types of projectors today: traditional (for use with slides; this is now a bit outdated), opaque (where you lay your photo or line drawing on top) and digital (which you can plug into your computer or insert an SD card or USB drive).

Don't Overdo It All of these enlargement methods come in handy, but depending on your goals, it's easy to get caught up in all of the tiny details, which can take away from the artistic process and result in a painting that's more of a technical rendering than a true work of art. Don't lose sight of the painting and the spontaneity of watercolor by obsessing over the drawing.

Transferring the Design
Once the design is enlarged and ready to be applied to your watercolor paper, you have a few options for transferring your drawing:

- Tape the drawing to a window, sliding glass door or light box, place the watercolor paper on top, then trace your clean enlargement. This works very well for both 140-lb. (300gsm) and 300-lb. (640gsm) paper. Just make sure your design has more simplified shapes than little details.
- If you don't have enough light for the first option, use graphite or transfer paper.

Using Graphite or Transfer Paper Graphite paper and transfer paper are basically the same thing but with different names. It can be purchased in sheets or rolls. Simply cut the paper to the same size as the painting you want to create, tape the graphite side facedown on your watercolor paper, tape the drawing on top of that, then use a pencil, pen or stylus to trace over your design, which will transfer the graphite to the watercolor paper.

Removing Grid Lines From Watercolor Paper
When removing grid lines on watercolor paper, try to lift as much graphite as possible with a soft kneaded eraser. Simply roll over and dab the pencil lines, otherwise, the excess graphite residue can muddy the color once it is applied.

Making a Grid on Sketch or Tracing Paper
One approach is to grid and enlarge the design on a separate sheet of sketch or tracing paper. This allows you the freedom to change your design as much as needed without ruining the surface of the watercolor paper.

If your design is larger than the sheet of graphite or transfer paper, simply move the sheet where needed or tape a few together. You can use the same piece of graphite or transfer paper multiple times. You can also make your own graphite transfer paper.

Making Your Own Transfer Paper To make your own graphite transfer paper, rub one side of a sheet of tracing paper or lightweight bond paper with a soft lead pencil or a solid graphite stick (available at art or hardware stores) until it is fully covered.

To prevent the graphite from smearing and rubbing off, gently wipe a small amount of rubber cement thinner (different than rubber cement) over the surface with a paper towel and let it dry. This coating still allows the graphite to transfer. Use in the same manner as the commercial paper.

Reducing Graphite Residue One problem with graphite or transfer paper, whether commercial or homemade, is that it can leave behind graphite dust or residue, which can smudge and make colors muddy when painting.

To prevent this, wipe a facial tissue (make sure it's lotion-free) over the graphite side of the transfer paper to eliminate any excess before using it. Once the design has been transferred, shake off the excess graphite or gently roll a kneaded eraser over the image to remove remaining unwanted lines or residue.

Protecting Your Transferred Drawing

If you're not planning on painting immediately after making your enlargement, place it somewhere it won't be disturbed, scratched or smudged. Protect it from the elements by wrapping it in glassine or placing it in a drawer or between pieces of foamcore board until you're ready to paint.

Graphite or transfer paper comes in sheets or rolls.

How to Transfer a Drawing Using Graphite or Transfer Paper

1. Cut the graphite or transfer paper to the same size as the painting you want to create. If your transfer sheet is much larger in size and you don't want to waste it, fold it back in a way that only exposes the graphite side; or, if the opposite is true and the sheets are smaller, tape together as needed.

2. Using artist's tape, gently tape the graphite side (the darker, messy side) facedown along one or two edges of the watercolor paper to hold it in place.

3. Place the drawing on top of the transfer paper and tape it down the same way. Additional tape may be needed to secure it, otherwise, it may be difficult to realign.

4. Using a pencil, ballpoint pen or stylus, trace over your design with a light touch to transfer the graphite lines to the watercolor paper.

Working in Layers
This way of transferring your drawing to watercolor paper can be a little less tedious and time-consuming, and the graphite or transfer paper is reusable. This transfer process is basically the same, but you're working in layers (drawing over graphite paper over watercolor paper).

An Alternative to Whole-Sheet Graphite Coverage
If you're making your own transfer paper but don't want to apply graphite to an entire sheet, you could just shade over the lines on the reverse side. The advantage of this is less waste, and you can see your lines more clearly.

Transfer Tips

- Test first to see how much pressure you need to put on your pencil, pen or stylus to transfer the lines.
- Double-check occasionally to make sure your drawing is aligned properly by turning back a corner to see how it is transferring.
- Dark lines are not necessary. If your lines are too dark and thick, lighten the pressure.
- If the drawing is too light, you can always go over it again later with a pencil. You just want to get the basic perspective and design placement down on paper.

Tools for Making Your Own Transfer Paper
Solid graphite sticks or soft lead pencils can be used on a single side of tracing paper or lightweight bond paper to make your own transfer paper.

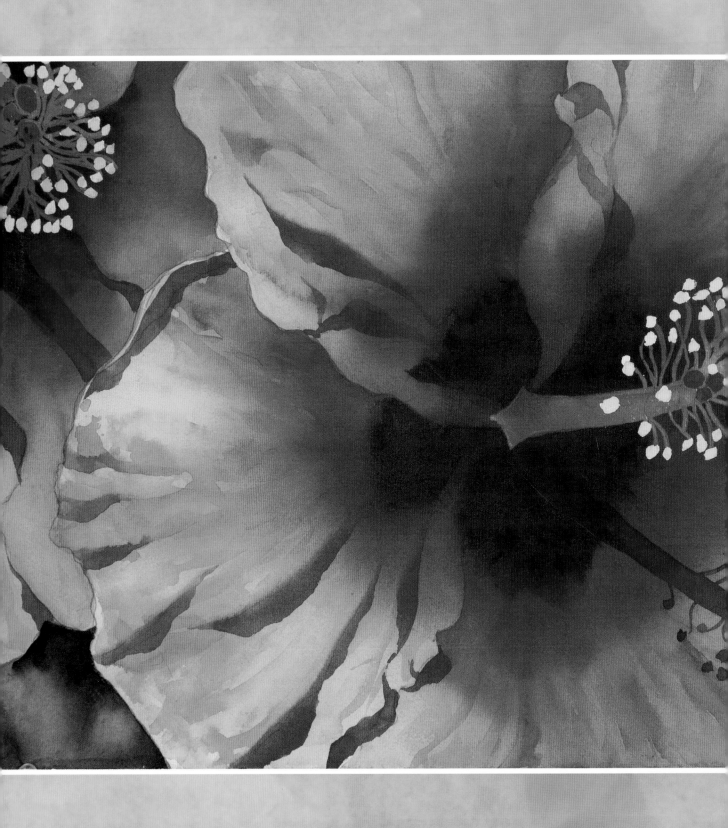

Chapter 5
Lessons and Demonstrations in Watercolor

Let's put everything you've learned until now into practice by painting a variety of beautiful blooms and cover some crucial watercolor lessons as we go.

We will discover how brushstrokes can be used to develop shape and dimension. We'll talk a little about shadows and why they're so important to realize depth in your paintings. We'll see the luminous effects of layering (or glazing) color and how this technique differs from applying color mixed on the palette. We will look at how negative painting can be helpful to build flower shapes and to resolve areas you may not know what to do with. We'll also explore our options for creating various backgrounds and learn methods of masking to preserve the white of the paper.

You will find that the amount of water you use in any watercolor technique is critical to achieving the results you want. Be particularly aware of this as you work your way through the demonstrations, and your attentiveness will help make your paintings more successful.

Hibiscus
Watercolor on 300-lb. (640gsm)
cold-pressed paper
15" × 22" (38cm x 56cm)

Using Strokes to Create Shape

Knowing how to apply a brushstroke applies to all painting styles, the only difference is whether you see it. Strokes applied to wet or damp paper can blend into the water held on the surface. The same stroke on dry paper delivers a deliberate line with a defined edge. Let's practice with this exercise, using strokes to create shapes.

Exercise: Paint Shape Squares

1. Using pencil or tape, divide a quarter sheet of watercolor paper into four squares, and within each square draw a simple shape.
2. Working each square and shape separately, choose a base color you want to work with and paint the background area around the shape. Let it dry.
3. Fill the inside of the unpainted shape area with clean water. Allow the high shine on the surface to dull to a sheen.
4. Decide how you would like to form each shape, or if you don't know, just experiment. Using a no. 8 or no. 14 round sable/synthetic blend brush and the same color as in the background, apply a stroke of color along either the bottom of the shape, just above an edge, or in the middle, and let it dry. The placement of the stroke changes how the shape will fold or roll.
5. Layer the color as needed to achieve the saturation you like. Darken the background, and use the same loose stroke to create contrast and add a cast shadow.

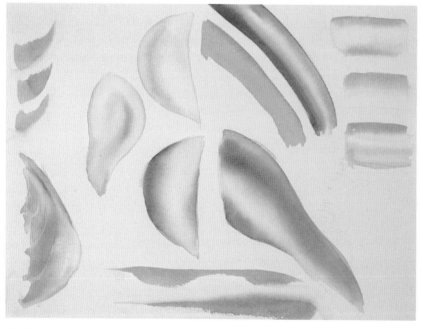

Practice Sheet
Practice making many different shapes, varying the placement of your strokes to control how you develop their form.

Shape Squares
The size and placement of the strokes of color on each shape give it form.

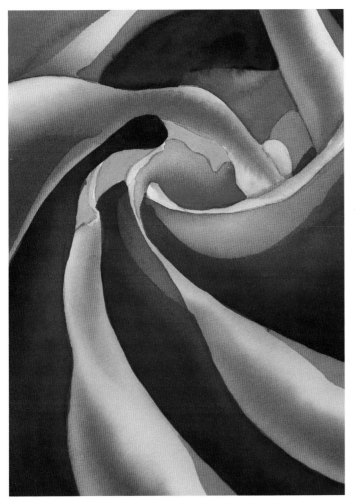

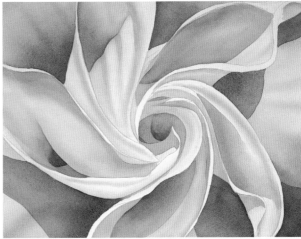

Folding and Rolling Petals

Painting a composition that focuses on the natural repetition found in rose petals will help you have a better understanding of how to create defined shapes. Keep the lightest color as the highlights, apply shadow and build depth with contrast.

The same is true when working with white flowers—start with your lightest values, then gradually deepen the color as you start to work your way into the shadows.

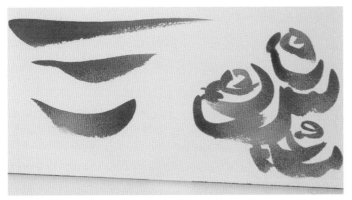

The Form Created by Simple Strokes

Try making these fun little roses to practice a more painterly stroke. Hold the brush loosely in your hand, move your wrist and apply different amounts of pressure, making strokes that go from wide to thin or thin to wide.

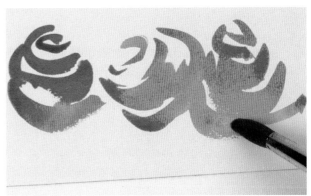

Get Looser and Lighter as You Work Your Way Down

Starting at the top, with little half-moon strokes, gradually increase the size and width as you expand toward the bottom.

Painting Shadows

Shadows make most of us a little uncomfortable. This is a natural reaction to the dark and the unknown. Some artists avoid painting them altogether. Lighter areas of color always feel more comfortable and safe, but unfortunately when all we see is the light areas of a subject, a painting can appear weak, washed out and not very interesting.

Other artists will start out with a light painting, then dive in and add really dark shadows, with no tones in between. If the painting only has light color and dark shadows that are all of the same value, those shadows may just appear as dark holes. Your eye is immediately drawn to the extreme contrast and ignores the rest of the composition.

In a painting, shadows have the ability to keep the eye moving and break up boring areas. How light interacts with an object is what gives an object its shape and form, through highlights and the range of value within the shadow. Without this, objects appear flat.

Shadows that are painted properly and placed well can give balance to the lights and darks in your painting and provide drama that will not only attract the eye but hold the viewer's attention.

Not Just Dark

Most of us don't have any problem seeing that shadows make up the darkest areas of a painting, while highlights (areas where the light reflects off of the subject the most) are the lightest. When looking at your subject you may think you only see highlights and dark shadows, without even noticing the mid-range values. Shadows contain a wide range of mid-range values, not just dark. Without them, a painting would appear flat and lifeless. We control these values with the amount of water, pigment and variation of transparency within the hues we are using, all of which create the depth perceived in a shadow. Balance is the key to believable values.

To help you see these values better, it often helps to make a black-and-white copy of a reference photo or to cover it with a piece of red acetate (as discussed in chapter 3). This will help you ignore color and notice the other values that you may have missed at first glance.

Form Shadow vs. Cast Shadow

Form shadows are located on the side of an object that faces away from the light source. They are softer and reveal an object's shape and form. The curved shadows of a flower facing up are warmest and lightest in value toward the top and cooler and darker toward the inside.

Cast shadows are produced when light from the light source is blocked by the object, which then casts its shadow on a surface opposite to the light (the ground, a table, another flower, etc.). Cast shadows contain no reflected light and are darkest and most sharply focused near the object.

The Direction of Shadows

Shadows are more believable when they fall in the same direction, and this is always on the opposite side of the light source. So when doing a painting, all shadows need to be on one side.

Hard or Soft Edges?

Usually you will find that a combination of hard and soft edges is what gives an image shape and a painting life, and the same goes for shadows. The nature of the light also affects the edges of shadows. A bright, sunny day full of direct light creates hard-edged shadows. Foggy or high overcast days produce softer edges.

The Color of Shadows

At first glance, shadows can appear black, but shadows painted black will appear harsh and unnatural. Inherently, shadows have a bluish or violet hue—basically, the complementary color of the light source mixed with some of the local color from the surrounding objects. When mixed together, the complementary color creates a neutral shadow color that enhances highlights and increases contrast by making the image more interesting and stimulating.

Shadow Temperature

In theory, whatever temperature the light source is, the shadows will be the opposite. So, paintings with warm light will have cool shadows, and paintings with cool light will have warm shadows. This doesn't necessarily mean the shadows in a cool painting will be orange, red or yellow—it simply means you can warm your shadows by using variations of these.

Surrounding objects will also affect the shadow color by how much light bounces off. Here is a simple way to see your shadow colors a little easier: Try not to look directly at the shadow, but rather around it.

The Values of Shadows

The value intensity will be the same in the shadow as it is in the light. The side of an object that faces the light source will have the least amount of color (the lightest value), while the side that is in indirect light will have the most vivid color (the medium value). The side in the darkest part of the shadow, depending on the reflective light, will have the darkest color and the deepest value.

When deciding the general range of values to use when painting shadow, it all depends on the type of day. If it's bright and sunny, use middle to dark values; for high overcast and fog, use light to middle values.

How Dark Should a Shadow Be?

In general, think of the shadow as being 40 to 50 percent darker than the lightest area of an object—but this is subjective to the light source and how much filtered light is able to come through.

Reflected light is also a consideration, and how much light bounces off of surrounding objects and reflects back into shadow. This helps to add dimension, bring life to uninteresting areas and give shadows a glow.

When to Paint Shadows

Some artists like to paint their shadows first and use them as a map for finishing the rest of the painting, while others like to paint the main subject first, then add shadows. Both approaches will have slightly different outcomes.

If you apply shadows first and then layer, edges may soften and smear or the previous color may lift. Depending on what you need, you may consider using more staining colors. This would be a good technique for backlit areas. Painting shadows last will give you defined shapes, harder edges and increase the drama.

I recommend doing your basic painting first, then applying your shadows on top. This will give you the glow and texture of the image underneath and, if layering, help you avoid having too many edges of overlapping color.

The Length of Cast Shadows

This will depend on the time of day and season of the year. For instance, midday or summer shadows can be short or almost directly under an object, while evening or fall shadows appear long.

Decide the length, load the brush with enough water and color, then apply in sweeping strokes. Avoid outlining the shadow shape, or the outline can dry faster than you are working, which results in a shadow that looks labored rather than effortless.

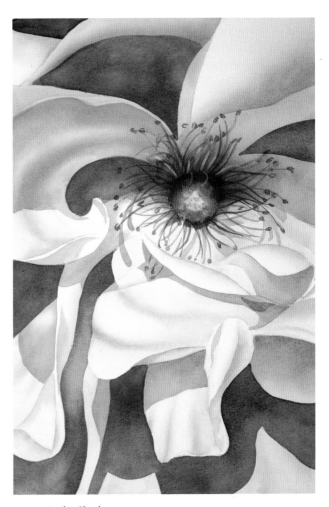

Drama in the Shadows
The hard and soft edges of shadows and the values of the shadow colors have the ability to make paintings more interesting and dramatic.

From Within
Watercolor on 300-lb. (640gsm) cold-pressed paper
22" × 15" (56cm × 38cm)

Glazing or Layering

Glazing is a watercolor term used to describe the stacking (or layering) of multiple thin washes of color. To understand how this looks visually, imagine stacking different pieces of colored glass—as each layer is applied, it changes the result of the underlying color. In watercolor it's the same idea, but instead of stacking glass, we are layering very thin washes (or glazes) of transparent color, with each one being thin and transparent enough for light to still pass through the color and reflect off the white of the paper below.

Why Glaze Instead of Mix?

Layered color looks very different than color mixed on the palette or directly on paper. Layering individual colors over one another and letting each layer dry before applying the next allows the underlying layers to affect the topmost layers, creating beautiful, jewel-like effects. Any areas where the new layer has not been applied will show like little windows to reveal the color below.

Glazing, like so many other techniques in watercolor, can bring a degree of excitement and unpredictability into a painting and is very effective and rewarding. It creates luminosity, depth and glow, and it can also add texture.

This can be very effective in paintings where intentionally looser brushstrokes are used to show the multiple layers, or for large, smooth, seamless washes or for areas where unifying color is needed.

Watercolor always dries lighter—10 percent lighter when applied to dry paper and 25 percent lighter when applied as a wash. If you try to speed up the process without building layers, color can appear weak and wimpy. Glazing allows you to gradually deepen or modify color.

How to Glaze

For optimum results, the cleanest color and the purest glazes, choose the most transparent colors for layering. Colors to avoid are the more earthy, staining and opaque colors. Although these have greater coverage and are helpful to tone down color mixtures, they can easily turn muddy, appear flat and even leave a chalky residue.

Remember, you are stacking multiple layers of color, so when glazing, each layer must be completely dry before applying the next, and the colors you choose will affect the results you want. To see if your paper is dry enough for the next layer to be applied, test the surface of the paper with the back of your hand. If the color is cool to the touch, it is still too damp to add another layer. If you apply the next layer of color too soon, before the previous layer is dry, the layers can easily mix and turn into mud.

Another helpful tip when using this technique is to use soft brushes, or you can unknowingly lift the damp color and end up with unwanted brushstrokes.

How Many Layers Can Be Applied?

This really depends on each individual artist and the effect that you are trying to create. For a looser style, you might apply multiple layers of lots of little brushstrokes here and there. Large, expansive washes might be built with dozens of layers. Although time-consuming, it can be well worth the effort to create a luminous effect. Others may prefer using more pigmented washes to build color intensity in three to five layers. It all depends on the desired color and effect.

Glazing to Unify Color

If somehow your applied colors are off, you didn't mix enough color, or you forgot the colors you used and need to tie the painting together, you can apply a unifying wash over the painting.

On your palette, mix together the colors closest to what you would like them to be. Then, with a large, soft wash brush, apply the color over the entire painting. This will soften the edges of any details. Once dry, you can redefine the edges, working individual areas.

This helps to unify a painting and harmonize color, but if the initial colors are completely different from each other, a unifying glaze applied later won't change that underlying fact.

Light Shining Through Layers

When applied in thin layers or glazes, transparent watercolor allows light to pass through, reflecting off of the white of the paper for a beautiful, jewel-like effect that you can't get with mixed color. For this to work, each layer must be fully dry before you apply the next.

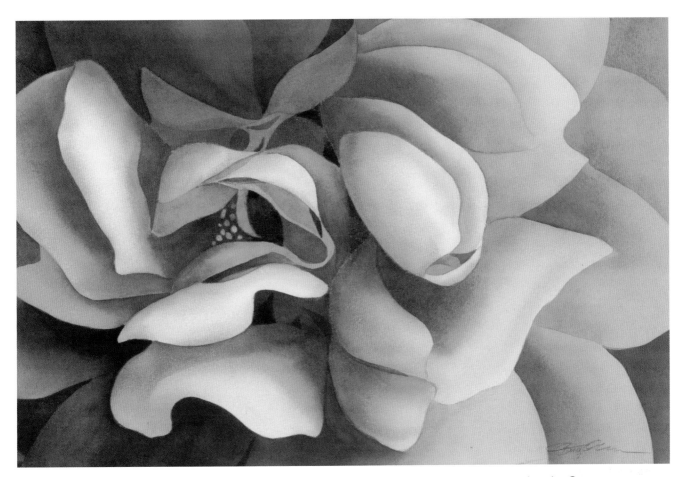

A Single Unifying Glaze
This composition was originally intended to be vertical, but a few areas turned out to be distracting with the painting ori-
ented that way. Turning the painting horizontal worked much better. However, one of the problems this change created was
that the light and dark areas were now too separate. To resolve this, a unifying wash was applied over the entire painting,
then details were reworked with a combination of hard and soft edges.

Amazing Grace
Watercolor on 300-lb. (640gsm)
cold-pressed paper
15" × 22" (38cm × 56cm)

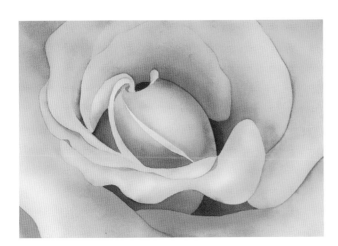

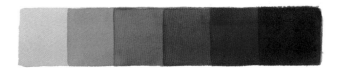

Layering to Intensify and Deepen Color
Using a very light value of water and color, paint a long rectangle and let it dry.
Leave a 1" (2.5cm) square on the left dry, then reapply the same color on the
rest of the rectangle and let it dry. Move over another 1" (2.5cm) square and
repeat. Continue until you reach the end of the rectangle. See how layering
the same color changes the intensity of the value and deepens the hue.

Layering Lesson: Paint the Center of a Rose
This is a great lesson in layering. Start with a light-tint underpainting (wash of
color) and work one petal at a time. Keep the darker values directed more
toward the bottom of the petals inside the center and transition them into
lighter values as you move up and out toward the edges.

Negative Painting

Negative painting simply means that, instead of painting an object, you're painting the space around it. By doing this, you have the ability to create more depth and dimension with each additional layer of paint.

In watercolor many artists like to paint one little section at a time, which is fine—but just in case you have areas of uneven color and need to unify them, or places where more detail is needed, understanding negative painting can be

helpful and give you more flexibility. I use this technique in many of my paintings to give an area a lift or to create a shape.

Negative painting is all about painting the area around a shape, but we can take several approaches. Let's explore them in the following exercises, which can all be done on 140-lb. (300gsm) cold-pressed watercolor paper.

Exercise 1 Instead of applying a wash to the entire sheet of paper first, one option is to leave it dry and use the white of the paper as the background. Then, where the areas of color will be, consolidate into one large shape, fill it with water and apply color.

1. Fill in with color around a white background
On the palette, make two puddles of Hansa Yellow Medium and Permanent Sap Green. Fill in the area where the shapes will be with clean water, then, using the wet-into-wet technique, drop in the colors and allow them to mingle on the surface. Let it dry.

2. Define shapes with darker color
Once dry, mix a little Permanent Alizarin Crimson into the Hansa Yellow Medium to make a soft orange or darker yellow. Then, using that mixture and a no. 14 sable/synthetic blend round, separate some of the petal shapes. Let it dry.

3. Create contrast
With the same brush and a darker value of the Permanent Sap Green that was used in the first layer, separate the yellow flowers from the leaves and create stems and other shapes, while leaving little windows of the previous layer showing through.

Exercise 2 Mingling color as an initial wash can make for some interesting effects as well as a wonderful foundation to build upon. If using complementary colors, make sure to leave enough space between them or the two can mix into a neutral color.

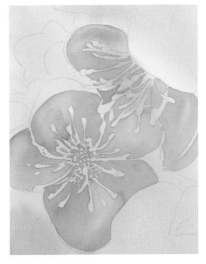

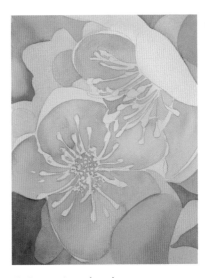

1. **Apply an all-over wash**
 On the palette, make three puddles: one with Permanent Rose, another with Permanent Sap Green and a third that combines both colors into a neutral blend. With a large wash brush, apply clean water to the paper surface. Then, using the wet-into-wet technique, drop in the two individual colors and allow them to mingle. Let it dry.

 Once dry, use a pencil to create a line drawing. You can play with detail, but think in terms of larger shapes and try to keep it as simple as possible.

2. **Paint around the lighter stamens**
 Once dry, use a darker value of the green color and a no. 8 or no. 14 sable/synthetic blend round to paint around the center stamens, creating petal shapes. The contrast will help to pull the stamens forward.

3. **Determine other shapes**
 Gradually deepen and darken the color to add more depth. With darker values of both individual colors and the same brush, paint around the other petals and leaves, leaving the lightest areas dry.

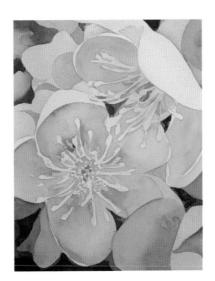

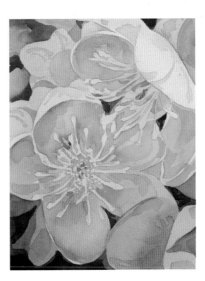

4. **Give definition**
 Using the same brush with the neutral blend, define the smaller shapes and details.

5. **Enhance flat areas**
 Negative painting is great to help eliminate overlapping hard edges and define shapes, but it can leave areas appearing flat. To break up the sameness of color, soften edges using a damp brush, or enhance with strokes of color where needed.

Exercise 3 In this slightly different approach, we use the glow of the initial wash of color as our background and try to work more with the shapes of lightest value.

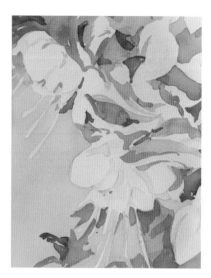

1. Start with an all-over wash

On the palette, mix two puddles. Make the first a light pink such as Permanent Rose by itself or mixed with Quinacridone Magenta, or if you want to play with a brighter color, you could even use Opera (though be aware that this color is fugitive, not permanent). In the second puddle, mix a light yellow, such as Hansa Yellow Medium.

Using a large wash brush and clean water, wet the surface and, with a no. 14 or no. 20 sable/synthetic blend round, apply each color and allow them to mix and mingle on the surface. Let it dry.

2. Establish the main shapes

Using a no. 14 sable/synthetic blend round and darker values of the same colors, paint around the main flower shapes of the composition. Let it dry.

3. Begin the details

Using darker values of the same two colors, paint around the lightest shapes. Also mix the two colors into a neutral blend and define the smaller details.

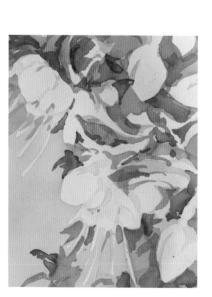

4. Keep defining with more layers

If you really want to experiment and make it more interesting, keep adding other details, shift the color hue and create more contrast.

Try Negative Painting Old Paintings

You can intentionally do a painting using this technique, or use one of your older paintings to experiment. If you happen to have a painting with large areas that you aren't quite sure what to do with, change the feeling of the painting with a little negative painting to break up the space.

Creating Backgrounds

When it comes to painting a background, many artists are at an absolute loss about what to do. Should it be colorful or limited in color, light or dark, full of detail or vague?

Your approach to the background also depends on the type of feeling that you want to convey and the emphasis you want the background to have. How important is it to the painting?

There is no right or wrong way to do a background—it's up to the personal preference of each individual artist. Here are some factors and options to consider.

When to Paint the Background

Some artists paint their background first and the subject last, while others do the opposite. This can change from painting to painting depending on the subject itself, and the intention and importance of the background.

For the techniques I use when painting florals, I like to save the background for last. This way I don't have to worry about any of the background color bleeding into parts of my subject, especially where clean, crisp edges are needed. I also like to create a push-and-pull effect with my color choices, and that's easier for me to do with the background after I've painted the subject. In contrast, for my landscapes, painting the background first gives me a wonderful foundation to build upon, using different glazing effects and seamless overlapping color.

Let's say you aren't exactly sure about what you want in the background, but you know if it were painted, it would help you from getting confused as you paint the rest of the composition. When this happens, consider adding a light tint of color to the background first—water with a hint of color—just enough that it contrasts some of the other white shapes.

Some artists like to start in one corner and paint their way across the paper, working on both the background and foreground simultaneously, one small section at a time. Do whatever suits you and the painting you're creating.

Should It Be Dark or Light?

A dark background creates an air of mystery and drama. When trying to accomplish a rich darker background, consider painting with Indigo. Depending on the brand, some will be a deep blue, gray or even black. Look for a nice deep blue, because this works well for most paintings, and the blue hue pushes nicely into the background (some may even prefer Indanthrone Blue or Phthalo Blue mixed with black or a dark Payne's Gray).

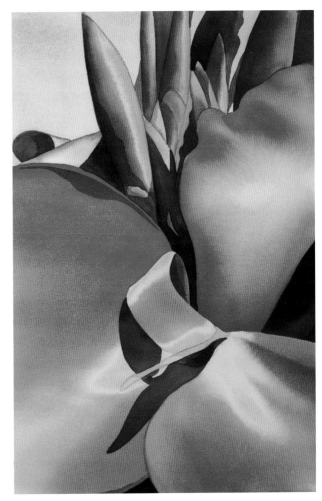

A Lighter Look
Depending on the colors used, lighter backgrounds create a sense of peace and ease without a lot of drama.

Like all color, darks will dry lighter after applied and will most likely need a few layers to get the color and coverage you want. Avoid trying to do it all in one pass because you can easily make the color too pasty or dry, leaving a glossy film on the surface and visible brush lines. Avoid using black for dark backgrounds, because its harshness can kill a painting.

A lighter background can create a sense of peace and calmness without challenging the viewer beyond the subject. In paintings with lighter backgrounds, the only thing that may create a distraction is the color choice. It can draw unwanted attention to parts of your subject that may be too dark.

A white background is simple and clean, requires no effort and shows off most floral subjects nicely, but depending on your painting style, it can also make the painting look incomplete and unfinished.

For luminous backgrounds, apply multiple thin layers of color where light is able to reflect off of the paper's surface easily, or try incorporating areas of transitional value, shifting from light to dark from one edge of the painting to another to engage the eye.

Color Choices

When considering the colors to use in the background, keep in mind how it will work with the rest of the painting. If you have certain colors that are dominant in the background, it's a good idea to incorporate some of those same colors into the rest of the painting, such as in the shading or the shadows, to keep the painting balanced. It doesn't have to be much. On the opposite page are some color schemes to consider and the effects they can create.

The temperature of the color in the background can change the mood or feeling of the painting or affect the viewer's perception of the season or weather conditions. For instance, warm colors can suggest a sunny summer afternoon, and cool colors might indicate cooler, windy weather.

In general, warm colors pull forward while cooler colors push back or recede. So, a warmer background will appear closer to the viewer than a cooler background, which will seem farther away.

Minimizing Details and Edges

Details are nice on your subject, but too many in the background can be distracting and compete for the viewer's attention. To give the impression of depth and distance, keep the focus on the main subject, then start to minimize and eliminate hard lines, edges and details as you move into the middle ground and background.

Testing Different Backgrounds

I mentioned earlier that some artists like to do their backgrounds first then work on the rest of the painting, but let's say you decided to work on the main subject first and leave the background for later. Sometimes this can be intimidating, especially if you have a lot of time invested in a painting and you like how it looks and are afraid of what to do next.

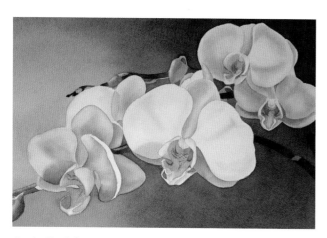

Gradually Shifting Values
To prevent the painting from looking flat and to make the background more interesting, try using transitional values that gradually become lighter or darker from one side to another. To harmonize the painting, use some of the same background color in the shading of the flowers.

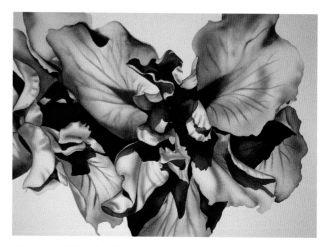

A Clean and Simple White Background
A white background allows the viewer to focus on the main subject without the challenge of deciphering its surroundings, and it relieves the artist from having to give extra thought to the background. But, depending on the composition, the painting can feel incomplete.

The Color Wheel

Analogous Color Scheme

These are colors that appear next to each other on the color wheel. For this scheme, choose any color as your main color, allowing that one to dominate, then select two or three colors alongside it as accent colors. Often found in nature, analogous schemes are harmonious, soothing and pleasing to the eye and create a comfortable design.

Monochromatic Color Scheme

Choose any one of the colors on the color wheel and repeat it throughout the entire painting in various shades, tints and tones. This color scheme approach creates a feeling of calm.

Complementary Color Scheme

Complementary colors, positioned exactly opposite each other on the color wheel, present the highest contrast and can appear bright and intense when placed side by side in a painting. They have the ability to make each other appear more vibrant, and this effect is very stimulating to the eye.

Split-Complementary Color Scheme

This variation of the complementary color scheme allows you to use two additional colors adjacent to one of your main complements. This also creates a strong visual contrast, only with less tension.

Triadic Color Scheme

This scheme uses three colors evenly spaced around the color wheel. These tend to be vibrant even when used in lighter unsaturated hues. Allow one color to dominate, and use the other two as accents.

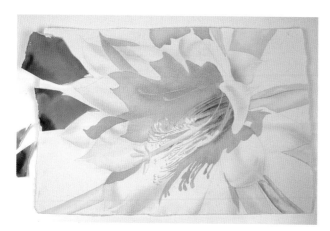

Position Painted or Colored Paper Shapes

Cut up pieces of colored craft paper, old watercolor paintings or any paper that you've painted. Place the cut pieces in the areas where you are trying to decide what to do to get a better idea of how the colors will work for the background.

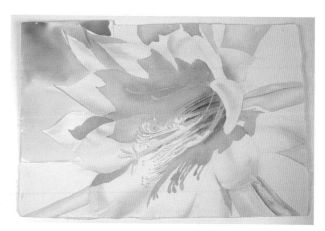

Make a Paper Background Template

You can also make a template out of watercolor paper in the shape of the negative area where the background will be. This gives you the same surface as the rest of the painting and larger areas to experiment with. Try painting it from light to dark or test entirely different colors.

Try an Idea on Wet Media Film

Also known as Dura-Lar (made by Grafix), this film is a mix between Mylar and acetate and has a coating on it that accepts all water-based mediums. Unlike regular acetate where water and color beads and runs, this product accepts water and holds color where needed, and color will dry nicely on the surface. It is available in a variety of sizes as well as in rolls (when purchasing, make sure the words "wet media film" are on the label).

To test a background idea, cover the painting with a sheet of the wet media film and experiment with color you like in the areas you want. To reuse, simply wipe with a damp cloth.

Try Out Backgrounds on Scrap Paper

Practice on a scrap piece of paper before committing to a background. Wet the surface and, while it's still damp, use the wet-into-wet technique to drop in various colors. Try dark colors, then a combination of dark and light colors; try brushstrokes to give the impression of branches. What you will learn is how the wetness of the paper affects the results. If any areas are dry or too dark, try using a brush or sponge to lift highlights and make different shapes.

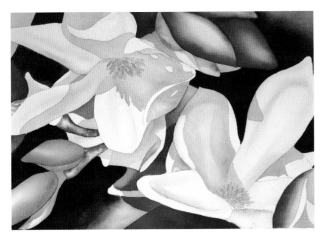

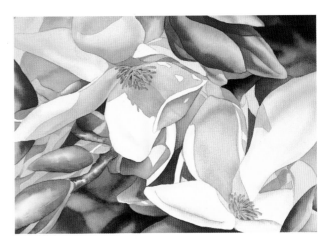

A Simple Background Keeps the Eye on Your Subject
By eliminating all details in the background, our attention is forced to focus on the main subject. The simplicity of this background creates a sense of mystery and serenity.

Use Color to Give the Impression of More Detail
Using the wet-into-wet technique, we can change the feel of the painting with mingled color and softer shapes. Details become less significant, and the flowers are not as dramatic and do not dominate the painting. The lighter background reflects a happier, lighter, more springlike feel, all of which changes the emotion of it.

The soft diffused background is created by dropping different colors onto a damp surface.

If the colors are too dark or you want more definition, use a sponge or brush to lift out areas of color.

Subtle Background Differences
Here are two more examples using a combination of colors, shapes and soft edges. Looking at the background detail, you can see how these are slightly different. Both were made using the wet-into-wet technique, but the one on the right was given additional definition by lifting out areas of color with a sponge.

Masking Methods

At times you may want to preserve areas of white on the paper to save them for your brightest highlights or for painting later, or to protect them from large washes of color. You can either paint around those areas, or if there is a lot of detail involved, consider protecting those areas by using masking materials.

One disadvantage to using masking materials is the hard edges they leave behind, which can be a bit distracting and easily break up the flow in a painting unless you soften them. It's up to each individual artist to decide how and what they want to use to achieve the results they want.

Types of Masking and Tools
Masking fluid, liquid frisket and drawing gum are good for protecting smaller areas; you can brush, dab or even spatter it onto your paper with a brush.

Most masking fluids are latex-based or a synthetic compound that is similar in characteristics. Some are thick while others are thinner, which can make them easier to use. As the fluid dries, the latex hardens. Once dry, the masking will be tacky but not stick to your finger. Make sure the label says it's removable (some brands are permanent).

Just about anything can be used to apply masking fluid to your paper, including inexpensive craft brushes, color shapers, crochet hooks, toothpicks or old credit cards. Masking pens are also available. Never use your good brushes to apply masking fluid, or you will permanently ruin them. Use old synthetic brushes that you no longer paint with, or try tools like the Grafix Incredible Nib or the Cheap Joes Uggly Brush.

Before using a brush for masking, I dip it into slightly soapy water to coat the hair, then dab off the excess water on a paper towel before dipping it into my masking fluid. The soapy coating makes it easier to remove the masking from the brush when done. If you accidentally get masking fluid on a good brush or the masking residue has built up, use a little Citra Solv (a natural citrus cleaner) or lighter fluid to dissolve the dried fluid. All you need to do is soak the brush for a moment, then try to work out the residue with a paper towel. Dip it in a little soapy water again, then rinse.

When using any type of masking, whether it's fluid or adhesive film or tape, realize that over time, residue may remain in areas where the fluid or adhesive touched the paper, and, as it ages, tiny spots may appear.

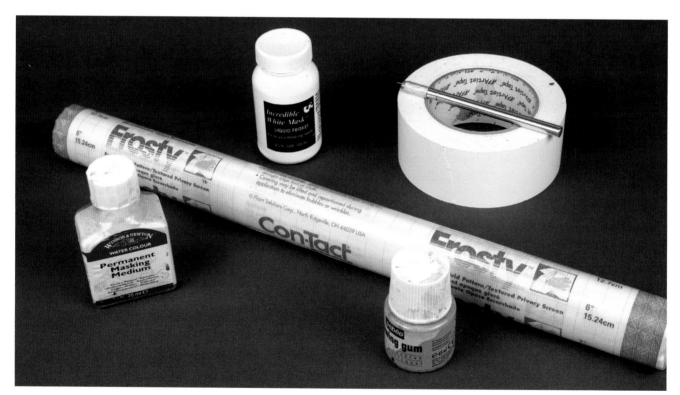

Materials for Masking
Many products can be used to mask areas of a painting to protect them from either splatter or washes of color, including masking fluid, liquid frisket, contact paper (also called shelf paper; make sure the label says it's removable), frisket film, drawing gum, masking tape or artist's tape.

Using Masking Fluid

Masking fluid is probably the most common product used by artists who do masking. Here are some important tips to keep in mind:

- **Stir, don't shake.** For some reason, when we grab that bottle, our first reaction is to want to shake it. For most brands, however, it's not a good idea—it will create tiny bubbles that can burst after the fluid dries on your paper, leaving pinholes where paint can leak through. Generally, it's best to gently stir the fluid instead to keep it usable, but check the directions to see what the specific product you're using requires.

- **Thin it out as needed.** Many brands of bottled masking fluid have a tendency to thicken over time. All masking fluids and drawing gums are water-based suspensions of latex, so most can be thinned with small amounts of water; but since each brand has a different formula, some may need to be thinned with ammonia. Test yours by putting a small amount of fluid in a different container, mix with ammonia or water, then apply to paper and remove.

- **Wait to paint.** Once you have applied masking fluid or drawing gum following the manufacturer's instructions, let it completely dry before painting. This can take 30–50 minutes, depending on the air's humidity. It can be tacky but not sticky, meaning it should leave no residue on your fingertips.

- **Make sure surrounding areas are dry before removing it.** When you're done painting areas that have masking and are ready to remove it, be sure all the surrounding color is dry first, or you might smear any damp color. Then, using a rubber cement pickup or your fingertips, rub over the dried masking to remove. If rubbing it off with your fingers, be aware that oils from your skin can deteriorate the paper over time.

- **Store it upside down.** If you're not going to use your masking fluid for a while, keep it out of the sun and turn it upside down to prevent air from making its way into the bottle and drying out the fluid.

Can Masking Fluid Be Applied to Wet Paper?

Depending on the brand, some manufacturers suggest that you only apply masking fluid to dry paper and definitely not to a wet or damp surface. The reason is that some masking fluids adhere and bond with the surface, making it almost impossible to remove without damaging and tearing the paper. It can also be a little more challenging to apply masking to softer-sized papers for the same reason—it can bond with the paper fibers. If you must use masking on a damp surface, choose a more durable paper with harder sizing, like Arches.

How Long Can You Leave It On?

Some masking fluids need to be removed almost immediately after painting, while others can still be removed weeks and sometimes months after—it all depends on the brand, how old it is and the environmental conditions (see the sidebar for information on some of the more popular brands).

Don't expose applied masking to heat or direct sun, because they can make the latex more adhesive and less removable. You don't want to invest all of your time creating a beautiful painting only to find you can't get the masking off, so remove it as soon as possible.

If the masking fluid has been left on for an extended period of time, or exposed to heat or direct sun, and the latex has bonded with the paper, you can try to soften it with a hair dryer and loosen it with your fingers or a rubber cement pickup, but don't get your hopes up—removal is not going to be easy, if possible at all.

Masking Fluid: Tinted or Clear?

Depending on the brand, some masking fluid has a hint of color to make it easier to see where it has been placed, while others are clear. The tints available range from very light to strong enough that it can stain the paper. Clear masking when dry can be difficult to see, but it can work well if masking in layers because it allows you to easily see the underlying color of your design. Here are the details of some of the brands available:

- **Pebeo Drawing Gum:** gray color, non-staining, can be removed over a few months; thin with water

- **Winsor & Newton Art Masking Fluid:** two types, colorless or yellow; remove 24–48 hours after application if possible; thin with ammonia

- **Grafix Incredible White Mask:** off-white, can be left on paper over long periods of time; thin with water

- **Grumbacher Misket Liquid Frisket:** bright orange, can stain paper; remove as soon as possible

demonstration
Daffodils

As a painter, you want your composition to tell a story and evoke an emotion. In the original reference photo shown, we see a lot of flowers and many details, but the background isn't very exciting. In fact, it dulls down the entire painting. Let's use strong shadows to define these lovely blooms against a simpler background that conveys the freshness of early spring.

Materials

Paper
15" × 22" (38cm × 56cm) 300-lb. (640gsm) cold-pressed (for painting)

11" × 15" (28cm × 38cm) 140-lb. (300gsm) cold-pressed (for practice)

Brushes
No. 30 natural round

Nos. 8, 14 and 20 sable/synthetic blend rounds

Bamboo hake brush

No. 60 wash Mottler or other synthetic wash brush (optional)

Watercolors
Burnt Sienna • Cerulean Blue • Cobalt Blue • French Ultramarine Blue • Hansa Yellow Medium • Indian Yellow • Permanent Rose • Permanent Sap Green • Quinacridone Gold • Quinacridone Magenta • Winsor Violet (Dioxazine) or Carbazole Violet

Original Reference Photo

Move in Closer
To make the composition more intimate, focus on the areas you find most interesting.

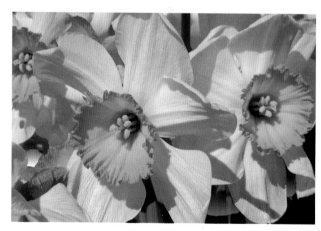

Change the Background
To add more color or brighten the feel of the painting, eliminate some of the details and change the background color.

1. Shape the petals and add the glow

After making your drawing, mix French Ultramarine Blue, Cobalt Blue and Burnt Sienna into a soft blue/gray blend on the palette. Make another separate puddle of the same mixture, but add a tiny amount of Quinacridone Gold and lighten the value with just enough water not to be soupy.

With the wash brush, apply a thin layer of clean water over two to three large petal sections at a time. As the high sheen starts to dull down and there are no puddles on the surface, use the no. 14 or no. 20 round and the soft blue/gray blend to shape the petals with large sweeping strokes. The strokes should be slightly curved, not straight. Add a little of the Quinacridone Gold mixture here and there to enhance the flowers.

To give a yellow glow inside each flower, mix Hansa Yellow Medium and Indian Yellow on the palette and, while the paper is still damp, apply the mixture on one side around where the orange center will be, and let the color soften into the damp surface. Let it dry.

2. Begin the flower centers

Working one flower center at a time, use a hake brush to apply clean water to each round center, almost to the pencil line. On the palette, blend Hansa Yellow Medium and Indian Yellow (or simply use one color). Load a no. 20 round and apply the yellow color along the dry pencil line, allowing the color to touch the water and flow toward the center.

Mix Quinacridone Magenta or Permanent Rose (or both) into the yellow mixture to make an orange. Then, with a no. 8 or no. 14 round, apply the orange mixture along the pencil line of the ruffled edge and allow it to transition toward the lighter yellow in the center. Let it dry.

How to Keep Track of the Composition

Once you've decided on the composition you want and have transferred it to your watercolor paper, it can be difficult to keep track of where you are once you start painting. Keep your reference photo close at hand and start by painting your largest shapes first. As you go along, these will help give you reference points to follow in your composition as you refer back to the photo. Another little trick is to keep one finger from your nonpainting hand at the point where you're painting on the reference photo as you paint with the other.

Brighten the Centers With Another Layer of Orange
To make each flower center really pop, allow the surface to completely dry, then wet the area once again and apply another layer of the orange mixture along the edge, letting it flow into the clean water.

3. Add shadows to the flower centers

With the no. 30 round, wet the inside of the shadow area. Then with the no. 14 or no. 20 round, apply shadow color to the area and allow the value to transition and change. Paint the area around the stamens to give them their shape. The change in value inside the shadow, along with the contrasting lighter stamens, will help prevent the shadows from appearing flat. Let it dry and reapply color where needed.

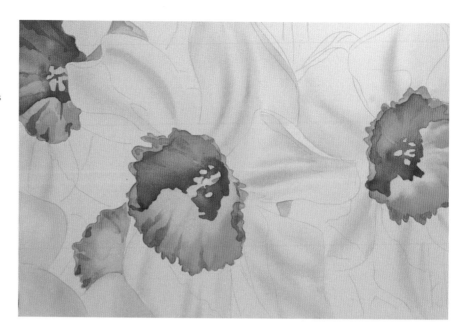

Practice Painting Flower Center Shadows

Try making these shadows on your practice sheet of watercolor paper first before adding them to your painting.

On the palette, mix two separate puddles of your orange mixture from step 2. In one puddle, add a little Quinacridone Magenta to make a stronger orange, and in the other introduce a tiny amount of Winsor Violet (or you could substitute Daniel Smith's Carbazole Violet). Then make a separate puddle of Quinacridone Magenta with a small amount of Winsor Violet (Dioxazine) mixed in.

Paint sample flower centers as you did in step 2 and let it dry. In separate areas, test the three shadow colors you just mixed.

If you like, practice applying these colors to simple rectangular bars rather than painting flower centers.

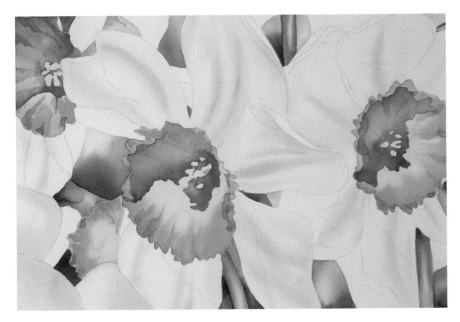

4. Add the background

To get a better perspective of how the composition is working, using the wet-into-wet technique, mingle color into water and start adding in the background.

On the palette, mix a blue using a combination (or just one) of Cerulean Blue, Cobalt Blue and French Ultramarine Blue, and apply it for the background sky. You may use different colors to reflect more of your own personality or whatever feeling or mood you want to convey.

For the stems, mix Permanent Sap Green with Hansa Yellow Medium or French Ultramarine Blue, or mix another favorite green of your choice.

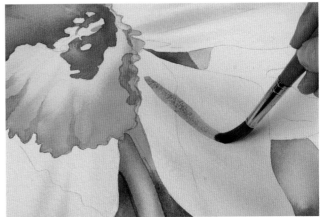

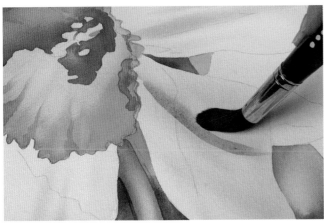

5. Define the petal shapes

With the wash brush, apply a thin layer of clean water over petal areas that need more shape. The water must be clean, or you'll end up with pigmented edges along the water line. A synthetic wash brush will apply less water, making stroke shapes easier to control.

The surface should be damp but not wet. With a no. 8 or no. 14 round and the same blue/gray blend as in the original layer, but in a medium value, use the previous colors as your guide and reapply strokes. To make it more interesting, mix in hints of other surrounding colors or incorporate a little Quinacridone Gold.

With a no. 30 round, soften the stroke along the hard edges. Make sure to run your brush along the edge only, not on top of the stroke, or you might remove the applied color.

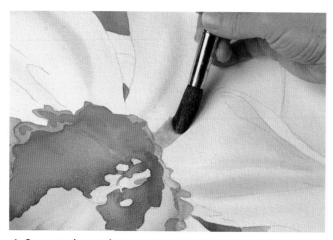 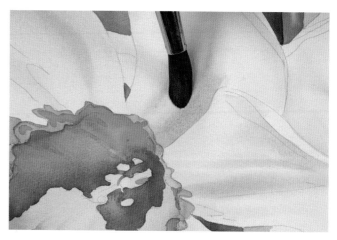

6. Separate the petals

Use the same technique you used to shape the petals to create separations. With a no. 14 or no. 20 round, do a little negative painting. Apply a darker value of the shading color along the pencil line of the area you want to push back.

With a damp (not too wet) no. 30 round, soften the edges of the color as needed. To prevent a halo effect (a hard line around the petal), make sure to pull the color out far enough and transition into clean water.

7. Add shadows to the petals

For shadows, mix the same basic color mixture used to shape and separate the petals. On the palette, mix French Ultramarine Blue with Burnt Sienna (and, if you like, incorporate a little Cobalt Blue) into a blue/gray blend. Then, using a variation in values, apply the shadows. Hard edges will give the appearance of cast shadows and bright sunlight.

The use of orange, yellow, blue, white and green in this painting will give it a clean appearance. You can leave the painting this way or add more depth by deepening some of the values.

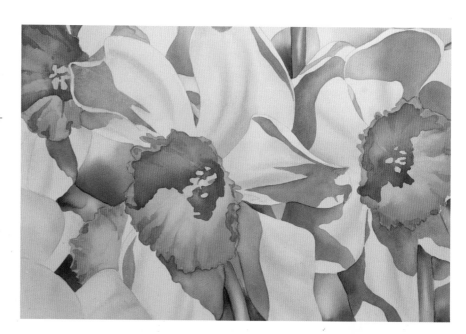

Whenever You Make a Change, Reevaluate the Whole

You will notice that every time you change an area—whether you're adding the background, deepening a color or making other adjustments—the entire painting changes. Areas that you thought were rich and saturated may not seem as much as before or, perhaps, even look a little washed out. When this happens stand back and evaluate where you need to add more color. This doesn't mean you have to add it to the entire painting—only where needed.

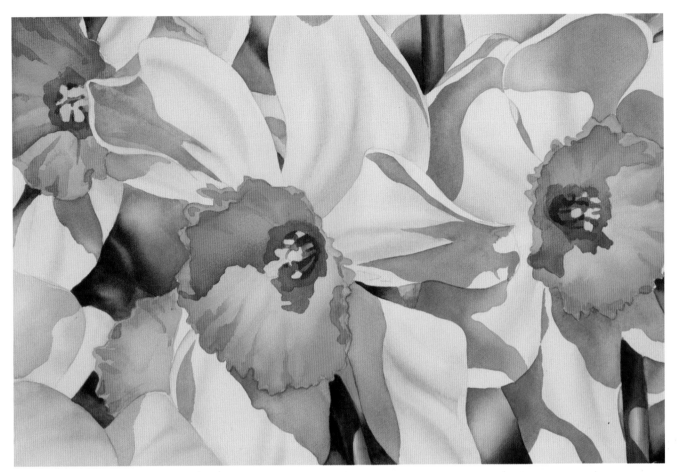

8. Add darker values in the flower centers and background

Using the same shadow colors, but in a darker value, do a little negative painting around the stamens to add contrast and depth inside the flower. In the background, use the wet-into-wet technique to increase the color and darken the values.

Daffodils
Watercolor on 300-lb. (640gsm)
cold-pressed paper
15" × 22" (38cm × 56cm)

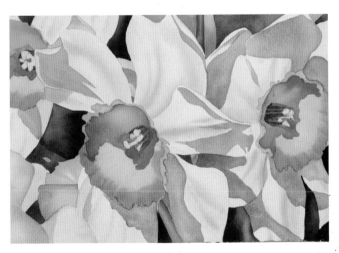

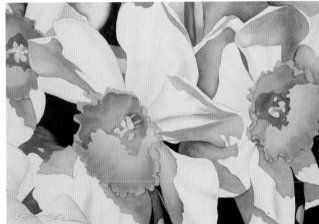

The Effects of a Different Background

Notice how the mood and all-around color change with different background choices: on the left, with greens, and on the right, with darks.

Orange Cactus Flowers

Depending on what you prefer, masking can be applied to the white of the paper or to layers of color. The advantage of masking the different layers is it helps to avoid overlapping edges of color and can give a cleaner look. If your intention is to layer and mask, make sure to allow the previous layer of color to completely dry; otherwise, some of the color may lift when removing the masking.

Materials

Paper

15" × 22" (38cm × 56cm) 300-lb. (640gsm) cold-pressed

Brushes

No. 30 natural round

No. 20 sable/synthetic blend round

No. 60 wash Mottler or other synthetic wash brush (optional)

Watercolors

French Ultramarine Blue • Hansa Yellow Medium • Indian Yellow • Indigo • Permanent Rose • Permanent Sap Green • Quinacridone Magenta • Transparent Yellow • Winsor Violet (Dioxazine) or Carbazole Violet

Other

Masking fluid or Pebeo Drawing Gum

Masking tool of choice

Rubber cement pickup

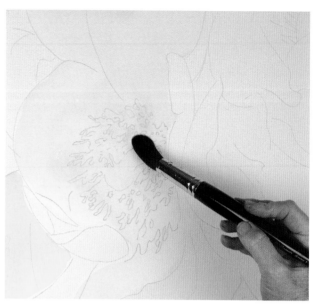

1. Underpaint first

After making a drawing, mix a light value of Hansa Yellow Medium on your palette using a large amount of water. Using a wash brush, apply an underpainting of this color inside the flower, painting over the pencil lines of the stamens in the center. The reason the wash is not applied to the rest of the painting is to retain the white of the paper for future highlights. Let it dry.

Test the Brand of Color

When mixing yellow and reds together, test the colors first. Some brands may lean a little more to the warm or cool side, which can affect the color mix, with some appearing clean and bright and others more toned down or muddy. The reds most likely to be problematic when mixing, depending on the brand, are Quinacridone Magenta and Permanent Alizarin Crimson.

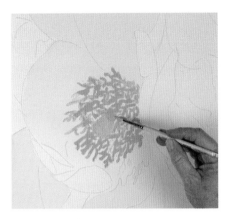

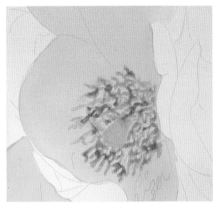

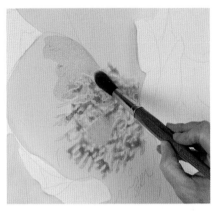

2. Apply masking

Once the surface is completely dry (no longer cool to the touch), use an Incredible Nib, old brush or other masking tool to apply masking fluid or drawing gum where the center stamens will be. Let it dry.

3. Apply a second layer of color

On your palette, mix puddles of Hansa Yellow Medium or Transparent Yellow with a small amount of Permanent Rose or Quinacridone Magenta into an orange blend. Once the masking is completely dry, paint over the masked areas using a no. 20 round and the wet-on-dry technique, and extend the color out to the edges of the petals.

4. Define petal shapes with a third layer

Using the same brush and color mixture, but adding more Permanent Rose or Quinacridone Magenta, and a no. 20 round, start to define your petal shapes. The additional color will also help to create more contrast once the masking is removed.

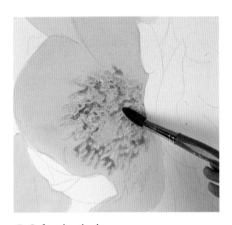

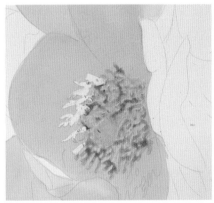

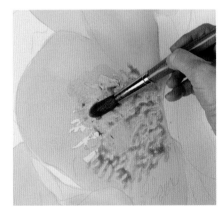

5. Soften hard edges

With a no. 20 or no. 30 round, soften the edges of the color inside the flower so you don't distract from the flow of color with too many brush lines. Let it dry.

6. Remove some masking

Where the shadows fall over the stamens (in a very limited area), remove the masking to reveal the white of the paper. Where the lightest stamens will be, leave the masking on.

7. Paint over the unmasked stamens

Using the same color mixture and a no. 20 round, add another layer inside the flower, painting over where the masking was removed. Let it dry.

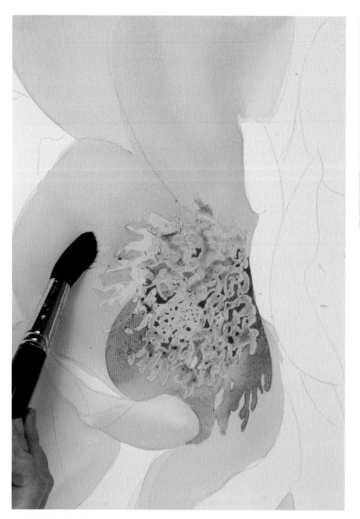

8. Add the shadow

On the palette, mix Quinacridone Magenta with a tiny amount of Winsor Violet or Carbazole Violet. To keep the shadow color as clean as possible, it's important to use more of the magenta than the violet; otherwise, the mix can look muddy once applied over the orange center of the flower.

Using this shadow color with a no. 14 round, define where the shadow of the stamens will be. Then, using the same color and a no. 8 round, do a little negative painting around the areas of the stamens where the masking has been removed, defining the shape of the stamens.

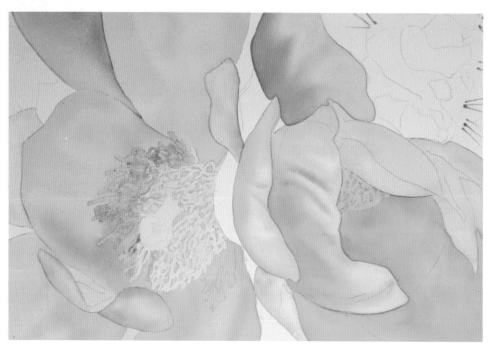

9. Build color in layers for the entire painting

Work on the overall painting one area at a time, using different values of the same color mix. At this point, each large petal should have only one layer of color. Let it dry.

Repeat with another layer where needed to build color. Using the same water and color application, continue to fill in the other petals and paint your way around your flowers. As you do this, allow variations of the yellow and orange to mingle directly on the paper.

(Note: The stamen masking looks different here for the full painting, but the same process shown in the previous steps applies.)

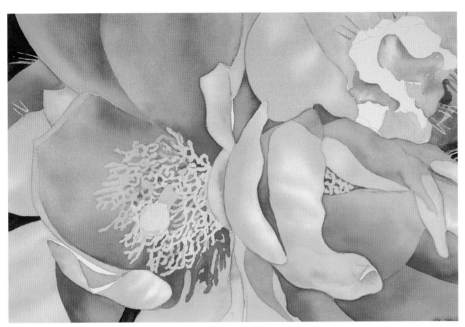

10. Develop the shadows and begin the background

Drama happens once you start applying the shadows. You can see the value changes from light to dark and how that affects the depth inside the painting.

Once you've applied color to the entire flower, add the shadows to the surrounding petals for more contrast. Then, using Quinacridone Magenta with a tiny amount of Transparent Yellow, start adding color to the bud.

For the background, try using different combinations of Permanent Sap Green mixed with French Ultramarine Blue and Indigo.

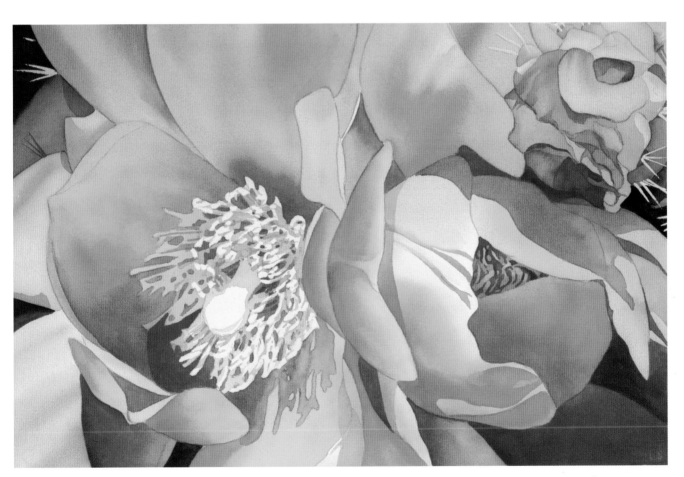

11. Finish the darkest darks and the details

Once you have applied color to entire painting, go back in with a no. 8 or no. 14 round to define details, softening the edges of your strokes as needed. The harder lines of color on the petals direct the eye and keep it moving.

Orange Cactus Flowers
Watercolor on 300-lb. (640gsm)
cold-pressed paper
15" × 22" (38cm × 56cm)

Hibiscus

When preparing to paint large shapes like the petals of this hibiscus, wet the paper with a lot of clean water first to avoid having overlapping edges of color once everything dries. When applying water with the wash brush, go further than you think you need to go. Once you add the color, it will continue to travel and migrate on the wet surface toward the edge of the water line.

Materials

Paper
15" × 22" (38cm × 56cm) 300-lb. (640gsm) cold-pressed

Brushes
No. 30 natural round

Nos. 14 and 20 sable/synthetic blend rounds

Bamboo hake brush

No. 60 wash Mottler or other synthetic wash brush (optional)

Watercolors
French Ultramarine Blue • Hansa Yellow Medium • Indian Yellow • Indigo • Permanent Alizarin Crimson • Permanent Rose • Permanent Sap Green • Quinacridone Magenta • Winsor Violet (Dioxazine) or Carbazole Violet

Other
Masking fluid or Pebeo Drawing Gum

Masking tool of choice

Rubber cement pickup

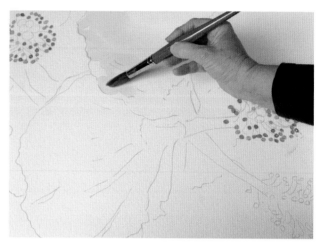

1. Generously apply water and color
Once you've made a line drawing, mask the stamen tips (called anthers), and let it dry. Since we will be using large amounts of water and color, we don't want to worry about painting around details.

With a bamboo hake or other large wash brush, and working clockwise, add water to one to two petals.

On the palette, make puddles of the following colors: Hansa Yellow Medium, Indian Yellow, Quinacridone Magenta, Permanent Rose and Permanent Alizarin Crimson. (Note: Depending on the brand, Permanent Alizarin Crimson can be a little tricky and may even make your flower a bit muddy. If you are new to watercolor, you may want to avoid this color for now.)

With a no. 20 round, apply the yellows along the pencil line and allow the color to flow into the clean water.

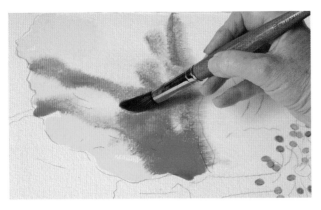

2. Stroke reds into the petals

With a no. 14 or no. 20 round, stroke the reds in the direction of the petal. Let the color mingle into the yellow and clean water.

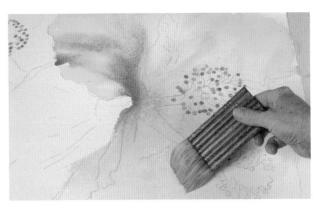

3. Keep it wet

To prevent permanent brush lines, use the bamboo hake or other large wash brush to soften the color as you pull the water around the flower. Don't worry, you will reapply more color.

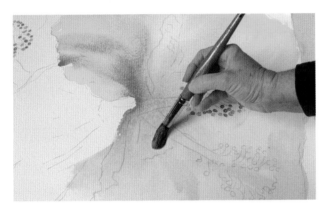

4. Add more wet-into-wet color

Taking advantage of the wet surface, increase the yellows with random strokes to intensify the hues.

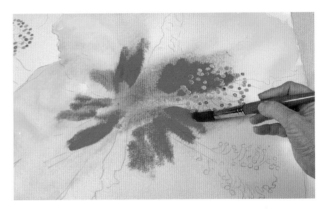

5. Saturate the centers with color

While the surface is still wet, use a no. 14 or no. 20 round to start on the inside of the flower and fan out the deeper reds toward the outer edges. While building the center of the flower, some colors may feather or not move as much, depending on how wet the surface is and how much pigment is in the color mix.

6. Soften and blend color

To soften the edges and blend the color, lift and tilt the paper while it is still wet. To prevent any unwanted blossoming, allow the excess water to run off and onto the table.

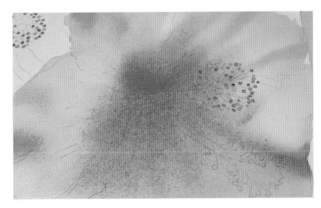

7. Let it dry

Once color has harmonized with the rest of the painting, allow it to dry, making sure the surface dries evenly and at the same rate. If blossoming does occur, try to incorporate it into the painting as texture or folds.

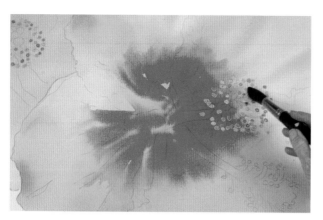

8. Add another layer

The flower still needs depth, detail and shadows. Using the previous layer as a guide, reapply water and color, lifting and tilting the paper to soften and feather the color. Let it dry. Repeat to build layers of color.

Once the paper is dry with no hint of dampness, mask the rest of each stamen—the stalk (pistil) and the connections to the tips (filament)—and let it dry.

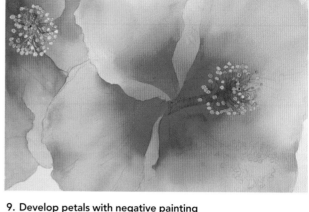

9. Develop petals with negative painting

Using the same petal colors, but in darker values, do a little negative painting to develop the petal shapes by applying color around the areas you want to lift away from the flower.

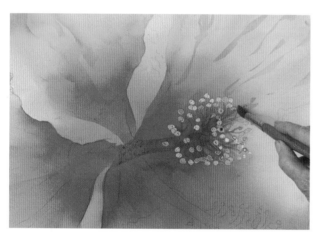

10. Make crinkles

To create the crinkles in the petals, apply random strokes of color using a no. 14 round, working from the outside edge inward. Then, with either a no. 20 or no. 30 round, soften one side of the stroke.

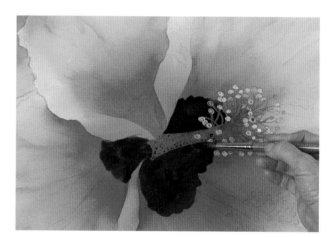

11. Paint the dark centers

In a separate puddle of the same color mix as in the flower, introduce Winsor Violet and a touch of Indigo. Working wet-on-dry, load a no. 14 or no. 20 round and paint the center of the flower, working over the masked stamen. Make sure to follow the flow, leave space between the petals and keep the darker color slightly irregular.

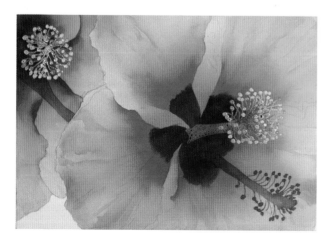

12. Paint the cast shadows

Using the same center color, lighten the value and continue to carry the color down into the shadow cast by the stamen. For the second flower, repeat with the same colors, defining petals with negative painting and adding any extra shadows. Let it dry.

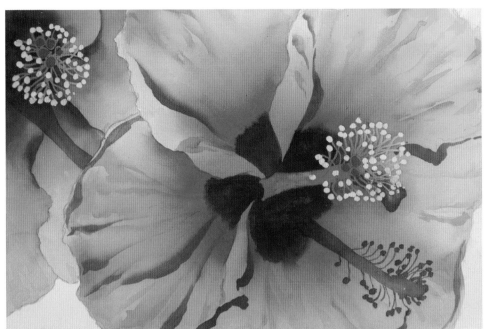

13. Finish the stamens and add darks to the petals

When the color has completely dried, use a rubber cement pickup or your fingers to remove all the masking. Using a light yellow tint, fill in the anthers of the flower. To give the impression of this area projecting out of the flower, keep the value of the color light.

Develop the curls and shadows of the petals with a little negative painting, using lighter values of the flower center color (similar to those applied in the previous step).

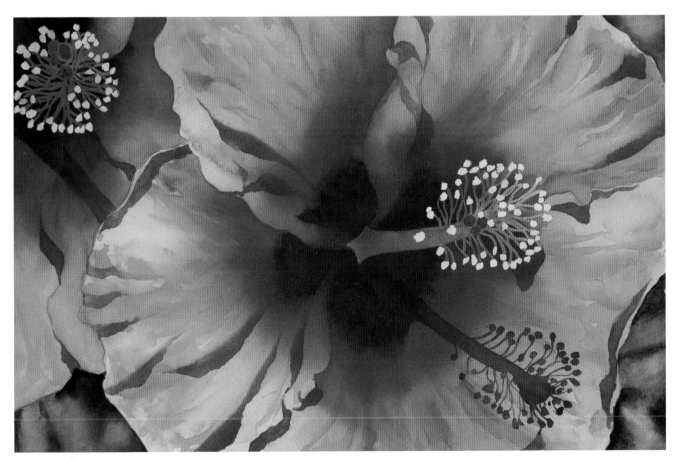

14. Add the background

This part pulls the painting together. You can add different greens or darker blues using combinations of Permanent Sap Green, French Ultramarine Blue or any yellow mixed with green, blue or even Indigo. Add shapes using the wet-on-dry or wet-into wet technique.

If for any reason the background competes with the subject for attention, or you feel the need to pull the flower closer, tone down the background by glazing over it with darker washes of color.

Hibiscus
Watercolor on 300-lb. (640gsm)
cold-pressed paper
15" × 22" (38cm × 56cm)

Tree Peony

This tree peony has huge petals, which allow us to play with large washes of color. Some of the most attractive elements in this composition are the highlights in the petals and the way the color moves through transitions of cool blues, pinks and magentas. Your challenge will be to find the best water-to-color ratio in the paint mixtures to achieve smooth washes, retaining your highlights rather than flooding areas with flat color.

When working on flowers with lots of petals, the goal is to keep it simple and not overdo it with detail. You can avoid overlapping edges of color by unifying large areas with glazing.

Materials

Paper

15" × 22" (38cm × 56cm) 300-lb. (640gsm) cold-pressed

Brushes

No. 30 natural round (to soften edges as needed)

Nos. 8, 14 and 20 sable/synthetic blend round

Bamboo hake brush or other large wash brush

Watercolors

French Ultramarine Blue • Hansa Yellow Medium • Indigo • Permanent Rose • Permanent Sap Green • Quinacridone Magenta • Quinacridone Pink • Quinacridone Purple • Transparent Yellow • Winsor Blue (Green Shade) • Winsor Blue (Red Shade) • Winsor Violet (Dioxazine) or Carbazole Violet

Other

Masking fluid or Pebeo Drawing Gum

Masking tool of choice

Rubber cement pickup

Peony Palette: Mix It Up

The materials list calls for several different pinks, magentas and blues. If you prefer, you may select just a few of the colors—Permanent Rose, Quinacridone Magenta, Winsor Blue (Green Shade) and Winsor Violet, for example—but the expanded list is provided if you want to experiment with slightly different tones and transitioning color.

Mix different puddles of pink on your palette to find the color blends that you like. Try:

- Quinacridone Pink + Permanent Rose
- Permanent Rose + Winsor Blue (Red Shade)
- Quinacridone Pink + Winsor Blue (Green Shade)

Test your mixtures on a piece of watercolor paper and pay attention to how they look when dry. Depending on the brands used and the types of pigment, some colors will appear cleaner and more vibrant than others.

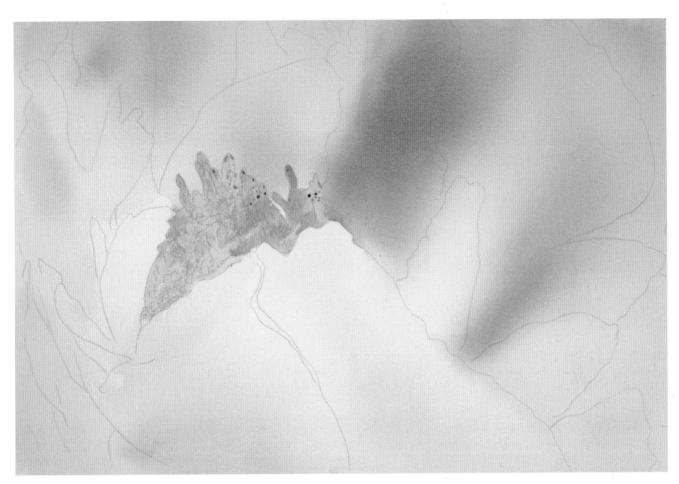

1. Begin to shape the petals with values

Make your drawing first, then apply masking over the stamens in the center of the flower and let it dry. Once the masking is completely dry (no longer sticky to the touch), use a bamboo hake or other large wash brush to apply clean water over the entire flower, including the masked area. You can even paint outside of the pencil lines if you like.

On the palette, mix together Quinacridone Pink with Permanent Rose, Permanent Rose with Winsor Blue (Red Shade) and Quinacridone Pink with Winsor Blue (Green Shade). You are mixing a pink, a magenta and a blue to paint with.

Using the wet-into-wet technique with a no. 20 round, and starting at the inside center, apply different values of the color mixtures in sweeping strokes toward the outside. Let the color run and flow through the entire flower; it's all right if you go outside the drawn lines. Don't go too dark too fast; you are only tinting the petals. Start thinking of how you want to shape the flower. Let it dry.

Once dry, leave the lightest petals in the foreground as mostly the white of the paper, then start to deepen the values and shift colors in the surrounding petals.

2. Define the petals with negative painting

Once you're happy with the color, deepen the values while keeping the darker color toward the inside of the flower. Let it dry. Start to define the petal shapes with negative painting. The negative painting will give you clean edges. To give the impression of detail, just make more shapes.

3. Pull the petals forward

Using the same color mixtures as in the rest of the flower, and working one petal at a time, determine your highlights in the foreground and deepen values in the middle of the flower.

Just as you did in the initial wash, when working an individual shape, apply clean water first. While the surface still has a glisten, shape the petals with a no. 14 or no. 20 round, keeping the darker color along the bottom and transitioning to a lighter value toward the top outside edges.

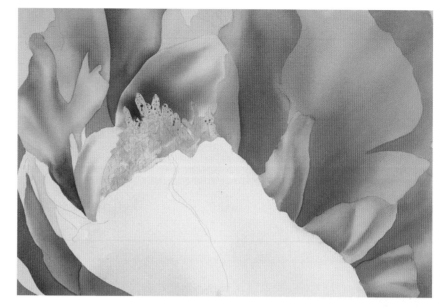

4. Build and unify

As you define the petals by darkening the values, if any areas look too busy or have too many different colors or shapes, you can unify them by glazing with light washes or variegated washes (blending different colors within the same wash). Make sure the previous color is completely dry, then apply water to the surface first. As the surface shine dulls to a satin sheen, apply color as needed. To give the flower more depth, use darker mixtures of the same petal color with a little Quinacridone Purple or Winsor Violet added.

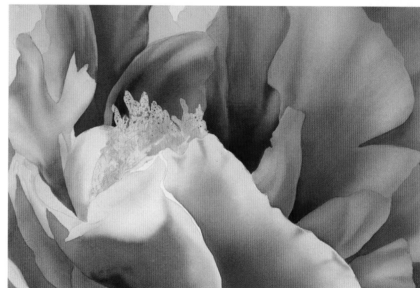

5. Remove the masking

When you're happy with the color, shape and form of the flower (it doesn't need lots of detail), and the surface is completely dry, remove the masking with a rubber cement pickup or your fingers. Step back and evaluate the painting. Look for the areas that you want to pull forward and push back. Leaving the lighter areas alone, build more darks by adding more Winsor Violet mixed with a touch of Indigo.

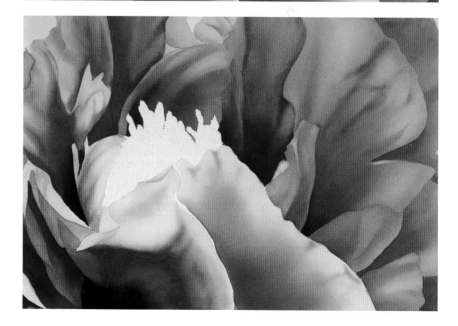

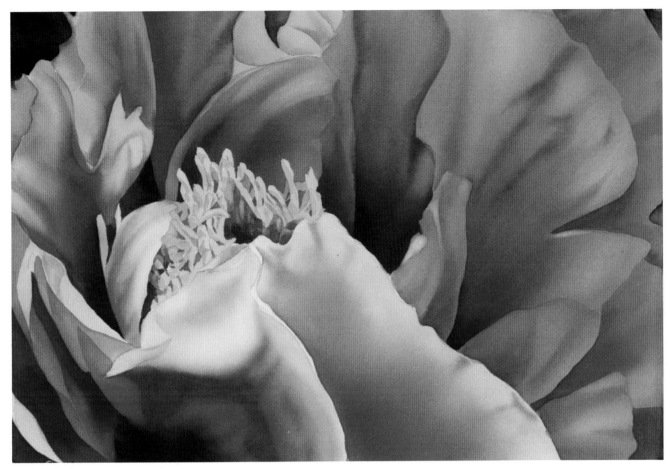

6. Add the yellow center and finish the darkest values

To make the flower pop, add a center that is bright yellow, the flower's complementary color. This excites the eye, making the painting more vibrant and bringing it to life. Use either Hansa Yellow Medium or Transparent Yellow with a no. 8 or no. 14 round, and be sure to test your colors before applying to the painting where the masking has been removed. Let it dry.

Mix a tiny amount of the petal color into the yellow used for the flower center to create a neutral color. Then, using negative painting and starting with the largest shapes first, add the shadow to the flower center. Use a no. 8 round for the smaller details.

Finally, add the background. You could make it light, but since not much of it is showing, consider using a dark color like Indigo to make it really dramatic. Alternately, try Indigo mixed with Permanent Sap Green or French Ultramarine Blue.

Gloria Shirley
Watercolor on 300-lb. (640gsm)
cold-pressed paper
15" × 22" (38cm × 56cm)

Rhododendrons

I often hear artists say they're afraid to paint shadows. Of course it's safer to leave the painting light and pretty, but depending on the subject matter, lots of little shapes can appear confusing and distracting without shadows in place. Shadows can bring into focus areas that need to be closer to the viewer while pushing other areas back.

In this demonstration, we'll develop the shapes first, using colors that work well together, and harmonize them throughout the painting. The use of complementary colors helps to make the composition more visually exciting. Then, once all the petals have enough color, the shadows will bring definition and drama to the rhododendrons.

Materials

Paper
15" × 22" (38cm × 56cm) 300-lb. (640gsm) cold-pressed

Brushes
No. 30 natural round

Nos. 8, 14 and 20 sable/synthetic blend rounds

Watercolors
Burnt Sienna • French Ultramarine Blue • Green Gold • Hansa Yellow • Indigo • Permanent Rose • Permanent Sap Green • Quinacridone Magenta • Quinacridone Pink • Quinacridone Purple • Transparent Yellow • Winsor Blue (Green Shade) • Winsor Violet (Dioxazine) or Carbazole Violet

Color Combinations to Try for the Flowers

On your palette, use the colors on the materials list to make several puddles of different variations of pinks and magenta mixed with blues. If you have favorite purples and magentas, you can use those, too. Mix only two colors at a time, three at the most. Some possibilities include the following:

- Winsor Blue (Green Shade) + Quinacridone Magenta
- Winsor Blue (Green Shade) + Quinacridone Pink
- Winsor Blue (Green Shade) + Permanent Rose
- Winsor Violet (Dioxazine) + Quinacridone Pink
- Winsor Violet (Dioxazine) + Quinacridone Magenta
- Winsor Violet (Dioxazine) + Permanent Rose
- Indigo + Permanent Rose
- Indigo + Quinacridone Magenta

Depending on the brands of paint used, some color mixtures may appear brighter and more vibrant than others. You will also notice slight color shifts and variations that can help to make the painting more interesting. This is why I recommend trying so many different mixture options.

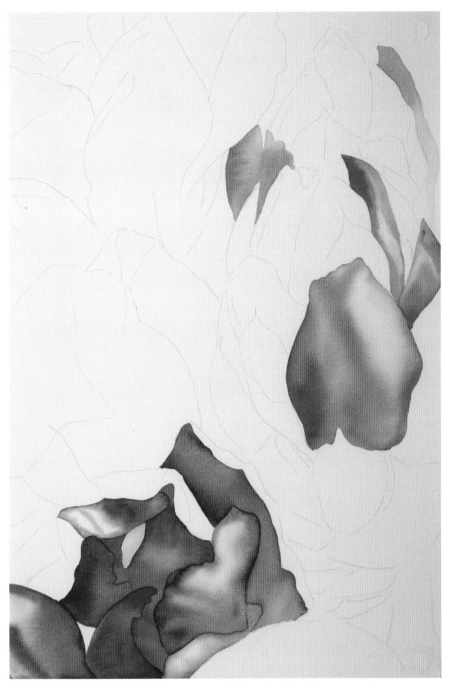

Mastering Highlights

Highlights have the ability to prevent an object from looking flat. You can always create them by lifting areas of color out after you've painted, but that could make a painting look over-worked. If possible, avoid putting color where you want your highlights and encourage the color to move on its own around those areas.

Reserving a Highlight
Apply water to the entire area, then drop color in and let it move. Direct the flow of color away from the highlighted area by lifting and tilting the paper.

Working With Multiple Colors
Wet the paper. While the surface is still damp, incorporate other colors into it, and lift and tilt the paper to help keep all color away from where you want the highlight.

1. Identify highlights
Make your drawing, then, working one petal shape at a time, determine where your highlights will be. With an appropriate size brush for the area, start forming the petals. Apply water followed by limited color so the mixture flows out into the clean water on the surface. This way, you are able to retain the highlights.

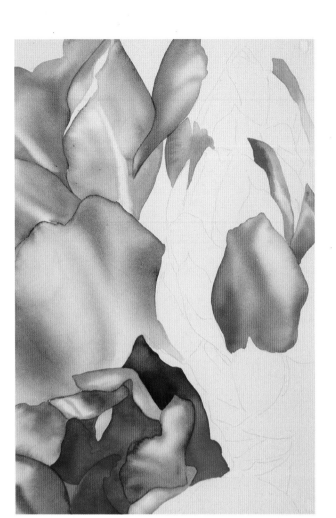

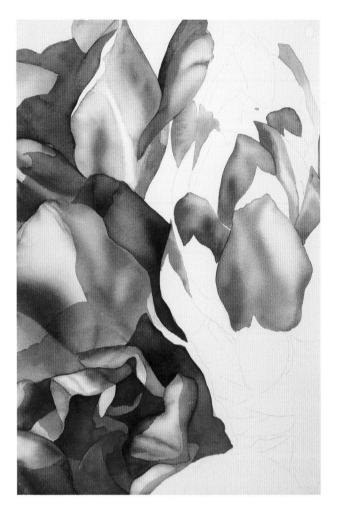

2. Shift the color

To give the impression of the different stages of the blooming flower, slightly shift the hues of color while retaining highlights. Start thinking of shadows and where to deepen hues to create contrast next to the lighter areas.

3. Consider the shadows

For cooler shadows, slowly add a little Winsor Blue (Green Shade) into your purple petal color on the palette. Using mostly water with a tint of the shadow color, and using either a no. 20 or no. 30 round, apply the mixture to areas where you want the most transparent shadows.

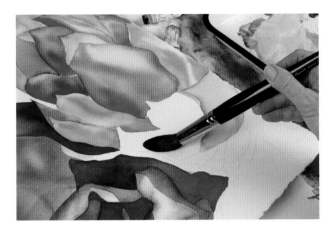

4. Introduce complementary color

Mix different shades of green on the palette, using combinations of Hansa Yellow Medium, Transparent Yellow, Green Gold, Permanent Sap Green and Winsor Blue (Green Shade). Mix yellows with greens and yellows with blues. Then, before applying to the painting, test your colors on a separate piece of paper to find the shades of green that you like.

Using the same technique of water first then color, work one section at a time to add the greens. Remember to think of the highlights, and if it's not obvious where they should be, make them up. This will prevent the painting from looking flat.

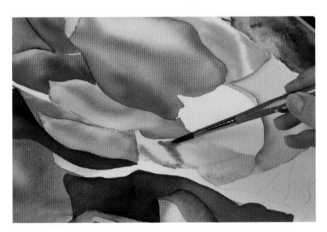

5. Harmonize the greens

Harmonize the various greens so the flower doesn't look like giant, separate blocks of color. With a smaller no. 8 round and a sweeping stroke, drop some violets or magentas into the green petals of the buds to pull it all together.

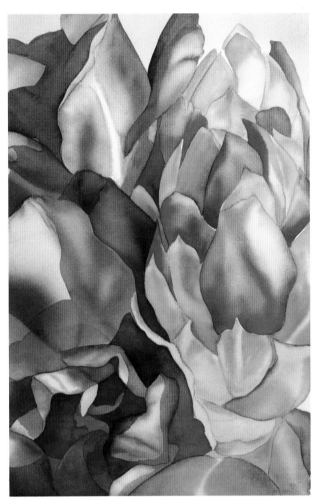

6. Mix a cool, smooth shadow color

In general, my go-to color combination for shadows is French Ultramarine Blue mixed with Burnt Sienna, but in this case I want to liven them up, so that combination won't work as well. We want a cooler and smoother shadow with less granulation. We also want to be careful not to split the painting in half down the middle. Since the shadow is such a large part of the composition, cooler shadows can still appear as part of the flower but not dominate.

On the palette, mix a generous amount of Quinacridone Magenta and Winsor Blue (Green Shade) with lots of water into a medium value. With either a no. 20 or no. 30 round, start to apply the shadow while trying to keep the color flow as one fluid area, moving from one petal to the next. Alternately, you could work with larger shapes first, unify the color, then break those areas down into smaller ones; this prevents overlapping edges.

By adding the shadow, the pink bud on the right now starts to take shape and pull away from the cluster of purple petals. To push areas back further as needed, deepen the Quinacridone Magenta/Winsor Blue shadow color with a bit of Winsor Violet.

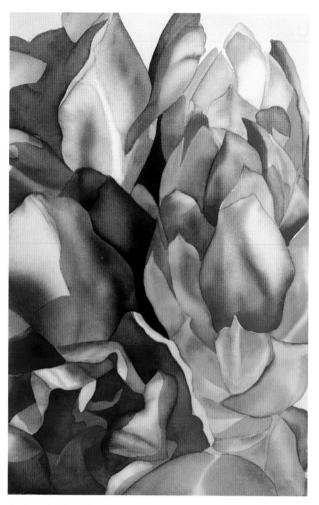

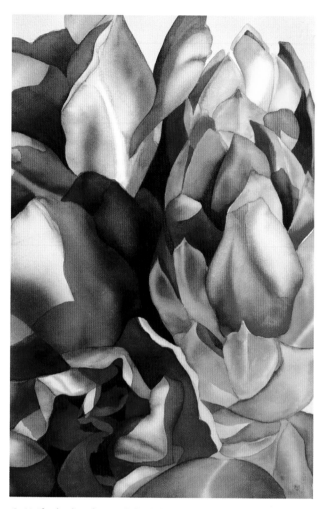

7. Step back and evaluate

Look at how the color is working in general, including the shadows and highlights. To give the pink bud shape and separate it from the darker purple flower on the left, glaze over the side of the bud next to the darker shadow. Use the same shadow colors, but in a much lighter value, with either a no. 20 or no. 30 round.

8. Unify shadow for a subtle shift

The cooler shadow works well to push the purple petals back, but it appears a bit too cool, almost lifeless. Warm or brighten it using a blend of Quinacridone Pink and Permanent Rose (or one or the other, if you prefer) mixed with Quinacridone Purple or a little Winsor Violet. (Note: Avoid using Permanent Violet, otherwise, the colors can get muddy.)

If you need to work on separate shadow areas to push some back, unify them again by glazing over with the same mixture in a darker value, if needed.

Choosing a Background

To help you decide what type of feeling you want to convey before committing yourself to a background, try using painted paper cutouts or wet media paper to test your ideas. For a light and airy feeling, keep the background values light; for more intensity and drama, go darker.

Keep in mind that some darker backgrounds can be challenging because choosing the wrong color can kill the painting. For instance, black is never good—it absorbs all light and can deaden the surrounding color. It would be better to use layers of Indigo or some other dark hue.

When using darker colors for the background, it's a good idea to incorporate a little of that same hue into other places in the painting to harmonize the composition.

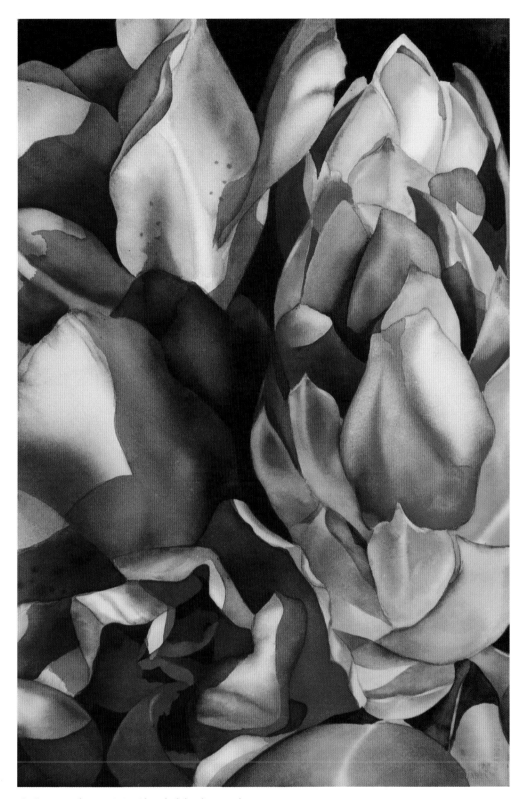

Rhododendron Bud
Watercolor on 300-lb. (640gsm)
cold-pressed paper
22" × 15" (56cm × 38cm)

9. Command attention with a dark background

Darker shadows and backgrounds can feel mysterious and draw us in, but they can also make us feel a little uneasy. When they are placed next to lighter areas of color, the painting becomes dramatic, commands attention and makes a statement. Try using a dark Indigo or Indigo mixed with one of the purple combinations or even a green.

For the darkest shadows on the leaves, use the same color mixed for that shape with the addition of either a little Indigo or French Ultramarine Blue mixed with Burnt Sienna.

demonstration
Sunflowers

Sunflowers are strong, stunning yet simple in form and, in the field, they always face the sun. Painting them seems like it would be fairly easy, but with all their petals, their big, dark centers and the way cut flowers fall, designing a good composition can be challenging.

There are several ways to approach painting sunflowers: Keep it simple and make a wet-into-wet painting without much detail, use negative painting to suggest the flowers or do something in between. It all depends on the technique you want to use and the story you're trying to convey.

Materials

Paper
15" × 22" (38cm × 56cm) 300-lb. (640gsm) cold-pressed

Brushes
No. 30 natural round

Nos. 8, 14 and 20 sable/synthetic blend rounds

Bamboo hake brush or other large wash brush

Watercolors
Hansa Yellow Medium • Indanthrene Blue • Indian Yellow • Permanent Rose • Permanent Sap Green • Quinacridone Magenta • Transparent Yellow • Winsor Violet (Dioxazine) or Carbazole Violet

Other
Melamine foam (original Mr. Clean Magic Eraser)

Mixing With Magenta

Remember, not all Quinacridone Magentas are the same. Test your color mixtures first, and if needed, substitute Permanent Rose or a similar color. Do *not* use a Permanent Magenta, however—this will get muddy.

Sunflower Shadows

Each sunflower faces a different angle, so the shadow color of each will be slightly different. The flower on the left receives more light than the one on the right, which is facing away and will be just a little darker. Also, since we are adding the shadows on top of the yellow, we need to be careful that the color doesn't get too muddy.

1. Establish the petals and centers
Start with a line drawing. With either a no. 20 or no. 30 round, mix several puddles of yellow on the palette (Hansa Yellow Medium, Indian Yellow and Transparent Yellow).

Using a bamboo hake or other large wash brush, apply clean water over the entire surface. With a no. 30 round, and using the wet-into-wet technique in a sweeping motion, start on the inside and brush out, randomly applying the different yellows for the petals. Let the color dissolve on the wet surface, allowing some of the white of the paper to show through. As the high glisten on the surface starts to dull to a sheen, use the same colors in a darker value (more pigment, less water) and a no. 20 round to randomly reapply strokes to intensify the petals' color.

While the surface is still damp, and using a no. 14 round and the same yellows as in the petals, mix in a tiny amount of Quinacridone Magenta to create a light orange blush. Then, using the wet-into-wet technique and working in a circular pattern, start forming the flower centers. Let it dry.

2. Build color to define the petals

Using the same color mixture, but in a medium value, start shaping the petals with negative painting, applying different amounts of pressure.

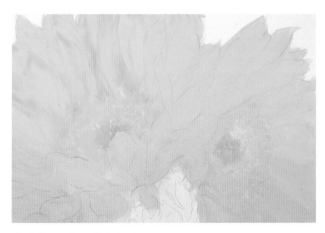

3. Soften edges if desired

After applying the medium-value color, if you find that the lines become distracting, use a damp brush or melamine foam to soften the edges, lift color and gently remove some pencil lines if needed. It may seem like you have defeated the purpose of all that work, but this can also suggest color variations inside the petals. Let it dry.

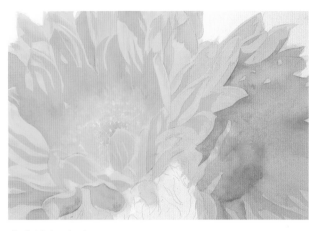

4. Add the shadows

On the palette, mix two puddles of the same flower color, then slowly introduce a tiny amount of Quinacridone Magenta into one and Winsor Violet into the other to create two neutral colors. Try not to add too much color too quickly.

Starting with the flower on the right, use a no. 14 round to add the Winsor Violet neutral, beginning with the smaller areas inside at the top. Gradually increase the size of the brush and amount of color as you work your way down into the center. To give the impression of sunlight across the center, leave two streaks dry, retaining the underlying color.

Now we want to draw more attention to the flower on the left and help pull it forward. To do that we will use the Quinacridone Magenta neutral, mixed not as dark. To prevent the mixture from being too orange or to tone it down, add a tiny amount of Winsor Violet. (If you don't have Winsor Violet, you could try using a blue, but be careful when layering—when layered upon yellow, it could create a green cast. Whatever you do, the shadow color will need to be the same basic formulation for each flower and all the shadows.) Painting the shadow as one large unit over most of the petals prevents overlapping edges. As you're applying inner shadows with a no. 14 round, add the same color to the center by gently dabbing the tip of your brush to the paper in a circular pattern. Let it dry.

5. Deepen the color

Once you have added the centers, work in layers to deepen the shadow as needed, allowing color to dry, then use negative painting to separate petals and define the space in between. Working on dry paper, define the edges of the centers, and, to give the impression of the sun filtering through the petals, leave those areas light.

To help pull it together as you deepen the color to the center shadows, bring some of that same color to the inside of some of the outer petals.

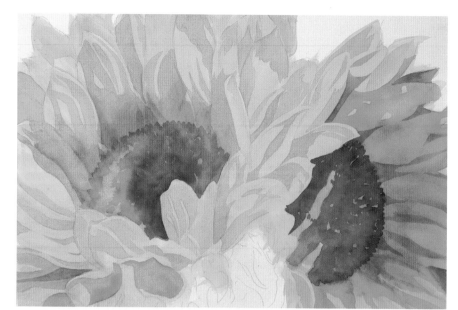

6. Begin the leaves

Mix Permanent Sap Green with a little Hansa Yellow Medium or another similar bright yellow and start adding the leaves. You can do this by filling the space with a flat wash, then when dry, using negative painting to create shape and form. You can also work each leaf if you prefer, but working it as a unit can save you time, help you avoid overlapping edges and unify the color.

Once this area is dry, continue to layer color over the leaves, to deepen the color and push them back. Then, using a no. 8 or no. 14 round, suggest the smaller details of the outside leaves, with just a brushstroke here and there or negative painting.

With a no. 14 round and the same shadow color, only in a darker value, add dots of color to the flower centers. Work in a circular motion and soften some of the edges, to prevent it from appearing overworked.

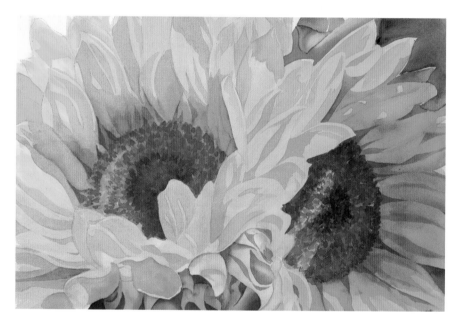

7. Work on the background

You could add other flowers or more leaves to the background, but it might become too busy, considering the details in the rest of the painting. To set off the yellow and make it appear brighter, contrast it with a strong Indanthrene Blue. You will be able to evaluate better those areas that you want to pull forward and push back once this background is in.

For the shadows on the leaves, use the same green color mixture, only with the addition of the background color. Brush over the areas that you want to push back. Look for where you can create contrast—light next to dark.

To help turn away the flower on the right and push it back, darken the value of your flower shadow color with a small amount of Winsor Violet and, if needed, a bit of the background color.

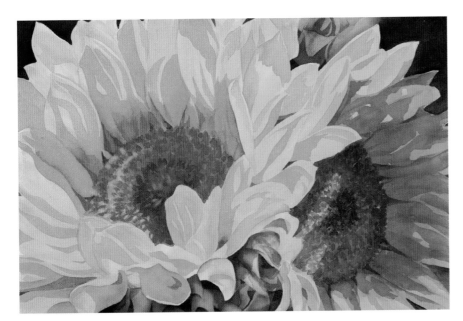

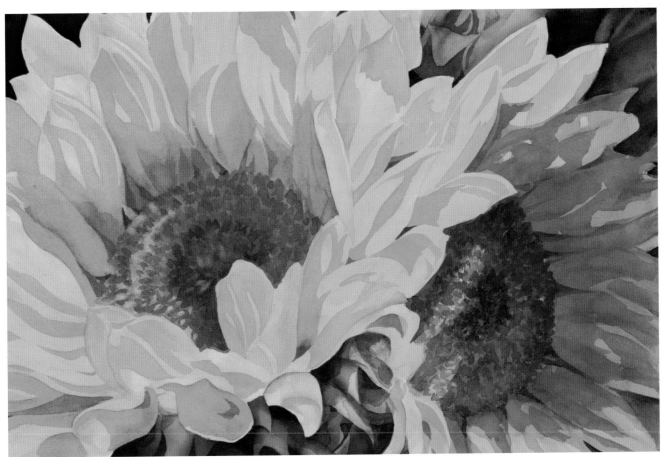

8. Break up the blue

The strong blue brightens the yellow but also draws too much attention to the two upper corners of the painting. We can solve this by breaking up the larger corner on the right with more of a suggested background. All we need to do is lift a little color and, while it is still damp, drop in some of the same colors used for the flowers and shadows. The blue stain helps this area recede, while our adjustments suggest there is another flower in the background.

Sunflowers
Watercolor on 300-lb. (640gsm) cold-pressed paper
15" × 22" (38cm × 56cm)

Calla Lilies

It's natural to want to fill all areas of a painting with color. This is why it can be difficult to paint a white flower. In watercolor, white flowers are created by the absence of color and light reflecting off of the surface of the paper, but letting only the white of the paper do all the work can easily lead to a flat, boring painting. Shading is what brings white flowers to life.

To shade properly, you need to see the values within the white flower. To help you see them, make a small thumbnail sketch in pencil, or, if you prefer, make a black-and-white photocopy of your reference photo. A photocopy might make it easier to see the values that you missed at first glance.

Materials

Paper
15" × 22" (38cm × 56cm) 300-lb. (640gsm) cold-pressed

Brushes
No. 30 natural round

Nos. 8, 14 and 20 sable/synthetic blend rounds

Bamboo hake brush or other large wash brush

Watercolors
Burnt Sienna • French Ultramarine Blue • Hansa Yellow Medium • Indian Yellow • Indigo • Permanent Alizarin Crimson • Permanent Sap Green

Other (optional)
Melamine foam (original Mr. Clean Magic Eraser)

1. Tint the background

Often, it can be difficult to see where the background ends and the flower begins. To prevent you from getting lost in the pencil design you make and help you see your main subjects more easily, apply a light tint to the background and paint around your white flowers. (This technique also works well for more complicated designs.) Use a no. 30 round and a light tint of Permanent Sap Green or another favorite green mixture. Don't apply too much color; keep in mind that you will be layering other colors on top or may want to change the color entirely. You only want to have enough contrast so you can see the areas you will be working on.

2. Apply water first
Working one flower at a time with a large bamboo hake or other wash brush, apply a generous amount of water (more like a puddle) toward the inside area of the shape you are working on. Draw the water out close to the pencil line, but not on it; for just a moment leave a dry space between the pencil line and the water area.

3. Pull to the edge
With a no. 30 round, pull the water all the way up to the pencil line. The amount of water applied to the surface gives you a more workable area for a longer period of time. Using the same brush, remove any excess pooling of water.

Mixing the Flower Shading Color

On your palette, using a no. 20 round with a good amount of water, mix together French Ultramarine Blue with Burnt Sienna into a nice, medium-value blue-gray. When shading a white flower, you don't need much color. Keep in mind that different brands, even with the same color names, can result in different blended outcomes. Some may even appear grayish black. Avoid black tones, because you can easily become unhappy with them and ruin your flower.

The French Ultramarine Blue and Burnt Sienna mixture has a tendency to separate on the palette and on the paper, which can give more color to the flower. This color combination will create a granulated appearance, so if this is something you don't like, choose a different color mixture (just test your color first). To flatten these colors, blow dry with a hair dryer.

4. Shape the flowers wet-into-wet

For this step, the surface should be damp but not shiny. With a no. 14 or no. 20 round, start shaping each flower one at a time by applying a light value of the blue-gray mixture. Do not have two wet flowers side-by-side or you will lose all edges. Vary both the length and width of your strokes by using different brushes. Follow the direction of each flower shape, either from the outside in or inside out, but not across. You want to lead the stroke into the center of the flower.

5. Fill the little shapes with water

Once all the big flower shapes have color, use a no. 30 round to fill the smaller shapes of the flower with clean water.

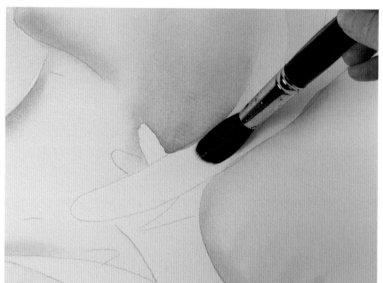

6. Roll the edge

Using a no. 8 round and the same color mix as inside the flower, apply color along the pencil line. As you move further up where the flower opens, transition into clean water.

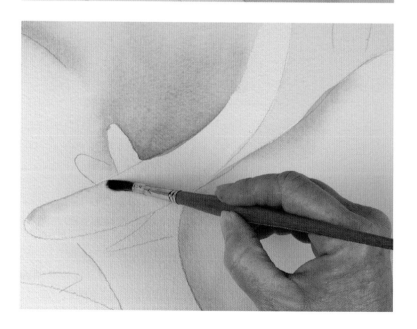

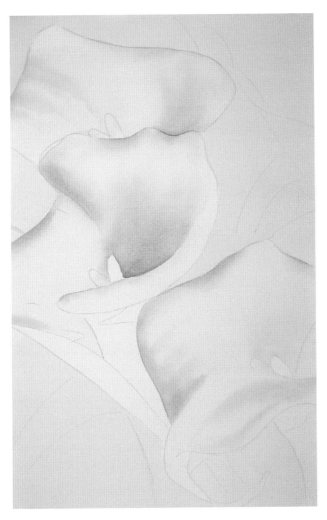

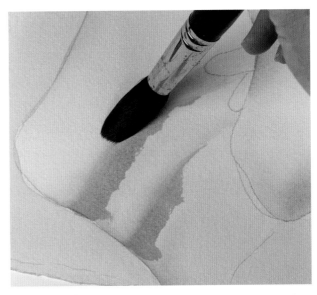

8. Shape the petals with darker layers

Working one flower at a time, and using the same color mixture in a darker value and on dry paper, apply a few strokes of color with a no. 14 round, using the previous layer as a guide. Vary the pressure, length and width of the strokes, and allow the belly of the brush to create the shape. With a damp (not sopping wet) no. 30 round, soften the straight hard edge of the stroke. The goal is to have a combination of hard and soft edges.

Again using the previous layer as your guide, but this time with the wet-into-wet technique, apply a few more brushstrokes over the previous color with a no. 14 round and a darker value.

7. Add more layers for shape

Once you have added shading to all the flowers, if any flower looks too flat and without shape, use the previous layer as your guide and reapply another layer. At this point, don't worry too much about how white your flowers are—once you add your background, you will be able to better evaluate them.

9. Add pistils, shadows and greenery

Add the bright yellow pistils in the centers, which will help you see your flowers individually. Apply them with a mixture of Hansa Yellow Medium and Indian Yellow, then add just a touch of Permanent Alizarin Crimson to this combination and apply to the edges to give the pistils more shape and color.

Using the same color combination as for the flowers but in a darker value, start adding the shadows. There may not be many, but the contrast in value and the combination of hard and soft edges define the flower.

To create more depth in each center, we need to contrast the outer roll of the flower with the center. Working on dry paper and using the same color mixture in a medium-dark value, apply a stroke of color to the center inside the flower. Then, with a damp no. 30 round, soften the edge of color on the inside while leaving a dry edge along the roll of the flower.

On your palette, make puddles of Permanent Sap Green mixed with different colors and combinations of Hansa Yellow Medium, Indian Yellow and French Ultramarine Blue. You can even try combinations of Indigo or French Ultramarine Blue mixed with yellow, or if you have other favorite greens, that works, too.

Working one stem at a time with a no. 30 round, fill each stem area with clean water. Starting at the bottom and using a no. 14 round, apply color, keeping it toward the outside edges, then gently transition to a lighter value as you move up the stem.

To draw attention to the flowers, minimize the details of the leaves in the background. Using big shapes of darker contrasting greens or dark blue (Indigo) will pull the flowers forward and make them pop (think dark next to light).

Once the background is added, the white flowers will look whiter. If you feel that you still have too many grays inside the petals, consider going even darker behind the flowers for more contrast.

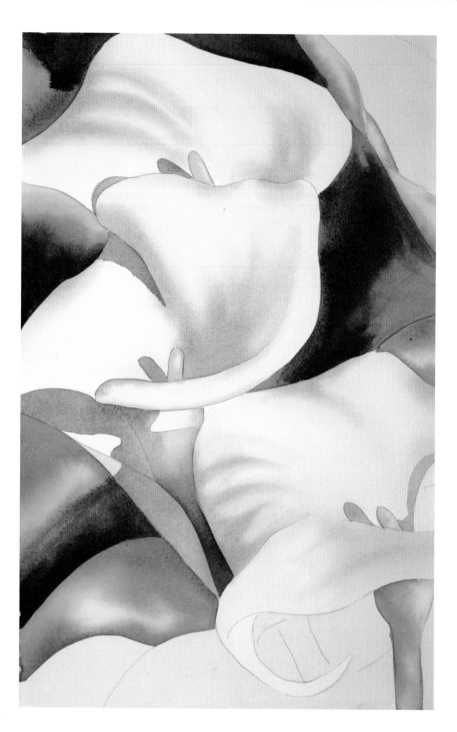

10. Add another layer to the center stem

To make the center flower's stem sink into the flower, deepen the color. Use the same stem color, and for more control, apply color to dry paper with a no. 14 round. The angle at which you hold your brush will help determine the crispness of the brush line.

11. Transition the color

Using a no. 30 round and clean water, gently soften the brush-stroke to give a seamless transition of color from dark to light.

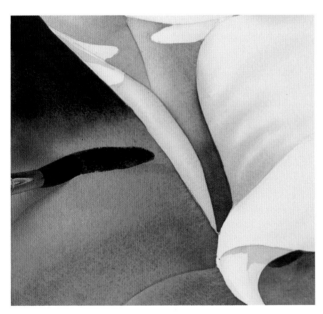

12. Add wet-into-dry color to the background

If you want to give the impression of other leaves and shapes in the background, use a darker value of color, and if it isn't dark enough, add a little Indigo into the blend. Apply the color to dry paper. For a hard-edged, more deliberate effect and more defined shapes, leave it this way.

13. Create diffused shapes

To only suggest shapes in the background and push them back, soften the edge of the colored stroke with a damp brush.

14. Unify with a wash

If shapes, values or colors in the background look too different or there are too many hard lines, you can harmonize them by applying a unifying wash of color, using French Ultramarine Blue mixed with Permanent Sap Green. You could also try variations of Permanent Sap Green and Indigo or any other green combination you like. On the palette, blend a generous amount of color with enough water to go on smoothly, then apply this color to areas of the background to pull the painting together.

15. Push the background back

If you have areas that you want to push further into the background, consider deepening the hue. For instance, the addition of a little blue (Indigo) drops the background away from the lighter flowers. You can also use the background color to clean up any wiggly lines or mistakes along the edges.

16. Lift color as desired

If you decide that you want lighter areas in the background after you have already applied the color, you can use a wet brush to gently scrub and lift. If that doesn't remove enough color, consider using melamine foam—wet the sponge and lift the color. More than likely you will end up with a halo around the area where color was lifted, so to harmonize the area, apply another light tint of the unifying wash.

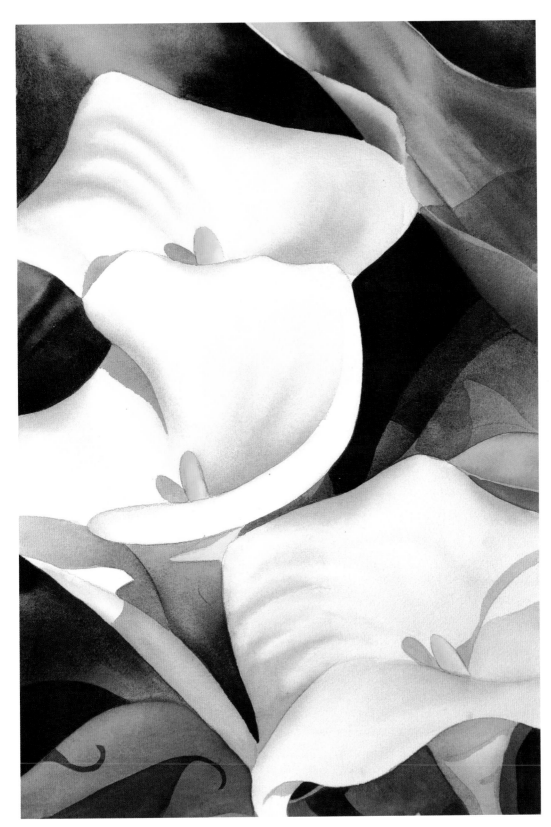

Calla Lilies
Watercolor on
300-lb. (640gsm)
cold-pressed paper
22" × 15" (56cm × 38cm)

17. Final details

Once you have the main structure of the painting done, fine-tune the details. Work on dry paper and use a damp brush to soften any edges. If you're not sure if your painting is done and want to avoid overworking it, walk away and take a break, then come back and see it with fresh eyes.

demonstration
Orchids

Orchids are wonderful flowers to paint. They are readily available in most grocery stores and nurseries, and with them you can make dramatic compositions with intimate views, or take a wider perspective to capture the lush greenery, buds and blossoms, as we will do for this demonstration.

If a composition contains a lot of small spaces or detail, instead of masking the entire design and wasting masking material, mask only what's really important. For this painting, we will use masking to protect the edges of the design and the leaves that sweep across the background.

Materials

Paper
15" × 22" (38cm × 56cm) 300-lb. (640gsm) cold-pressed

Brushes
No. 30 natural round

Nos. 8, 14 and 20 sable/synthetic blend rounds

Bamboo hake brush or other large wash brush

Watercolors
Burnt Sienna • French Ultramarine Blue • Hansa Yellow Medium • Indian Yellow • Indigo • Permanent Rose • Permanent Sap Green • Quinacridone Magenta • Winsor Violet (Dioxazine) or Carbazole Violet

Other
Masking fluid or Pebeo Drawing Gum

Masking tool of choice

Rubber cement pickup

1. Create a line drawing and apply masking
After making your drawing, apply masking fluid along the edges of the design and to any leaves that cross the background. Let it dry.

Bursting Bubbles
This is the reason you don't want to shake your masking fluid. Once you apply the shaken fluid and the bubbles settle, they can start to burst, which can leave pinholes where color may penetrate through to the paper below.

2. Apply a wash to the background

Once the masking is dry, use a large wash brush to apply a wash of color to the background using a combination of French Ultramarine Blue mixed with Burnt Sienna. You can apply color directly to dry paper or apply clean water to the area first with a bamboo hake brush or large wash brush before adding the color with a no. 30 round.

3. Adjust the color and remove the masking

As the initial wash was drying, it appeared to be more blue than intended, so I lifted color from along the top using a damp wash brush. I mixed French Ultramarine Blue with Burnt Sienna to create a blue-gray wash and applied it over the lifted area. This color mixture has a tendency to separate and granulate (or flocculate), which creates a two-tone effect and textured appearance as the neutral color settles onto the paper.

After you're satisfied with the background color and it has completely dried, remove the masking with your fingers or a rubber cement pickup.

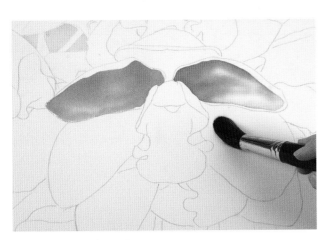

4. Paint one petal at a time

On the palette, mix Permanent Rose with Quinacridone Magenta. Working on one petal at a time, apply clean water with a no. 30 round, then with either a no. 14 or a no. 8 round, apply the color and allow it to transition into the clean water on the surface, creating areas of highlight.

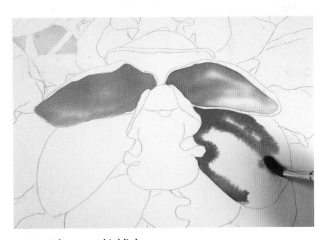

5. Don't lose your highlights

As you apply color, keep in mind your brush size. Use one that's too big and you could add too much color and lose your highlights; use one that's too small and you might not have enough color, leaving the painting too light and weak.

Exercise: Controlling Your Lines

Before you continue to work on the other flowers, give this exercise a try. It will prevent you from overworking the flowers by adding too many distracting lines, and it will demonstrate how the dampness of the paper surface affects the lines you do make.

As the surface shine dulls, using the same color mixture as for the flower—but with a little less water and more pigment—apply brushstrokes with a no. 8 round. Apply them to both a damp and dry surface. If the surface is damp, the stroke should appear smooth, with soft, blended edges (like the flower on the left). If the surface is too dry, hard lines will appear, with possible feathered edges (like the one on the right).

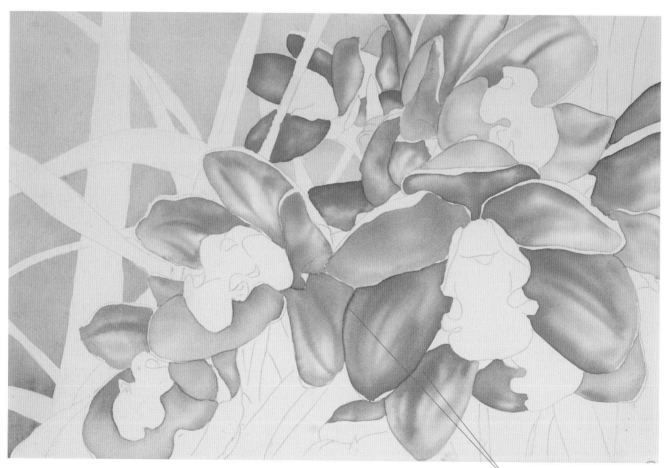

6. Step back and evaluate

Once you've filled in all the petals, evaluate your work, then intensify the color and deepen the values using the same petal colors but in darker values. Start with the softer lines inside the petals first; you can always add more details later.

Hard lines draw more attention, which can give the impression of detail, but too many can be distracting.

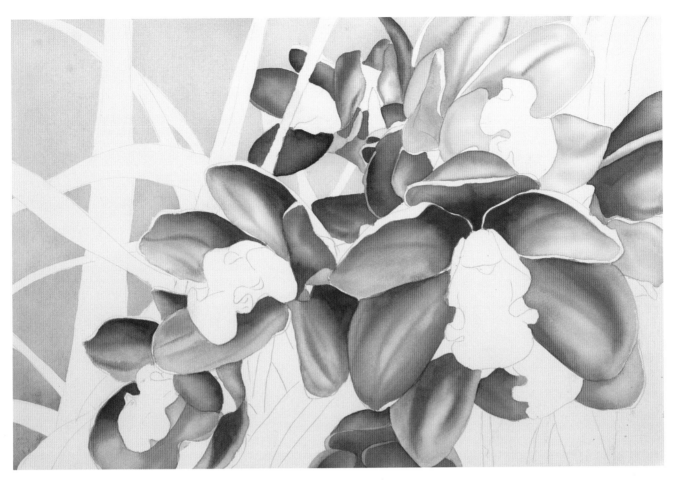

7. Introduce darker values

Since there are no obvious cast shadows in this composition to give the impression of light and depth, we need to create the illusion of it. Use the same petal color, but darkened with more Quinacridone Magenta and just a touch of Winsor Violet. Place this mixture toward the inside of the petals and alongside the ones you want to pull forward. The intention is to use contrast to create a push-pull effect.

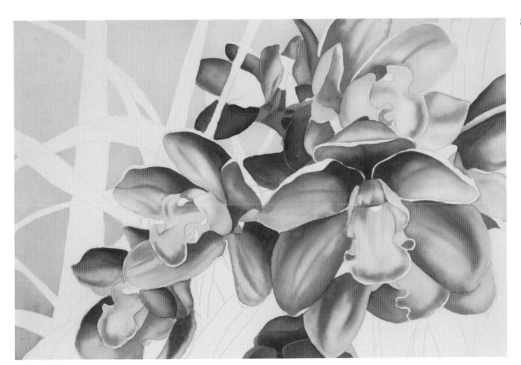

8. Develop the centers

On the palette, mix a puddle of Hansa Yellow Medium with Indian Yellow. Using the wet-into-wet technique, a no. 8 round and the same colors used for the petals, paint around the edges inside the center. While the color is still damp, mingle the yellow mixture into the drying color. Let it dry.

To intensify the hue, reapply the yellow mixture on dry paper. To give the impression of detail, leave a few hard edges.

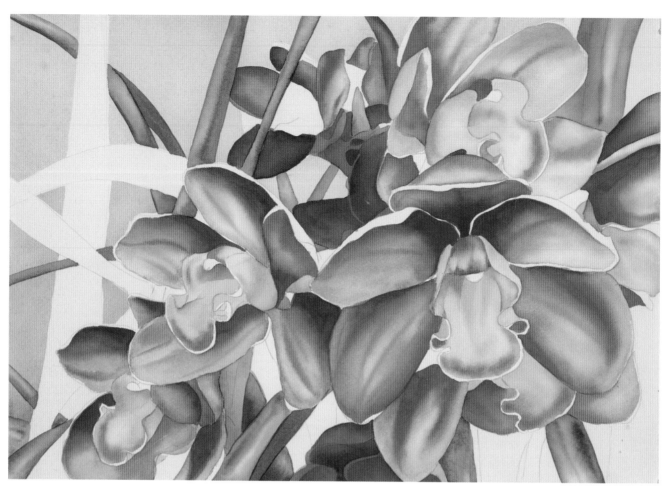

9. Paint the leaves

On the palette, make puddles of various greens: Permanent Sap Green mixed with Hansa Yellow Medium, Permanent Sap Green mixed with French Ultramarine Blue and so on. Applying water first then color, fill in the leaves, using a no. 8 or no. 14 round. Remember to vary colors and values and retain highlights, just as you did with the flowers.

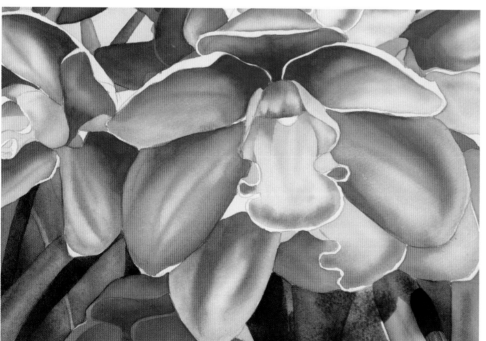

Detail: Adding the Leaves

To make it easier when working in the background, decide which leaves are the most prominent and fill them in one at a time with water and color, then let it dry. For the less prominent leaves, simplify those areas into bigger shapes, apply water and the same color combination, and let them dry. Use negative painting to separate shapes and give the illusion of more leaves.

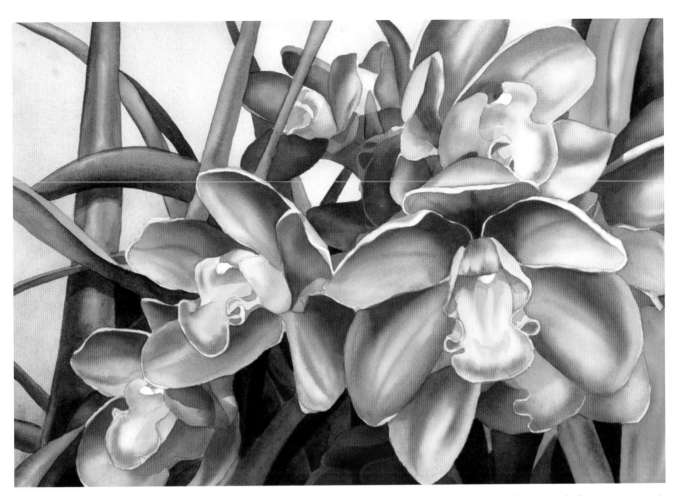

10. Create depth

Since there is no highly contrasting light available in this scene—and no obvious cast shadows—once all the color has been applied to the flowers and leaves, look for areas where you can add subtle shadows with soft edges to give the painting depth. To push areas back, consider glazing over them with transparent layers of shadow color (French Ultramarine Blue mixed with Burnt Sienna). For the darkest darks, use Indigo to separate the shapes.

Mom's Orchids
Watercolor on 300-lb. (640gsm) cold-pressed paper
15" × 22" (38cm × 56cm)

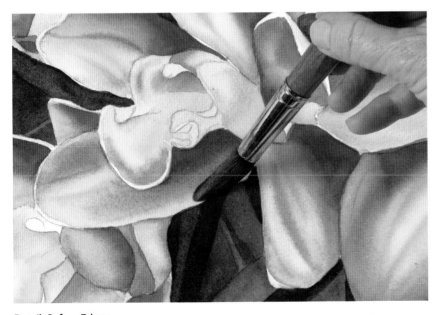

Detail: Soften Edges
When adding darker values, soften edges with a sable/synthetic blend or natural brush.

demonstration
Apple Blossoms

This demonstration uses the altered reference image of the apple blossoms from the composition chapter. We have already repositioned buds to add color to the design, and now we want to make the background a little more interesting by suggesting a sky peeking through leaves and branches in a wet-into-wet background. To break up the simplicity of the white flower shapes, we will use shadow to give the impression of filtered light on their petals.

Materials

Paper
15" × 22" (38cm × 56cm) 300-lb. (640gsm) cold-pressed

Brushes
No. 30 natural round

Nos. 8, 14 and 20 sable/synthetic blend rounds

Bamboo hake brush or other large wash brush

Watercolors
Burnt Sienna • French Ultramarine Blue • Hansa Yellow Medium • Permanent Rose • Permanent Sap Green • Quinacridone Gold • Quinacridone Magenta

Other
Kneaded eraser (optional)

Masking fluid or Pebeo Drawing Gum

Masking tool of choice

Rubber cement pickup

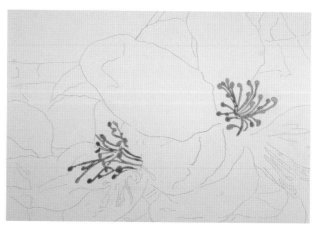

1. Mask the stamens
After making a drawing, apply masking to the stamens before painting. Once dry, the masking fluid can be tacky but shouldn't be sticky.

Dealing With Dark Lines
To lighten dark pencil lines or remove excess graphite, roll or dab a kneaded eraser over the line drawing.

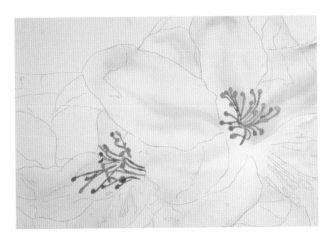

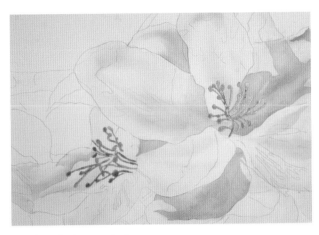

2. Shape the blossoms

Work large sections of two petals at a time. With a bamboo hake brush or other large wash brush, apply an even layer of clean water. On your palette, make a puddle of French Ultramarine Blue mixed with Burnt Sienna to create a blue-gray color. In a separate puddle, make a light value tint of Quinacridone Magenta mixed with Permanent Rose.

As you start to shape the flowers, keep the values light; you can always add more color later. We want an effortless flow and to avoid lifting out color, if possible.

Using a no. 20 or no. 14 round, apply the light Quinacridone Magenta/Permanent Rose mix along some of the edges of the petals to suggest a pink blush. Keep it light. Next, apply the blue-gray mix to all the petals with a no. 14 round. Following the contour of each petal, start to shape the blossoms with light values and long, sweeping strokes. Let it dry.

Once the color has set, re-wet the blossoms and reapply color as you did in the first layer. The surface should be wet and reflective, without puddles. Using a no. 14 round and light values of the blue-gray mixture, following the guide of the first layer of color, apply brushstrokes that are random in size and length. Let it dry.

3. Place the largest shadows

Use the same blue-gray mixture, but in a darker (medium) value. Before applying the shadows to the blossoms, make a test strip of value variations, each containing more or less water, on a separate piece of paper. The best mixture should be transparent enough to see through to the layer below, but dark enough to create the contrast we want.

Paint your largest shadow shapes first. Using a loaded no. 14 or no. 20 round, apply color to dry paper. As the size of the area you are painting expands, carefully incorporate more water to maintain the transparency of the color so you can see the shaping of the petal below. Remember to vary the values from medium to dark within the shape to create contrast, which will lift the petals away from the background.

Colors of Different Brands Blend Differently

Keep in mind when mixing that not all brands of color will blend the same. In one brand, a French Ultramarine Blue combined with Burnt Sienna might make a nice blue-gray, but in another, the same combination can be more gray-black. You may need to adjust or increase one of the colors to get the mixed color you want or possibly consider a different color entirely. That is why it's important to test colors on a separate piece of paper first before applying them to a painting.

4. Paint the smaller shadows

While you are shaping the petals, or even before adding the shadows, consider adding a light pink blush along the edges in some areas to liven up the flowers. Use a very light value of Permanent Rose or Quinacridone Magenta.

Once the largest shadows are in place, start painting the smaller ones using the same blue-gray mixture and a no. 8 or no. 14 round. Look for the details (including the shadows cast by the stamens) and keep in mind how the value of the shadow is affected by the amount of light that is able to reach that particular area.

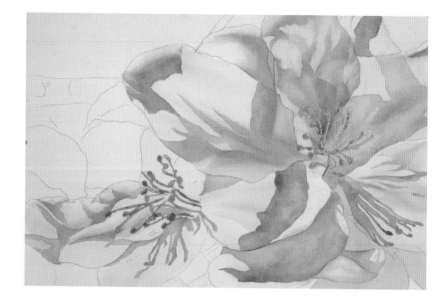

5. Add colorful buds

Using a no. 14 round, apply the Quinacridone Magenta/Permanent Rose mixture to the buds. This added color will liven up the painting. The addition of the darker pink buds also draws more attention to the other subtle blush colors inside the petals and along their edges.

At this time, deepen the center of each flower using a combination of French Ultramarine Blue mixed with Permanent Sap Green and a no. 14 round. Apply enough color around the masking so that when the masking is removed, you will notice a significant contrast.

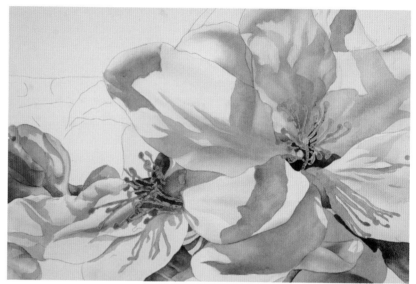

6. Add a branch

To break up the background space, add a branch or two, as instructed in the sidebar on the facing page. This addition lifts the blossoms up and into the tree, which makes the painting more interesting. The branch also creates a middle ground for viewers before they travel into the background.

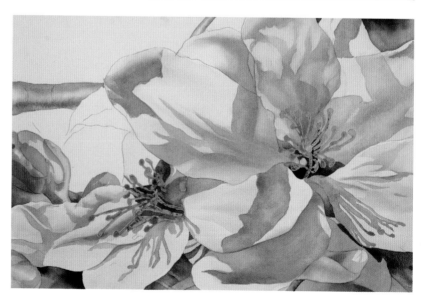

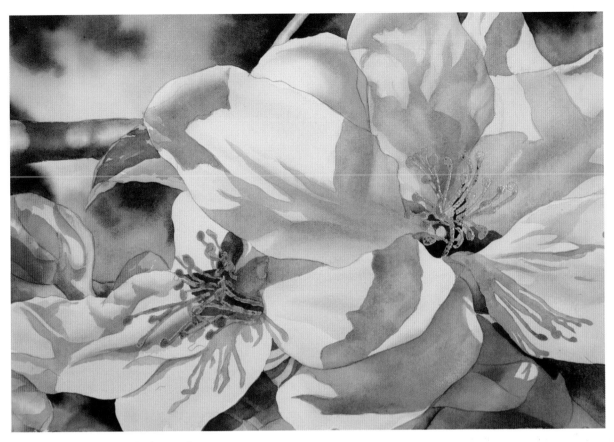

7. Paint the wet-into-wet background

To give the impression of the light of the sky, distant tree branches and other blossoms, use the wet-into-wet technique to fill in some of the large white areas in the background. We don't need to show all the details, only suggest that more is there.

On your palette, make puddles of various color mixtures—Permanent Sap Green with French Ultramarine Blue, or Permanent Sap Green with Hansa Yellow Medium (or a similar yellow) or French Ultramarine Blue with Quinacridone Gold—combinations of blues and greens, pinks and browns, any color that you might see in the background. Remember that other white blossoms are simply areas with no color, only water.

With a no. 30 round, wet the white background area with clean water. As the shine on the surface starts to dull down, suggest other leaves and branches with either a no. 8 or no. 14 round and the colors you mixed. To help incorporate the background into the painting, add a small suggestion of a leaf near the flowers. This can be done by wetting the leaf area first, allowing the same background green to run on the damp surface, letting it dry, then layering a slightly darker value on top.

The blurred background helps to draw attention to the main subject while leading the eye around the painting.

Practice Making a Branch

Before adding a branch to the painting, do this simple exercise. We want to use the same idea of adding water, applying color and retaining a highlight to give the image shape.

On scrap paper, draw a branch shape—basically, four lines roughly forming a Y on its side.

Use the same basic color mixture as in the petals (French Ultramarine Blue + Burnt Sienna), only this time lean it a bit more to the brown side of Burnt Sienna. With a no. 30 or a no. 20 round, apply clean water inside the shape, almost up to the pencil line. Then load a no. 14 round with color and apply along the edges of the pencil line, allowing the color to gently migrate into the center while trying to retain a highlight. The color granulation of the color mixture works well to create the texture in the branch. Let it dry.

8. Remove the masking and evaluate

When you're done adding the shadows inside the blossom and you've added your background, remove the masking from the stamens using your fingers or a rubber cement pickup.

After you have removed the masking, you can see how the stark white of the paper attracts attention and appears flat. At this moment you can decide how much or how little you want these stamens to stand out with the amount of color you choose to add.

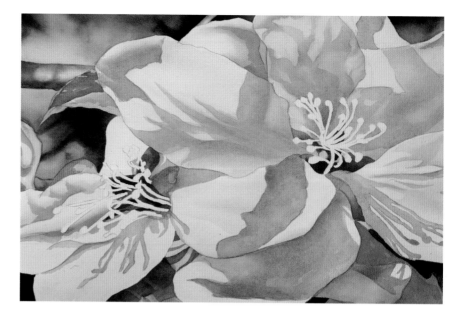

9. Start adding color to the stamens

Using a no. 8 round and a very light value of the green, add a tint of color to fill in the stamens. Once dry, clean up any edges or wobbly lines using a slightly darker value and the same brush.

At this time, if more detail is needed, do some negative painting to suggest more stamens or increase darker values for more contrast inside the flower.

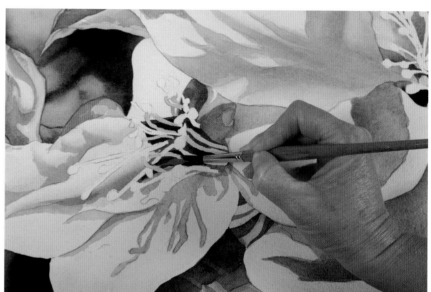

10. Develop the stamens

Paint some stamens with the same pink blush color as in the petals, transitioning into a light-value green. The green will help tie together the blossom centers with the stamens. Fill the yellow anthers (tips) with a light value of Hansa Yellow Medium. If needed, tone down the bright yellow by adding a small amount of Quinacridone Magenta. Once dry, add a dab of the same anther color mixed with Burnt Sienna to shadow the anthers.

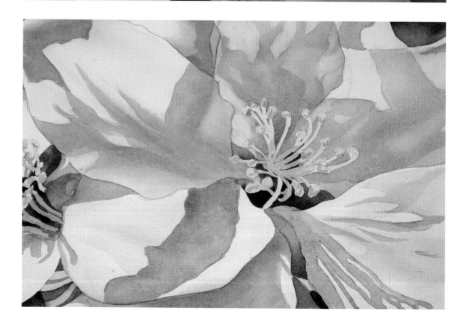

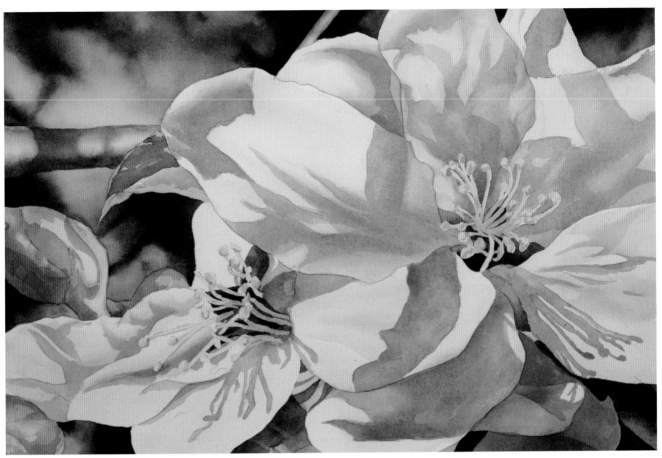

11. Stand back and evaluate

To really see your painting, put a mat on it and stand back. Evaluate the values of the shadows and how they play on the petals. Is there enough contrast between the background and the foreground? At this time, you will be able to see if the background needs more work, or if certain areas need to be toned down or color lifted. If you're not really sure, to prevent you from overdoing it, put your painting away for a while and look at it later.

Looking at the stamens, I decided to push them back further and sink them into the center using the same shadow color as the flower and a no. 20 round. Partially sweep over the stamens closest to the center, allowing the tips to remain in the light.

Apple Blossom
Watercolor on 300-lb. (640gsm)
cold-pressed paper
15" × 22" (38cm × 56cm)

Index

a content + ecommerce company

fwmedia.com

Other fine North Light books are available from your favorite bookstore, art supply store or online supplier. Visit our website at fwmedia.com.

22 21 20 19 18 5 4 3 2 1

DISTRIBUTED IN THE U.K. AND EUROPE
BY F&W MEDIA INTERNATIONAL LTD
Pynes Hill Court, Pynes Hill, Rydon Lane, Exeter, EX2 5SP, UK
Tel: (+44) 1392 797680
Email: enquiries@fwmedia.com

SRN: R3543
ISBN: 978-1-4403-4996-6

Edited by Stefanie Laufersweiler
Production edited by Jennifer Zellner
Cover designed by Clare Finney
Interior designed by Nicola DosSantos
Production coordinated by Debbie Thomas

Acknowledgments

To my husband, Dan, and my parents for their continued love and support.

To my granddaughters, Layla, Kiley, Emma and Gwyneth: Follow your dreams.

To my students, who always inspire me.

I would also like to recognize and thank Sharron MacBride, Patricia Dunbar and Gloria Shirley for their contribution and inspiration for the orange cactus flowers and tree peony and Nancy Long Brandt for her reference images of dahlias.

Metric Conversion Chart

To Convert	To	Multiply By
Inches	Centimeters	2.54
Centimeters	Inches	0.4
Feet	Centimeters	30.5
Centimeters	Feet	0.03
Yards	Meters	0.9
Meters	Yards	1.1

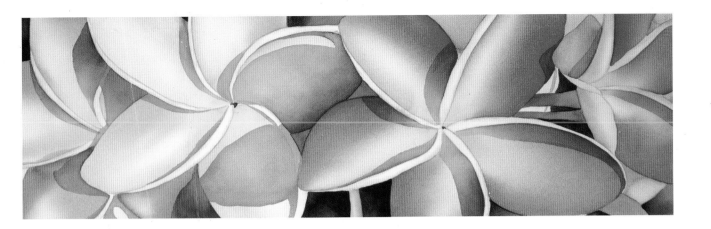

About the Author

Birgit O'Connor is a professional self-taught watercolor artist who has been painting for over twenty years, specializing in florals, landscapes and subjects in nature. Birgit lives in Bolinas, California, and sees her watercolor paintings as reflective of nature's voice.

Her award-winning work has been recognized and published in more than sixty national and international publications, including *Australian Artist* and *International Artist* magazines, and she has been featured in articles in the *San Francisco Chronicle* and the *New York Times*. Birgit contributes regularly to *Watercolor Artist* and *Artists Magazine*. She is also the author of *Watercolor Essentials* and *Watercolor in Motion*, both published by North Light Books.

Birgit has shown her work all over the world, including a one-woman show in Hong Kong. Her memberships include the California Watercolor Association and the Louisiana Watercolor Society, and she appears in the publications *Who's Who in America* and *Who's Who of American Women*. Birgit has produced a wide variety of instructional videos available online and on disc.

For the latest on Birgit, including her upcoming workshops, videos and online courses, visit birgitoconnor.com.

Ideas. Instruction. Inspiration.

Receive FREE downloadable bonus materials when you sign up for our free newsletter at artistsnetwork.com/Newsletter_Thanks.

Artists network
ARTISTSNETWORK.COM

These and other fine North Light products are available at your favorite art & craft retailer, bookstore or online supplier. Visit our websites at artistsnetwork.com and artistsnetwork.tv.

Find the latest issues of *Watercolor Artist* on newsstands, or visit artistsnetwork.com.

Get your art in print!

Visit **artistsnetwork.com/ splashwatercolor** for up-to-date information on *Splash* and other North Light competitions.

Follow north light books for the latest news, free wallpapers, free demos and chances to win free books!